THE BIBLICAL MESSAGE

MARC CHAGALL

This book was produced
with the joint assistance of Charles Marq and Charles Sorlier,
to whom we express our sincerest thanks.

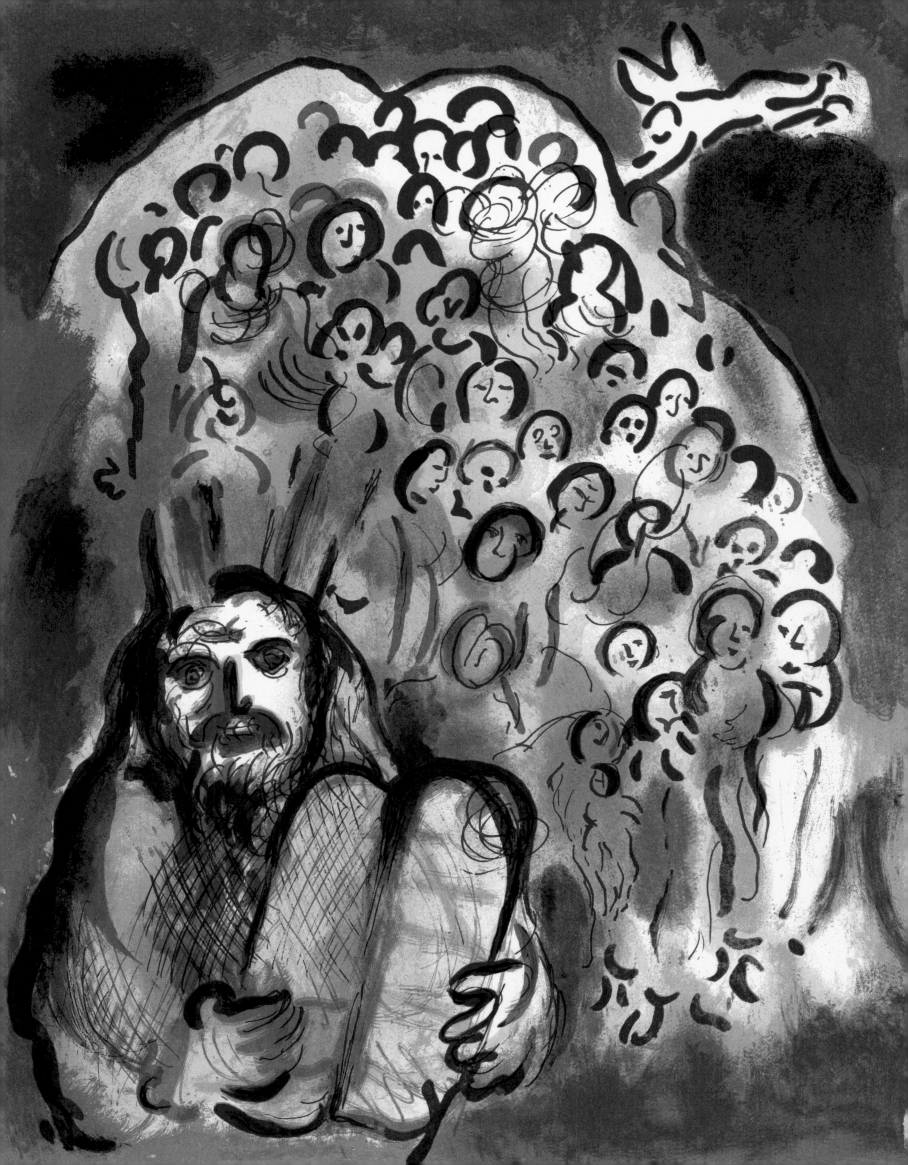

THE BIBLICAL MESSAGE
MARC CHAGALL

Preface by
JEAN CHATELAIN
Director of the National Museums of France

TUDOR PUBLISHING COMPANY
NEW YORK

Library of Congress Cataloging in Publication Data Chagall Marc, 1887 -
The Biblical Message of Marc Chagall.

Translation of Le Message Biblique.
1. Bible, O. T. — Pictures, illustrations, etc.
2. Bible — Influence. I. Title.

ND699.C5A5513 759.7 73-4832
ISBN 0-8148-0568-X

French museums rarely receive cash contributions nowadays; forty years of successive devaluations, as well as the almost total absence of real tax deductions, have discouraged Frenchmen from making such financial contributions. On the other hand, donations of artwork and art objects, whether given by the artists themselves, by their heirs, or by collectors, large or small, continue to be extensive. It would be both misleading and impolite to try to calculate the annual amount of these gifts, for neither generosity nor gratefulness can be weighed on a pair of scales. It can only be said that they substantially exceed the purchasing power of the French museums, although the museums' ability to buy is not quite as negligible as is often assumed.

Those in charge of the museums of France are, of course, delighted with these generous gifts and are deeply grateful to all the donors. However, the disproportionate ratio between purchases and gifts makes for difficulty in establishing a coherent policy for the distribution of artistic wealth among the various regions of France. Donors give whatever they wish to the museums of their choice, invariably favoring the most wealthy ones. In effect, the majority of donations to French museums go to the three most importants, namely, the Louvre, Versailles, and the National Museum of Modern Art.

We therefore have reason to be particularly grateful when a major donation escapes the centrifugal force that drains the provinces in favor of Paris and enriches one of the provinces; this is the case with the recent gift of Marc Chagall's *Biblical Message*, which was donated to the State to permit the foundation of a cultural center in Nice, a region dear to Chagall's heart. In addition to the rooms devoted to Chagall's works, this center will consist of music and lecture halls and a gallery for temporary exhibitions. The project was made possible thanks to the City of Nice, which itself offered the State a superb site on the Cimiez Hill purchased specifically for this purpose. Because of the generosity of Marc Chagall and Madame Chagall, who was closely associated with this endeavor, we here witness an exceptional decentralizing operation and a close tripartite cooperation between the donors, the State, and one of the largest provincial cities. This would be a significant event in itself, even if it were not connected with such a moving and important gift. But towering above all this stands the *Biblical Message* of Marc Chagall, the masterwork of a great artist.

These lines are intended simply to express our gratitude, not to determine the position of Chagall in contemporary art. But let us at least point out some undisputed evidence: the importance of the work he has produced and, even more notable, his originality, which, since the start of his career, has always made it impossible to classify him in any school or movement.

There is need for less restraint when it comes to situating the *Biblical Message* in Chagall's work. Not that the inspiration or expression changes: biblical themes and characters provide an almost permanent source for the artist's imagination, and the symbols and colors of the *Message* can be found in other of his works. But the *Biblical Message* is of special importance because it is a part of his œuvre that is more intentionally candid and, hence, more moving. From the beginning it was conceived as an indivisible unit. It is not composed of separate

paintings withdrawn from an intended market and assembled as an afterthought. It is a series, a complete work, coherent and disinterested from the very start. At the same time it represents a very sincere achievement because it is not the result of some temporary enthusiasm or passing fantasy: it is the outcome of fifteen years of steady, diligent labor in which the artist wanted to express the best of himself. It is a masterpiece in the sense understood by skilled craftsmen, in which the worker invests his whole heart and soul not only to make his mastery evident but, above all, to pay homage to the mysterious forces from which it is derived and which made him what he is. It is enough to see and hear Marc Chagall standing in front of the *Biblical Message* to know that this is precisely what he wanted to do. He intended not to surprise, startle, or overwhelm, but to express his deepest feelings: the joy and legitimate pride that come from knowing he is a master of his art and, at the same time, a respectful humility before the mystery of creation and the evolution of the world; the feeling that he is in community with other men obeying the same laws, that he understands their sufferings and, most important, that he experiences with them all the same gratitude for the most wonderful gift that is given to all, the gift of life.

Jean Chatelain
Director of the National Museums of France

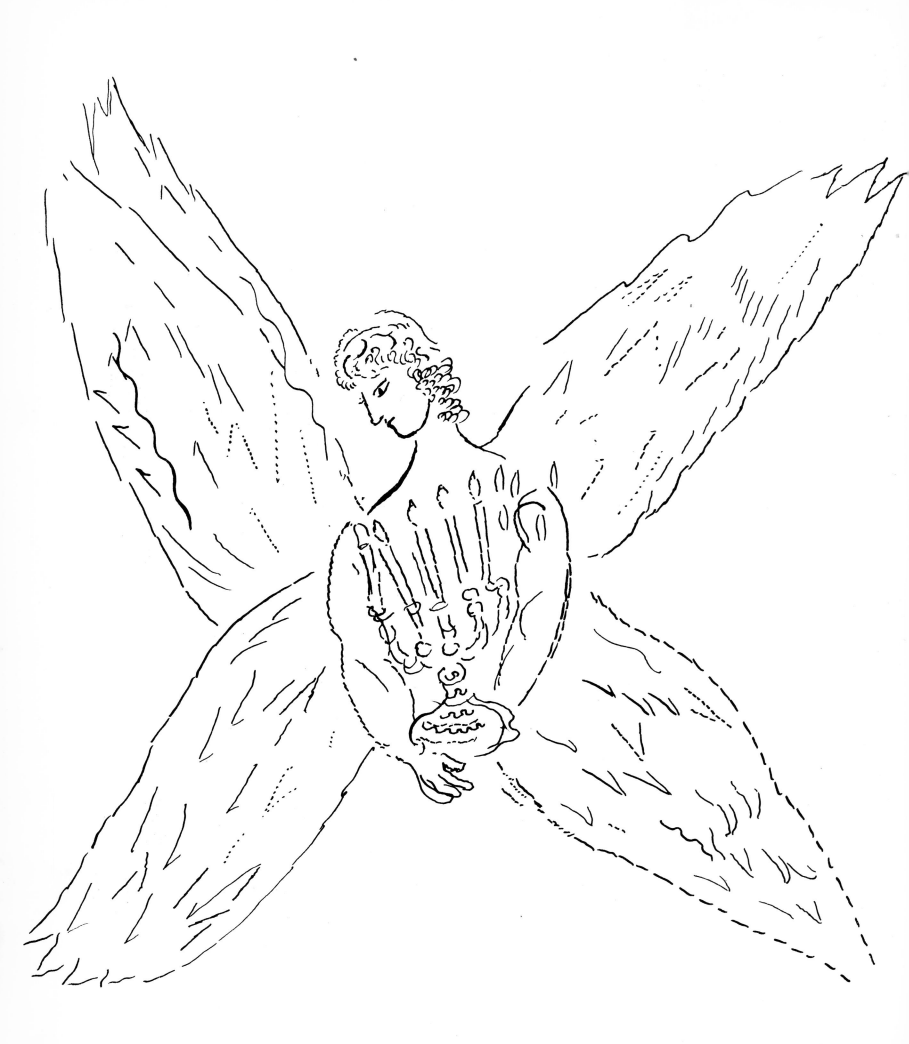

Since childhood the Bible has fascinated me. I have always thought of it as the greatest source of poetry of all time. I have continued to seek out its reflection in life and in art. The Bible is like a musical vibration of nature, and I have tried to communicate that secret.

Throughout my life, whenever I had the power—for I sometimes feel as though I were born, so to speak, between heaven and earth, as though the world were a great desert where my soul wanders like a flame— I have made these paintings in keeping with that faraway dream. I wanted to leave them in this House so that people would have an opportunity to experience here a certain peace, a certain spirituality, a religious feeling, a sense of life.

These paintings, as I conceived them, do not represent the dream of one particular people, but of all mankind. They are the outcome of my meeting with the French publisher Ambroise Vollard and of my travels in the Orient. I wanted to leave them in France, where I was born, as it were, for the second time.

I do not intend to comment upon them. Works of art must speak for themselves.

People often speak of the association between color and a particular style, form, or movement. But color is an innate thing. It does not depend upon the style or form in which it is used nor upon the mastery of the brush: it is outside all movements. The only movements that have outlived their time in history are those very rare ones that have captured innate color; the others have been forgotten.

Aren't painting and color inspired by love? Isn't painting simply a reflection of our interior selves, which alone enables us to go beyond the mere mastery of the brush. It amounts to nothing. Color and line sum up your character and your message.

If every life drifts ineluctably toward its end, we must color ours, while it lasts, with our own colors of love and hope. The social logic of life and the essence of every religion is founded upon this love. For me, perfection in art and life springs forth from the biblical source. The mere mechanics of logic and constructiveness cannot produce any fruit in art, as in life, without this spirit.

Perhaps the young and the not so young will come to this House to look for an ideal of brotherhood and love such as was dreamed of in my lines and colors.

Here, also, the words of that love I feel for all will perhaps be uttered. Perhaps there will be no more enemies, and, like a mother who gives birth to her baby in pain and love, so the young and the not so young will build a world radiant with new colors.

And all, whatever their religion, will be invited to come and speak of that dream, far from evil deeds and meaningless agitation.

I would also like this place to be used for the exhibition of the works of art and the manifestations of great spirituality of all peoples; I would like their music and their heartfelt poetry to be heard.

Is that dream possible?

In art, as in life, all is possible if conceived in love.

Marc Chagall

15. nov. 1972

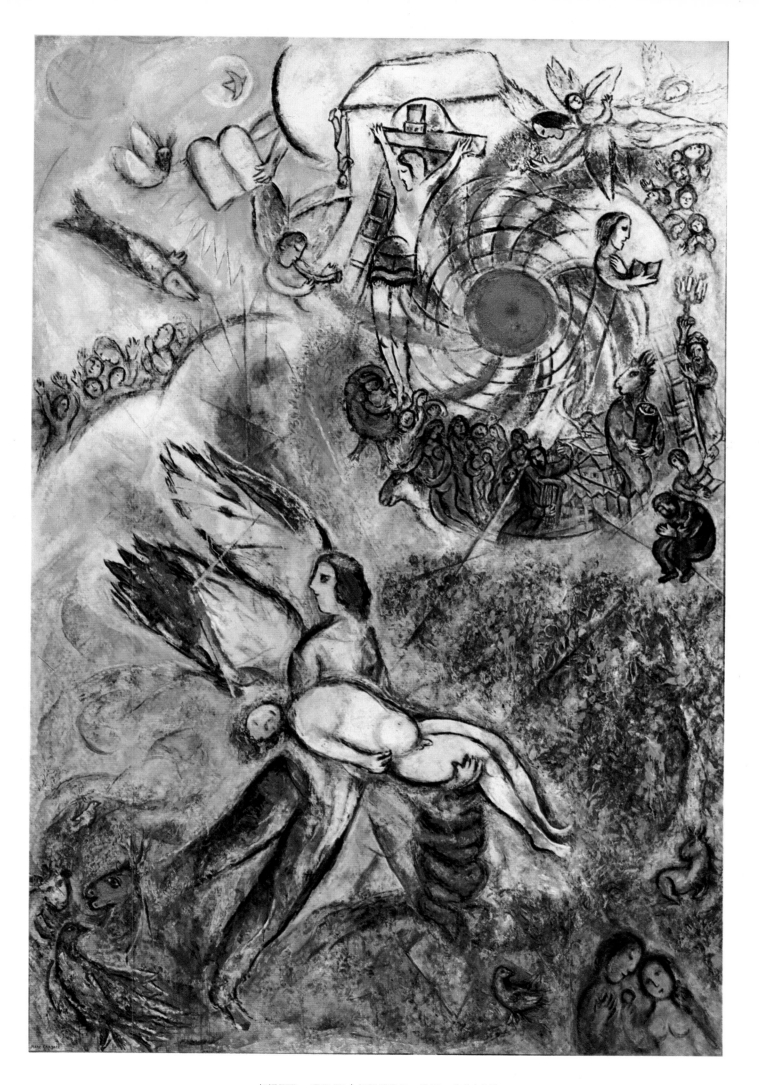

THE CREATION OF MAN

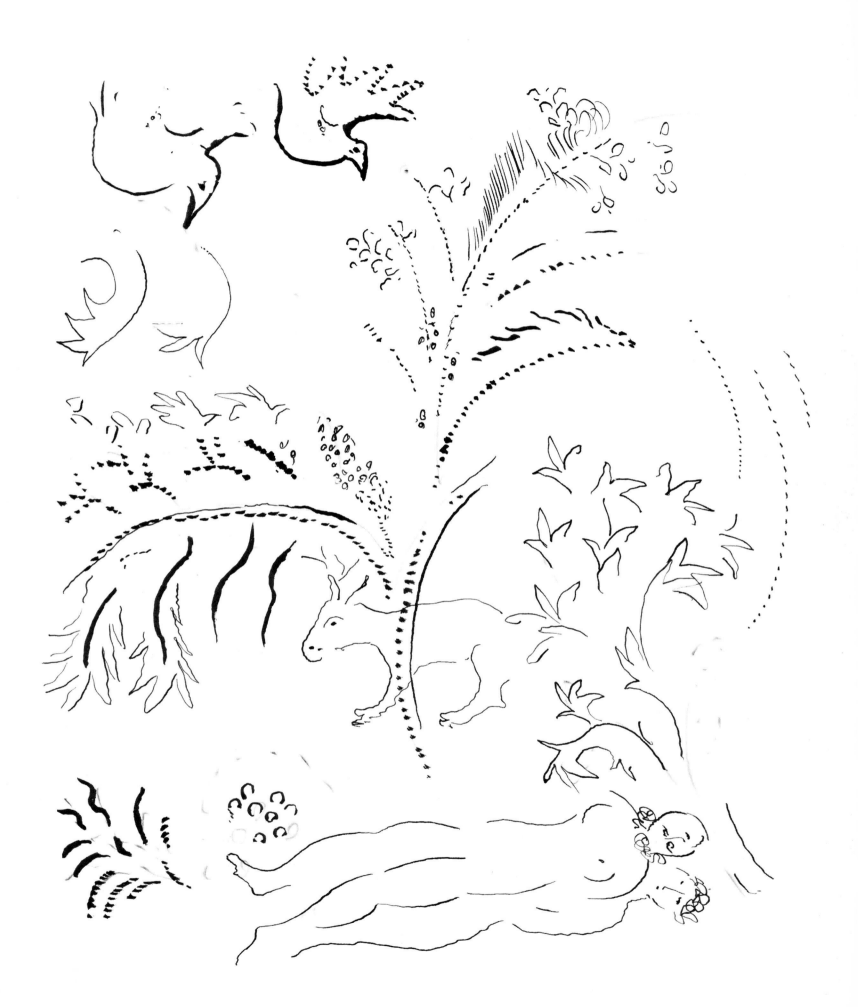

A sense of the present, the view of a painter who invests everything with light and splendor, is conveyed by every illustration in this book, even though they depict the dark mysteries of legendary history. From the vantage point of the present, Chagall explores the greatest of all pasts: he discovers, he sees, he shows the forbears of the human race and brings to vivid life that legendary golden age when the first men grew and multiplied like tall majestic trees and all were by their very birthright superhuman beings. Creator of a whole universe of forms and colors, with his reds and ochres, dark or softly radiant blues, Marc Chagall reveals to us the very hues of man's lost Eden. Under his pencil and his brush, the Bible becomes—quite naturally and in all simplicity—a picture book, a portrait album. Here the portraits of one of the greatest families of mankind are put together.

Hitherto when, left to my own resources, I pondered over the Holy Book, the glory of the words was so compelling that I often lost sight of the men behind them. The prophets seemed no more than voices of prophesy. But now, scanning the plates in this superb collection, I read the ancient Scriptures with new eyes. And I hear more clearly because I see more clearly, because Chagall, the seer, delineates the voice that speaks.

I might almost say that Chagall has enlightened my ears.

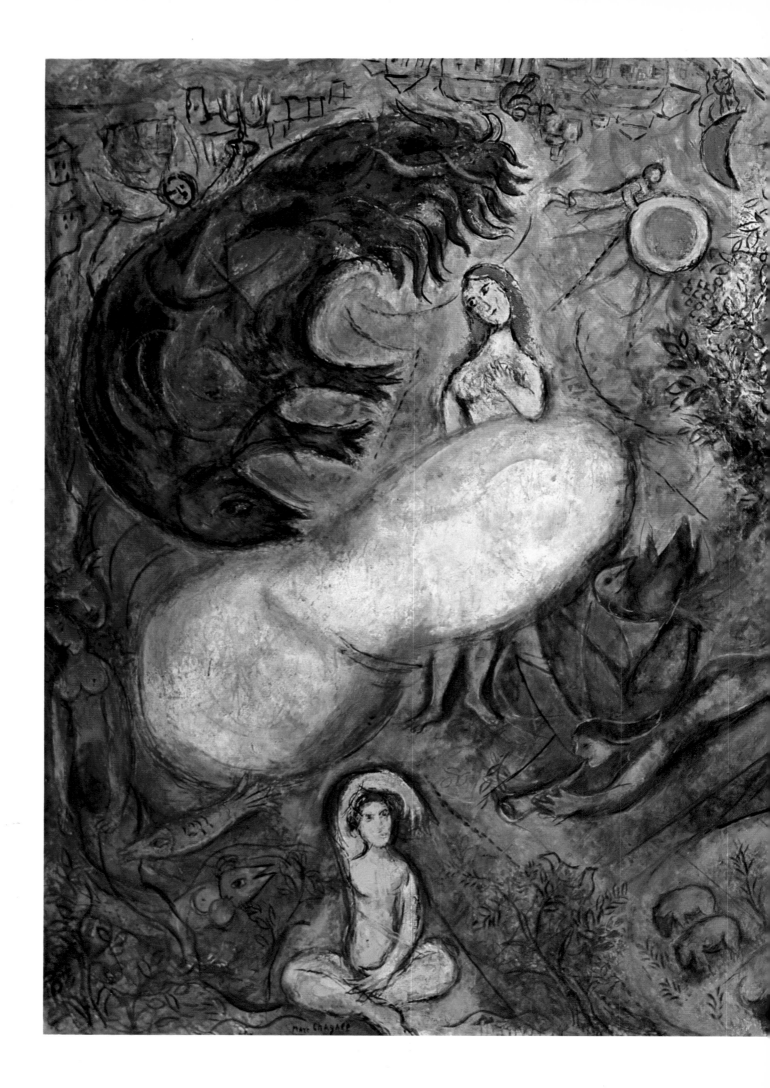

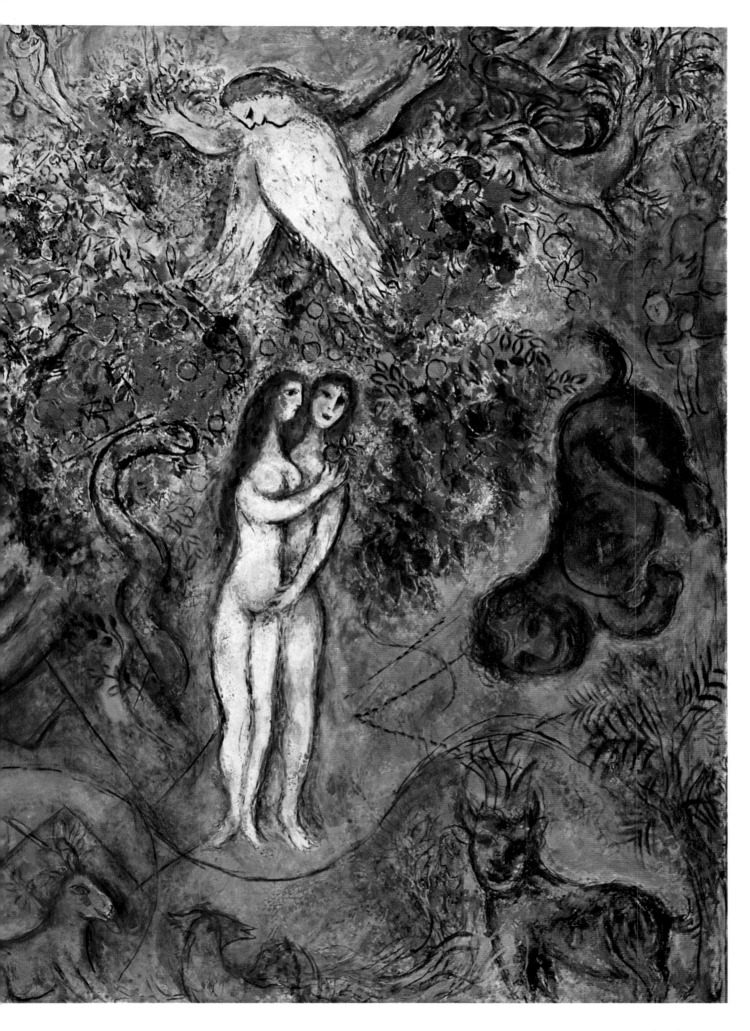

PARADISE

What a privilege for a creator of forms who is also a painter of genius to be called on to depict paradise! Yet surely all is paradisical to an eye that truly sees and delights in seeing. Chagall loves the visible because he knows how to look at it and, above all, because he has learned to depict it. Paradise is a world of beautiful colors, and for a painter to invent a new approach to color is a paradisical thrill. He conjures up something that he does not see; in other words, he creates. Every painter has his own Paradise, and when he is gifted with the ability to harmonize colors, he is sure to express the harmonies of the world.

Paradise is, above all else, a beautiful painting. In the fantasies of all who dream of Paradise, the beautiful colors bring peace to all the creatures of the world. All are pure because all are beautiful. All live together happily. Fish swim in air, a flying donkey fraternizes with the birds, the blue of the air gives buoyancy to everything that lives and moves. In Chagall's vision of this aerial Utopia, even the green donkey is dreaming so intensely that he has a dove inside his head, and, to perfume his fancies, he has carried up into the blue a lily of the valley picked in the world below.

Paradise has a quality of exaltation. A whole series of poems would be needed to express this, but a single Chagall sketch can convey these complex thoughts. There is no limit to what a single painting can say. Colors become words. Anyone who loves painting knows that painting is a source of words, a source of poems. Gazing at the scene of paradise, we seem to hear a hymn of praise. And the marriage of form and color is indeed prolific. The creatures produced by Chagall's brush are as alive and fertile as those called forth by God's hand. The first animals of Genesis were the first words of the vocabulary God taught man, and the artist shares in his creative act. We sense that Chagall is conjugating all the forms of the verb "create", that he too feels all the rapture of creation.

And what a joy to find an artist who creates as rapidly as Chagall does! Rapid creation is the secret behind creating forms that live. Life does not linger, it does not stop to think. There are no rough sketches, no preliminary flashes of inspiration. All of Chagall's creatures are first sparks of inspiration. Thus, in his cosmic scenes, he is the painter of vivacity; there are no languors in his paradise and a thousand reveilles echo in his skies dappled with happy birds in flight. The whole air is taking to wing.

Against a background of birds, in this paradise-garden which sings before it speaks, man enters on the scene, created in God's image but having a dual nature. "Male and female He created them." In the beginning the two bodies were one, and there are hints of the androgynous in several of the plates in this book. Even in the scene of the Temptation, the man and the woman are not completely differentiated. True, Eve takes the lead, but Adam makes no real effort to restrain her. True, Eve has the first "idea" of the apple, but Adam's hand already reaches out toward it. Here Chagall shows his understanding of psychology; the temptation is shared by both. When the serpent speaks, Adam holds back a little, but does not retreat. How subtly the artist has suggested this half-consent! We can almost hear Adam saying to his helpmeet: "Go ahead, my dear; experience temptation, but temptation only! Toy with the fruit, but do not pick it." Or else, even more subtly and equivocally, "Do not pick, but only touch!"

The painter, being very eager to see, acts and feels in much the same way; he caresses the world's fairest fruits with his gaze but does not detach them from the tree. And so, in this scene the artist conveys a crucial moment of man's destiny. He has sensitized the decisive moment of the legend, summing up in line and color all its psychological implications. Whoever gazes at this picture with an understanding eye finds the appropriate words rising to his lips. He sees the Temptation, then recites the story to himself in his own words. And there are dreamers who think up alluring voices to aid the serpent's wiles. Chagall has given us a talking picture, and, yielding to its spell, we find ourselves half-involuntarily playing a part in the drama of the Temptation.

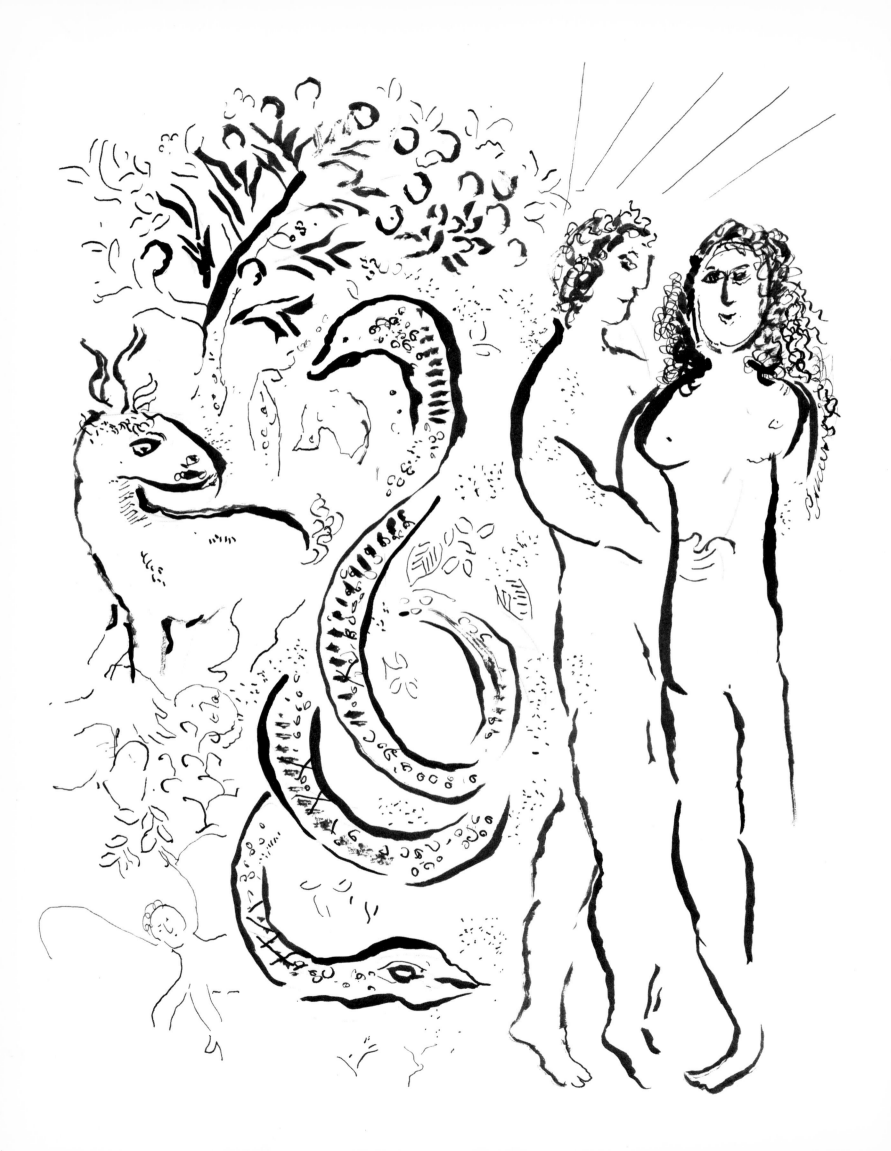

But the woman picked the apple. By means of this one act, paradise was destroyed. God the Creator became God the Judge. Chagall shows us this change in the relationship between man and his maker. God is given the form of a vengeful finger in the sky. Adam and Eve take flight before this God of Wrath.

Yet even in the color plate where God is cursing Eve and we see her stricken by her sense of guilt, there is a touch of typically Chagallian tenderness. Is it a bewildered lamb, or is it, perhaps, one of those odd, hybrid creatures that find their way into so many of Chagall's canvases— a cross between a donkey and a goat? How well this little token of the happy innocence of animals stresses the tragic responsibility of man in his dealings with the joys of life!

Henceforth the gates of paradise are closed. The Old Testament is a grandiose record of the destinies of mankind after the Fall. The Prophets tell the story of the great destiny of one group of people: the destiny of Israel.

Gaston Bachelard

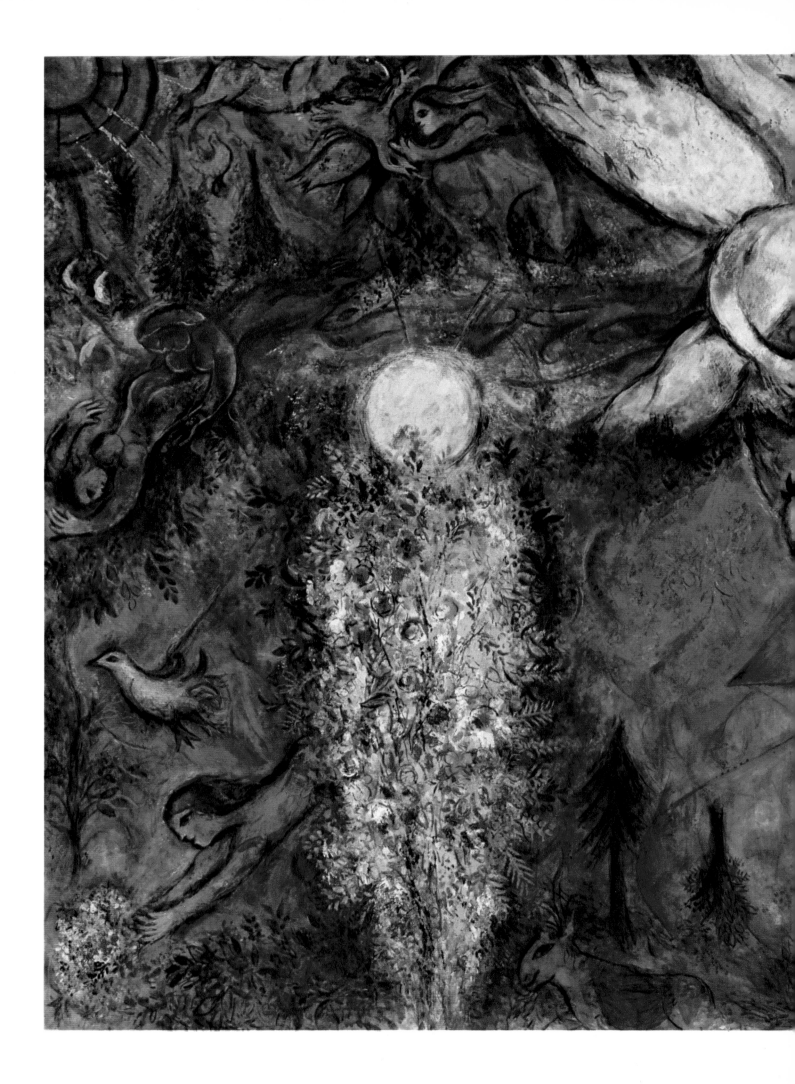

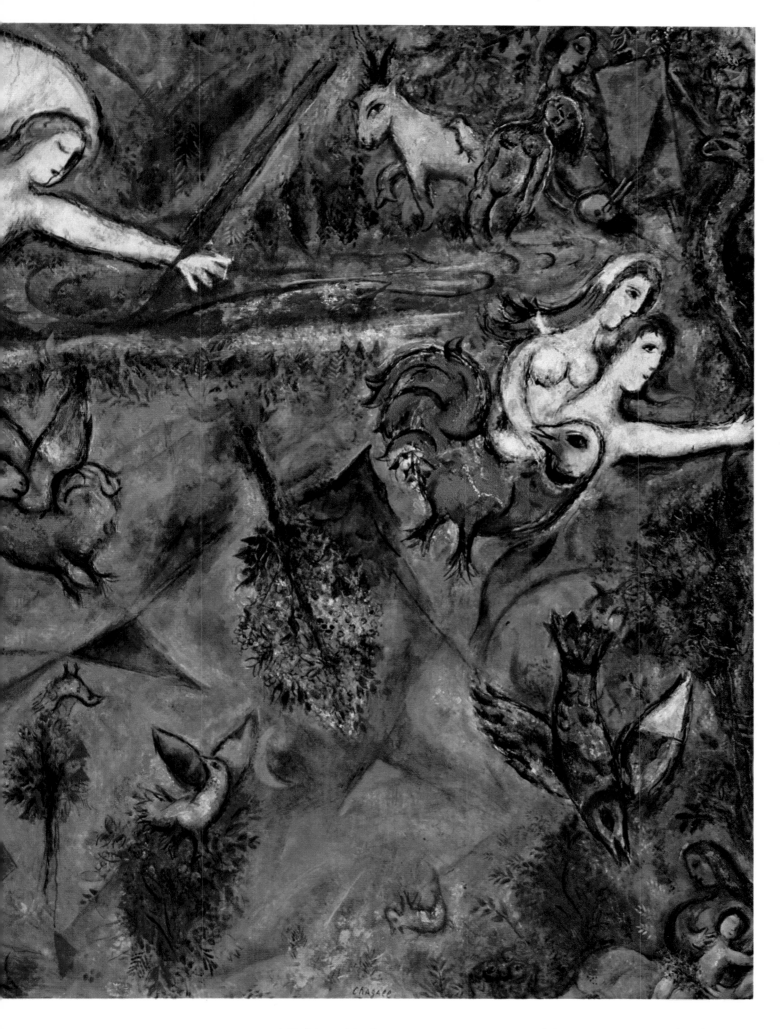

ADAM AND EVE BEING CHASED FROM PARADISE

And the Lord said unto Noah, Enter thou and al thine house into the Arke: for thee have I seene righteous before me in this age.

Of every cleane beast y shalt take to thee by seves, y male & his female: but of uncleane beasts by couples, the male and his female.

Of the foules also of the heaven by sevens, male and female, to keepe seede alive upon the whole earth.

For seven dayes hence I will cause it raine upon the earth fourtie dayes and fourtie nights, & all the substance that I have made, will I destroy from off the earth.

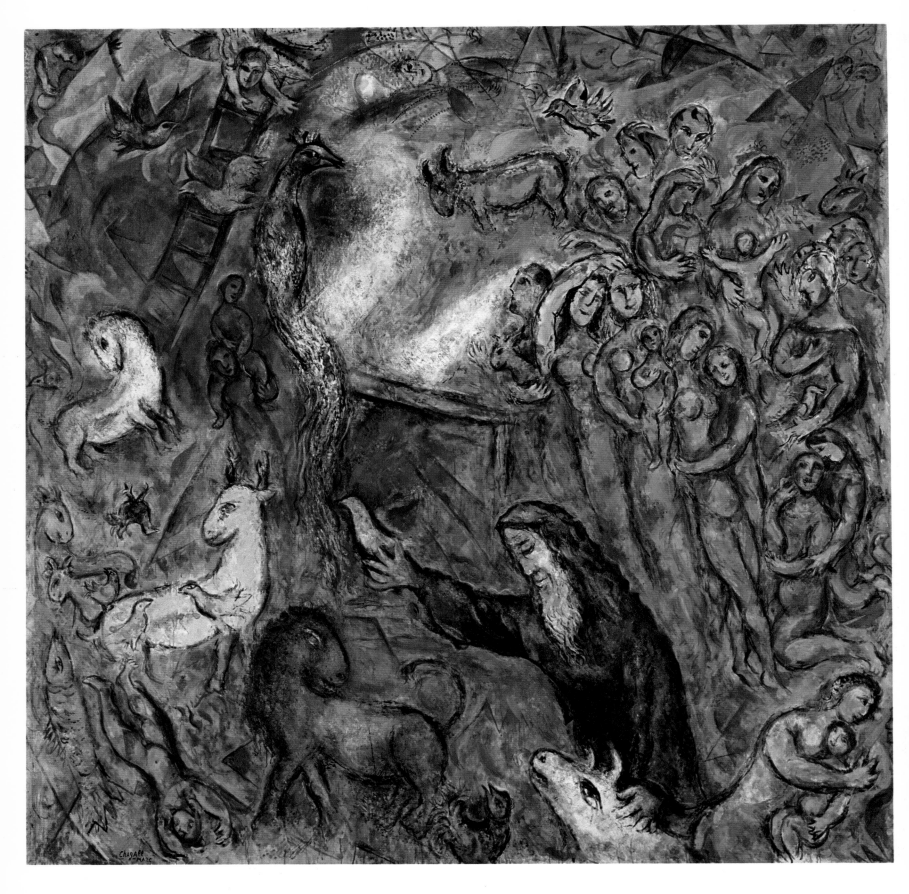

NOAH'S ARK

Noah therefore did according unto all that the Lord commanded him.

And Noah was fixe hundreth yeeres olde, when the flood of waters was upo the earth.

So Noah entred and his sonnes, and his wife, and his sonnes wives with him into the Arke, because of the waters of the flood.

Of the cleane beastes, and of the uncleane beasts, and of the foules, and of all that creepeth upon the earth,

There came two and two unto Noah into the Arke, male and female, as God had commanded Noah.

And so after seven dayes the waters of the flood were upon the earth.

In the sixe hundreth yere of Noahs life in the second moneth, the seventeenth day of the moneth, in the fame day were all the fountaines of the great deepe broken up, and the windowes of heaven were opened,

And the raine was upon the earth fourtie dayes and fourtie nights.

In the selfe same day entred Noah with Shem, and Ham and Iapheth, the sonnes of Noah, and Noahs wife, and the three wives of his sonnes with them into the Arke.

They and every beast after his kinde, and all cattell after their kinde, and every thing that creepeth and mooveth upon the earth after his kinde, and every foule after his kinde, even every bird of every fether.

For they came to Noah into the Arke, two and two, of all flesh wherein is the breath of life.

And they entring in, came male & female of all flesh, as God had commaunded him: and the Lord shut him in.

Then the flood was fourtie dayes upon the earth, & the waters were increased, and bare up the Arke, which was lift up above y earth.

The waters also waxed strong, and were increased exceedingly upon the earth, and the Arke went upon the waters.

The waters prevailed so exceedingly upon the earth, that al y high mountaines, that are under the whole heaven, were covered.

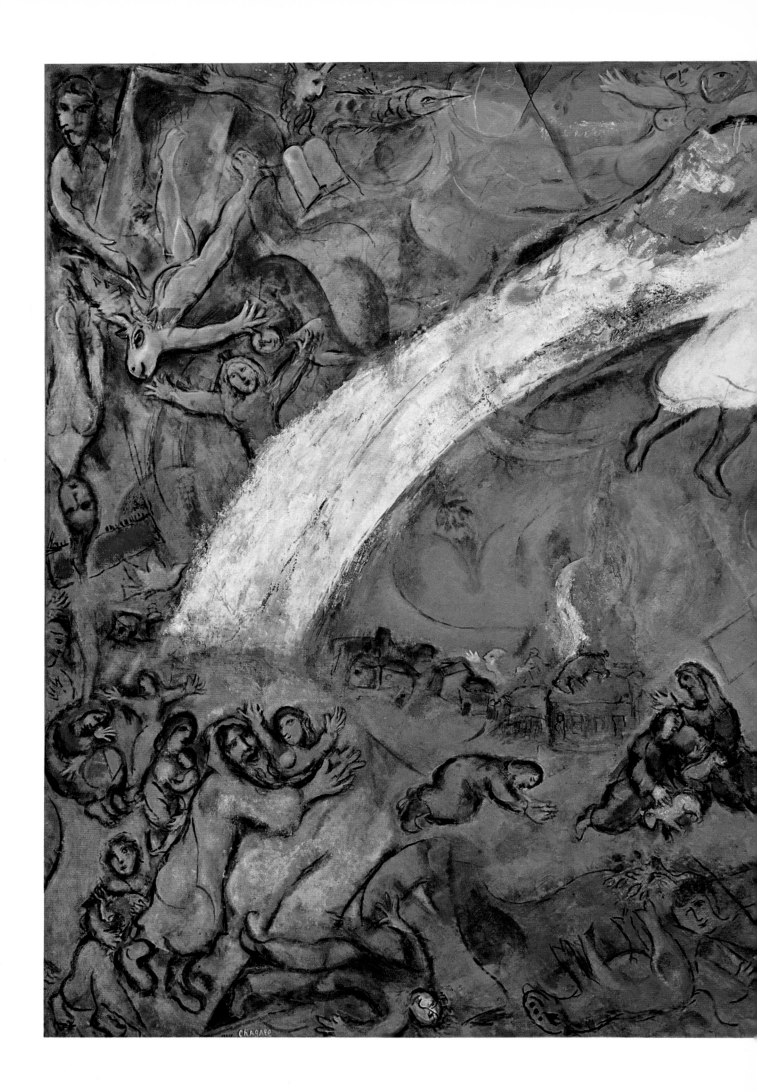

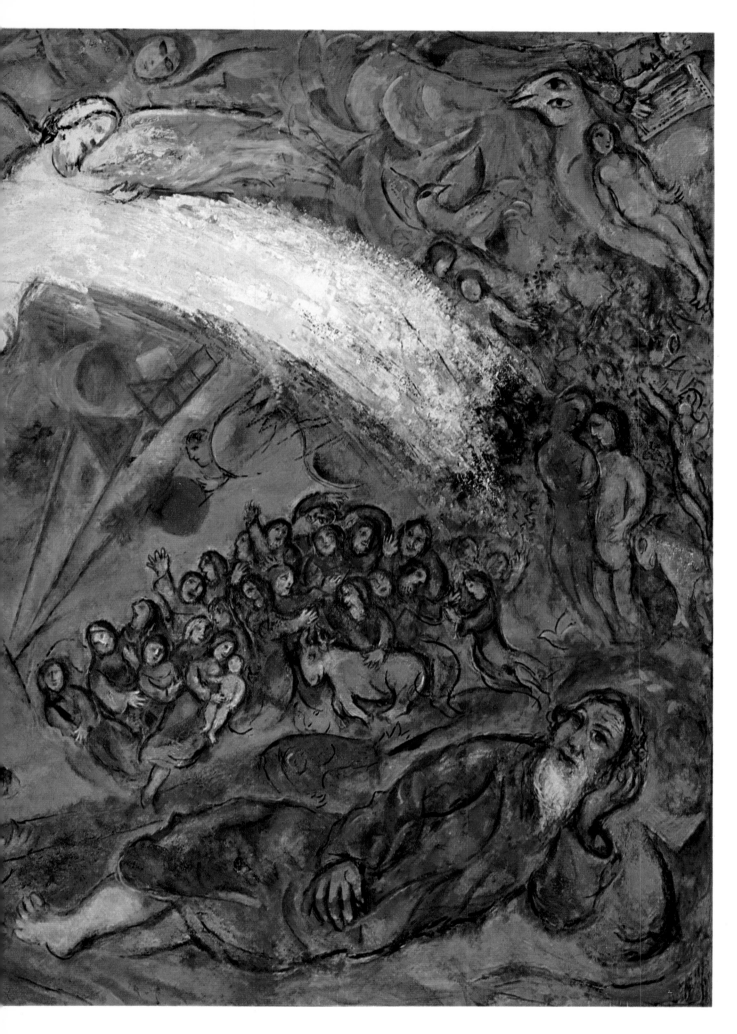

NOAH AND THE RAINBOW

Fifteene cubits upward did the waters prevaile, when the mountaines were covered.

Then all flesh perished that moved upon the earth, both foule and cattell and beast, and every thing that creepeth and mooveth upon the earth, and every man.

Every thing in whose nostrels the spirit of life did breath, whatfoever they were in the dry land, they died.

So hee destroyed every thing that was upon the earth, from man to beast, to the creeping thing, and to the foule of the heaven: they were euen destroyed from the earth. And Noah onely remained, and they that were with him in the Arke.

And the waters prevailed upon the earth an hundreth and fiftie dayes.

GENESIS VII - 1-24

Againe the Lord appeared unto him in the plaine of Mamre, as hee sate in his tent doore about the heate of the day.

And he lift up his eyes, and looked: and loe, three men stood by him, and when he sawe them, he ranne to meete them from the tent doore, and bowed himselfe to the ground.

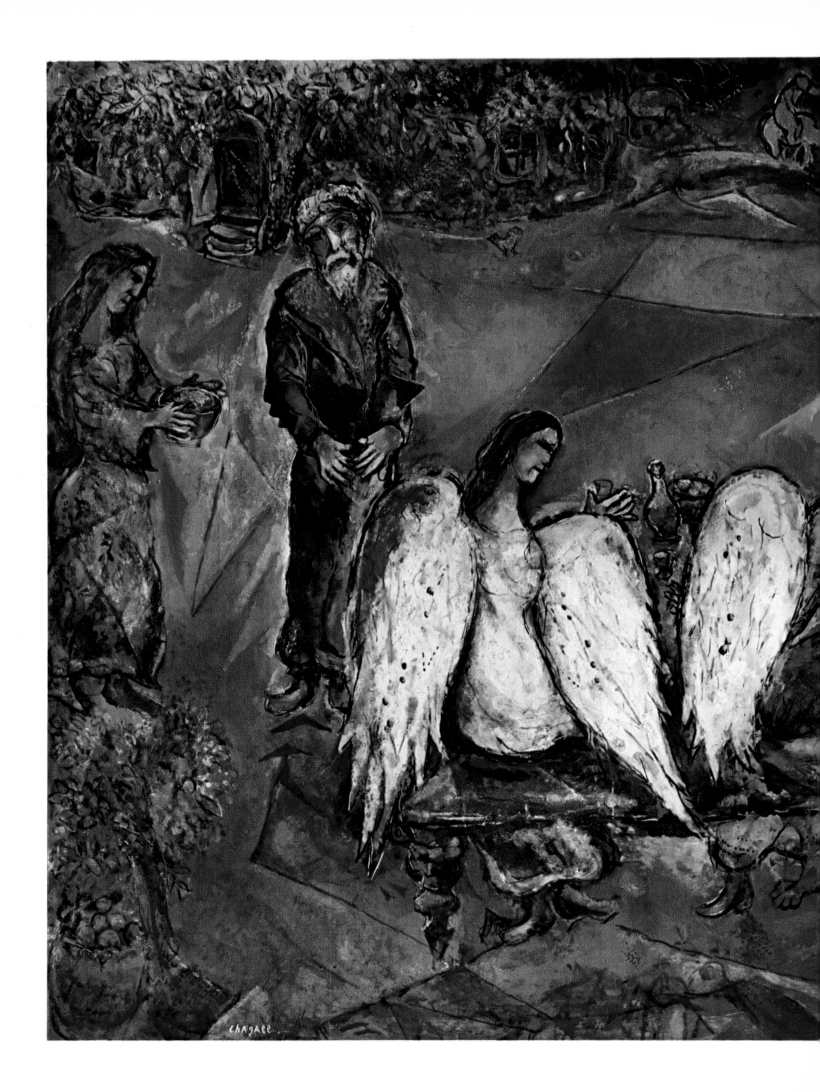

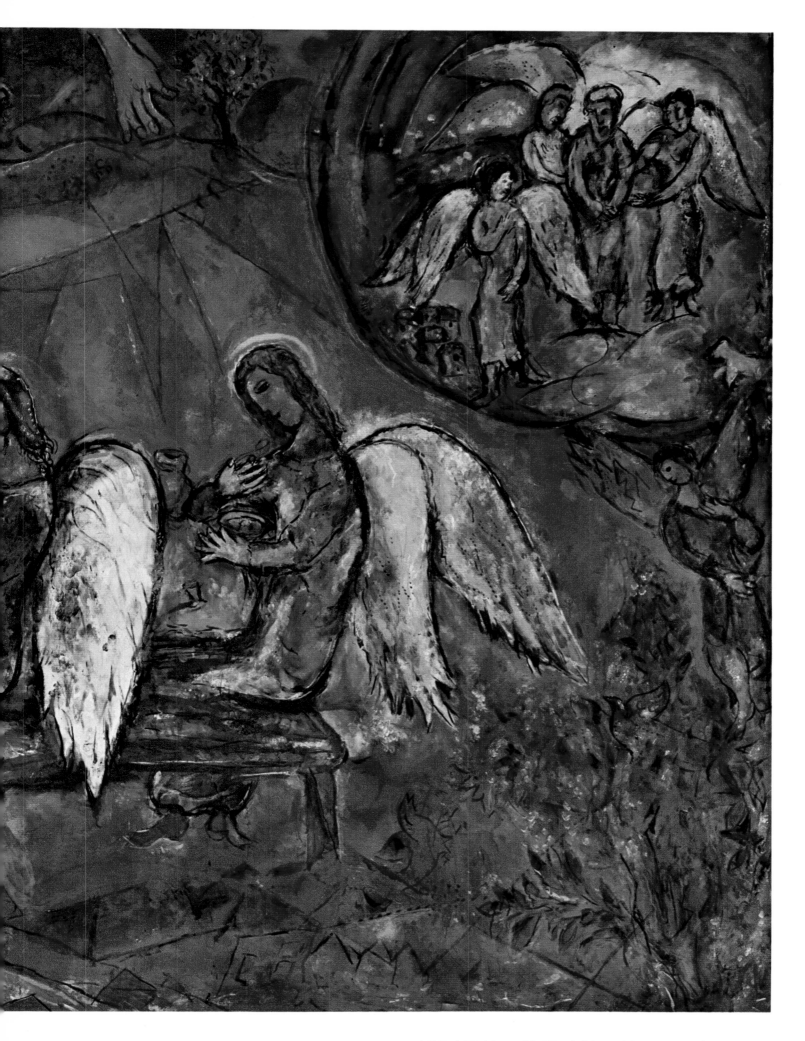

ABRAHAM AND THE THREE ANGELS

And he said, Lord, if I have now found favour in thy sight, goe not, I pray thee, from thy servant.

Let a litle water, I pray you, be brought, and wash your feete, and rest your selues under the tree.

And I will bring a morsel of bread, that you may comfort your hearts, afterward ye shall goe your wayes: for therefore are ye come to your servant. And they said, Doe even as thou hast said.

And Abraham ran to the beasts, and tooke a tender and good calfe, and gave it to the servant, who hasted to make it ready.

And he tooke butter and milke, & the calfe, which he had prepared, and fet before them, and stoode himselfe by them under the tree, and they did eate.

Then they saide to him, Where is Sarah thy wife? And he answered, Beholde, she is in the tent.

And he said, I wil certainely come againe unto thee according to the time of life: and loe, Sarah thy wife shall have a sonne. And Sarah heard in the tent doore, which was behinde him.

(Nowe Abraham and Sarah were olde and striken in age, and it ceased to be with Sarah after the maner of women)

Therefore Sarah laughed within her selfe, saying, After I am waxed olde, and my lord also, shall I have lust?

And the Lord said unto Abraham, .Wherefore did Sarah thus laugh, saying, Shal I certainly beare a childe, which am olde?

(Shall any thing be hard to the Lorde? at the time appointed wil I returne unto thee, even according to the time of life, and Sarah shall have a sonne.)

But Sarah denied, saying, I laughed not: for she was afraide. And he said, It is not so: for thou laughedft.

Afterward the men did rise up fro thence, and looked towarde Sodom: and Abraham went with them to bring them on the way.

GENESIS XVIII - 1-16

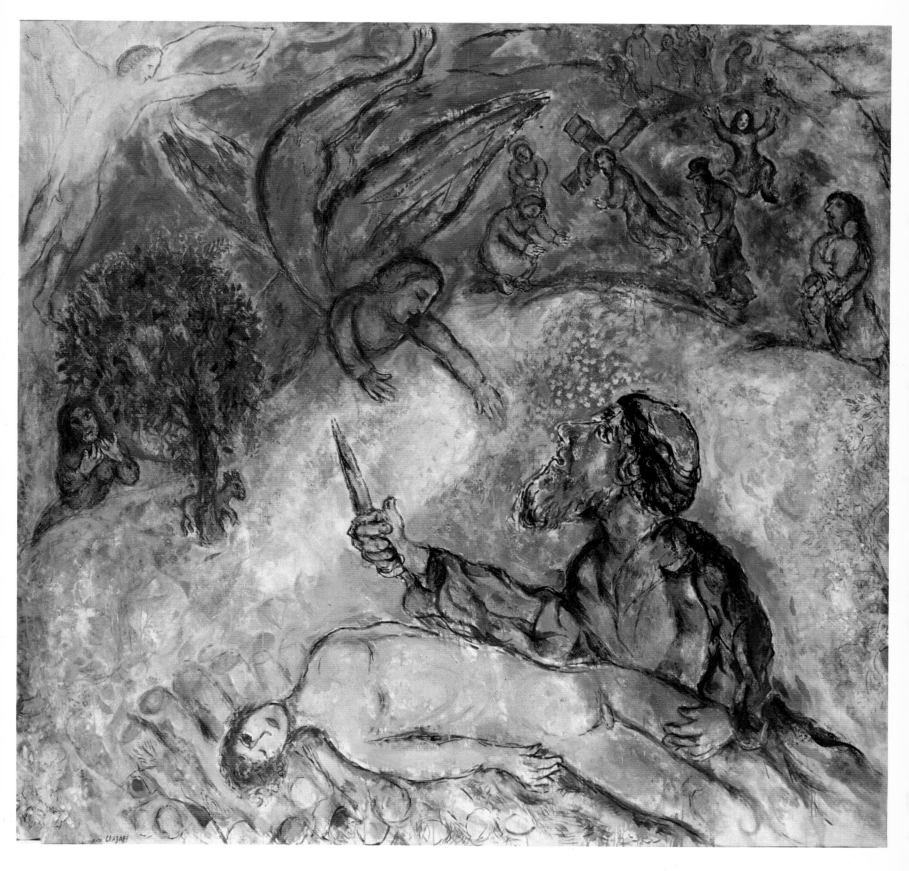

THE SACRIFICE OF ISAAC

Then Izhak called Iaakob and blessed him, and charged him, and sayde unto him, Take not a wife of the daughters of Canaan.

Arise, get thee to Padan Aram to the house of Bethuel thy mothers father, and thence take thee a wife of the daughters of Laban thy mothers brother.

And God all sufficient blesse thee, & make thee to encrease, and multiply thee, that thou mayest be a multitude of people,

And give thee the blessing of Abraham, even to thee and to thy seede with thee, that thou maiest inherite the land (wherein thou art a stranger,) which God gave unto Abraham.

Thus Izhak sent foorth Iaakob, & hee went to Padan Aram unto Laban sonne of Bethuel the Aramite, brother to Rebekah, Iaakobs and Esaus mother.

When Esau sawe that Izhak had blessed Iaakob, and sent him to Padan Aram, to fet him a wife thence, & given him a charge whe he blessed him, saying, Thou shalt not take a wife of the daughters of Canaan,

And that Iaakob had obeied his father and his mother, and was gone to Padan Aram:

Also Esau seeing that the daughters of Canaan displeased Izhak his father,

Then went Esau to Ishmael, and tooke unto the wives, which he had, Mahalath the daughter of Ishmael Abrahams sonne, the sister of Nabaioth, to be his wife.

Nowe Iaakob departed from Beer-sheba, and went to Haran,

And he came unto a certaine place, and taried there all night, because the sunne was downe, and tooke of the stones of the place, and laid under his head, & slept in the same place.

Then he dreamed, & behold, there stood a ladder upon the earth, and the top of it reached up to heaven: and loe, the Angels of God went up and downe by it.

And behold, the Lord stood above it, and sayd, I am the Lord God of Abraham thy father, and the God of Izhak: the land, upon the which thou sleepest, will I give thee & thy seed.

And thy seede shall bee as the dust of the earth, and thou shalt spread abroad to the West, and to the East, and to the North, and to the South, and in thee and in thy seede shall all the families of the earth be blessed.

And lo, I am with thee, and will keepe thee whithersoever thou goest,

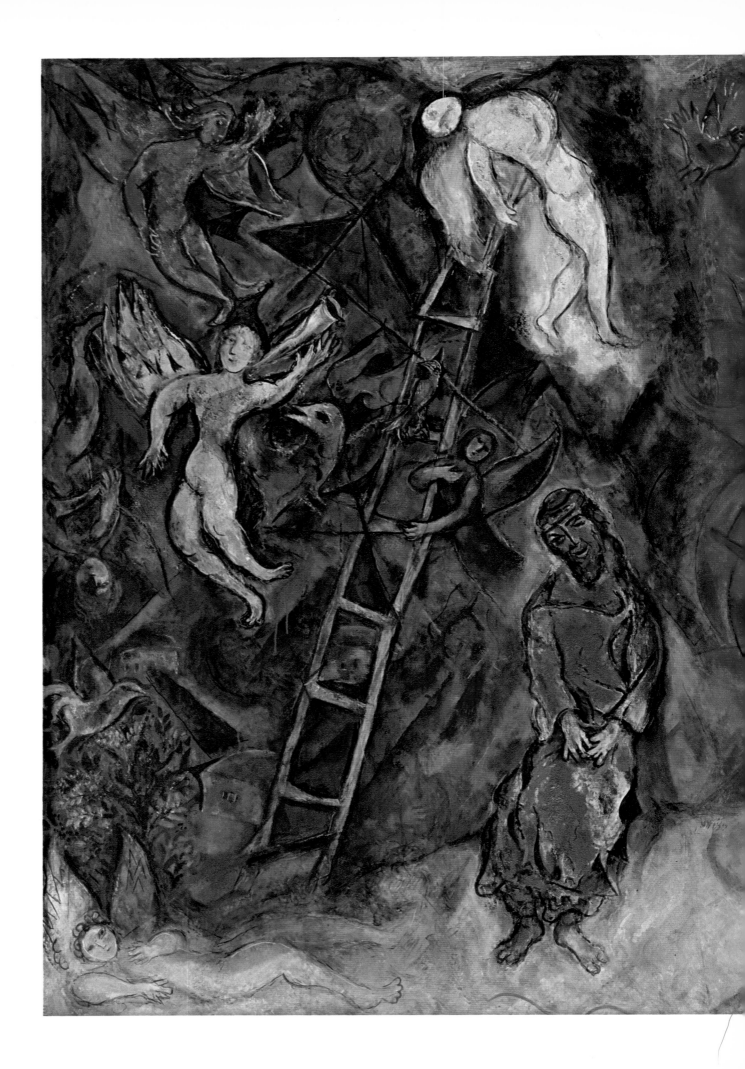

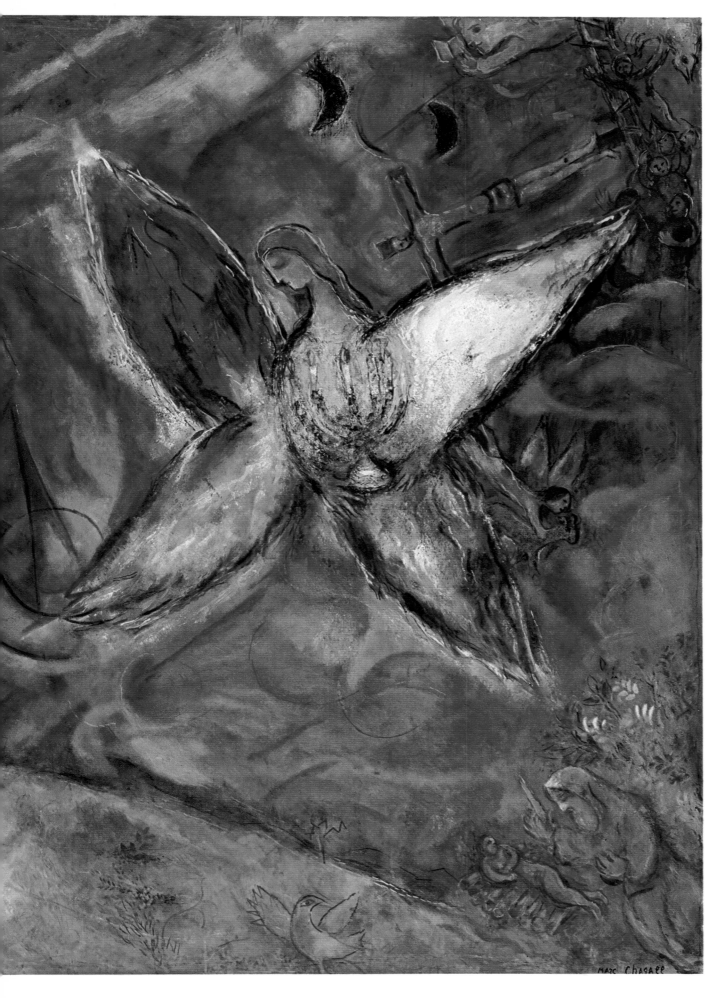

JACOB'S DREAM

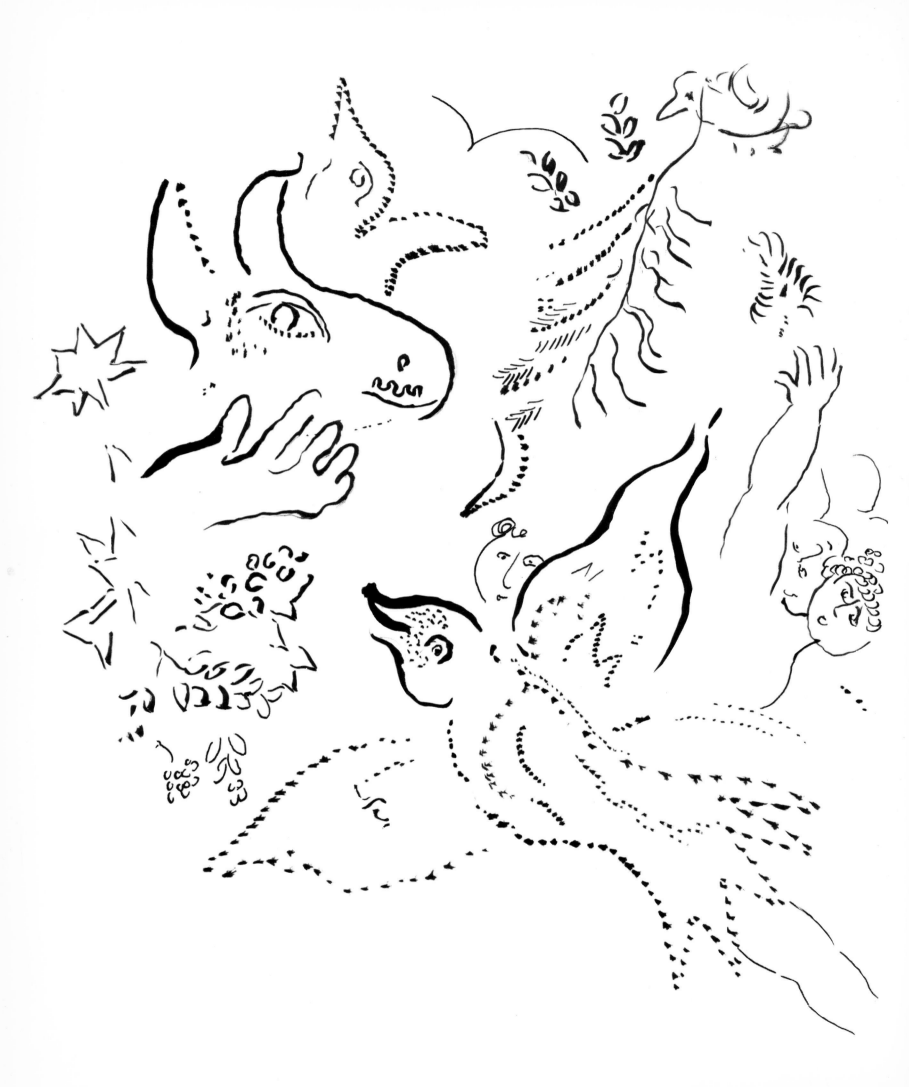

and will bring thee againe into this land: for I will not forsake thee until I have performed that, that I have promised thee.

Then Iaakob awoke out of his sleepe, & sayd, Surely the Lord is in this place, & I was not aware.

And he was afraid, and said, How feareful is this place! this is none other but the house of God, and this is the gate of heaven.

Then Iaakob rose up early in the morning, and tooke the stone that he had laied under his head, and set it up as a pillar, and powred oyle upon the top of it.

And he called the name of that place Beth-el: notwithstanding the name of the citie was at the first called Luz.

Then Iaakob vowed a vowe, saying, If God will be with me, & will keepe me in this iourney which I go, & wil give me bread to eate, and clothes to put on:

So that I come again unto my fathers house in safetie, then shall the Lord be my God.

And this stone, which I have set up as a pillar, shalbe Gods house: and of all that thou shalt give me, wil I give the tenth unto thee.

GENESIS XXVIII - 1-22

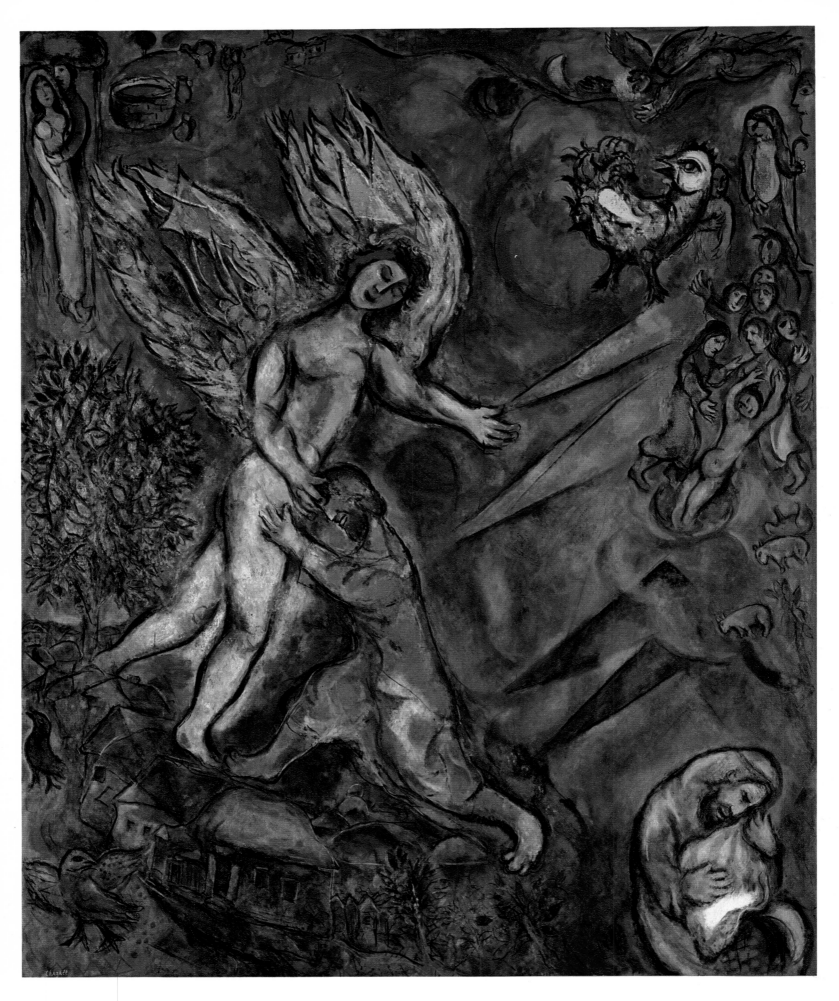

JACOB STRUGGLE WITH THE ANGEL

I pray thee, deliver me from the hand of my brother, from the hand of Esau: for I feare him, left he will come and smite me, and the mother upon the children.

For thou sayedst, I will surely do thee good, and make thy seede as the sande of the sea, which can not be numbred for multitude.

And he tarried there the same night, and tooke of that which came to hand, a present for Esau his brother:

Two hundreth shee goates and twentie hee goates, two hundreth ewes and twentie rammes,

Thirtie milche camels with their coltes, fourtie kine, and ten bullockes, twentie shee asses, and ten foles.

So he delivered them into the hande of his servants, every drove by themselves, and said unto his servants, Passe before me, and put a space betweene drove and drove.

And he commanded the formost, saying, If Esau my brother meete thee, and aske thee, saying, Whole servant art thou? And whither goest thou? And whose are these before thee?

Then thou shalt say, They be thy servant Iaakobs: it is a present sent unto my lorde Esau: and beholde, he himselfe also is behinde us.

So likewise commanded he the second and the third, and all that followed the droves, saying, After this maner ye shall speake unto Esau, when ye finde him.

And yee shall say moreover, Beholde, thy servaunt Iaakob commeth after us (for hee thought, I will appease his wrath with the present that goeth before me, and afterward I will see his face: it may be that he will accept me.)

So went the present before him: but he tarried that night with the companie.

And he rose up the same night, & tooke his two wives, and his two maids, and his eleven children, and went over the foord Iabbok.

And he tooke them, and sent them over the river, and sent over that he had.

Now when Iaakob was left himselfe alone, there wrestled a man with him unto the breaking of the day.

And hee saw that he could not prevaile against him: therefore he touched the hollow of his thigh, and the hollow of Iaakobs thigh was loosed as he wrestled with him.

And he said, Let me go, for the morning appeareth. Who answered, I will not let thee go, except thou blesse me.

Then said he unto him, What is thy name? And he said, Iaakob.

Then said he, Thy name shalbe called Iaakob no more, but Israel: because thou hast had power with God, thou shalt also prevaile with men.

Then Iaakob demanded, saying, Tell me, I pray thee, thy name. And he said, Wherefore now doest thou aske my name? and he blessed him there.

And Iaakob called the name of the place, Peniel: for, said he, I have seene God face to face, and my life is preserved.

And the sunne rose to him as he passed Peniel, and he halted upon his thigh.

Therefore the children of Israel eate not of the sinewe that shranke in the hollowe of the thigh, unto this day: because he touched the sinew that shranke in the hollow of Iaakobs thigh.

GENESIS XXXII - 11-32

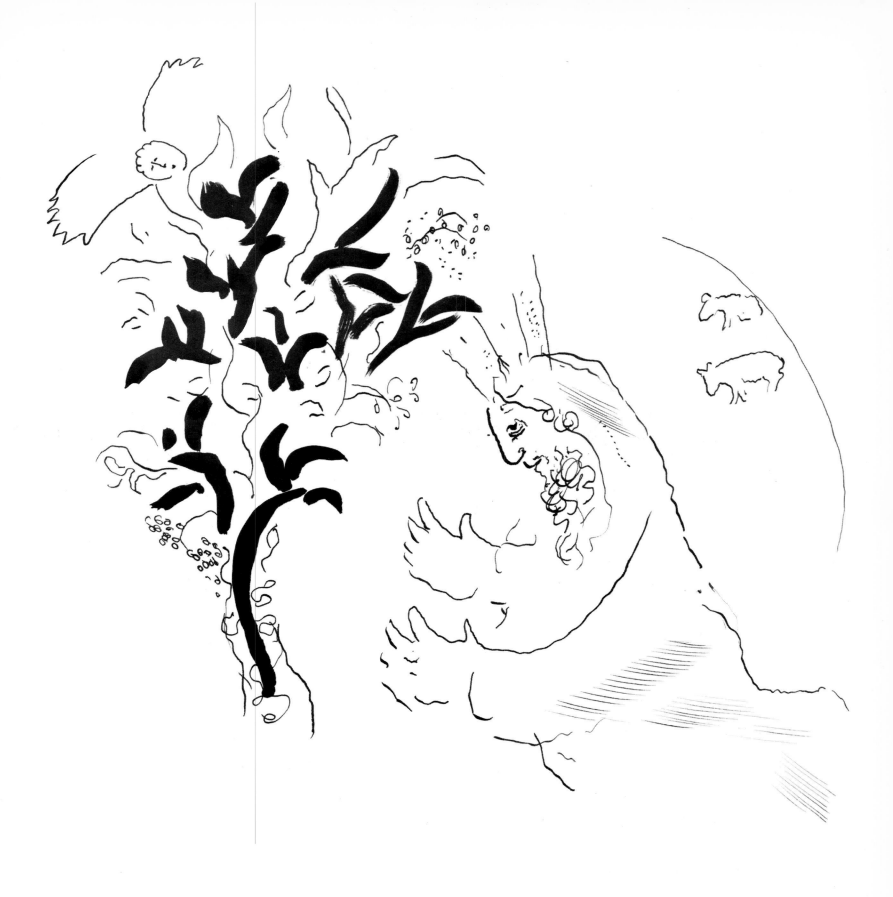

Then the Angell of the Lord appeared unto him in a flame of fire, out of the mids of a bush: and he looked, and behold, the bush burned with fire, and the bush was not consumed.

Therfore Moses said, I will turne aside now, and see this great sight, why the bush burneth not.

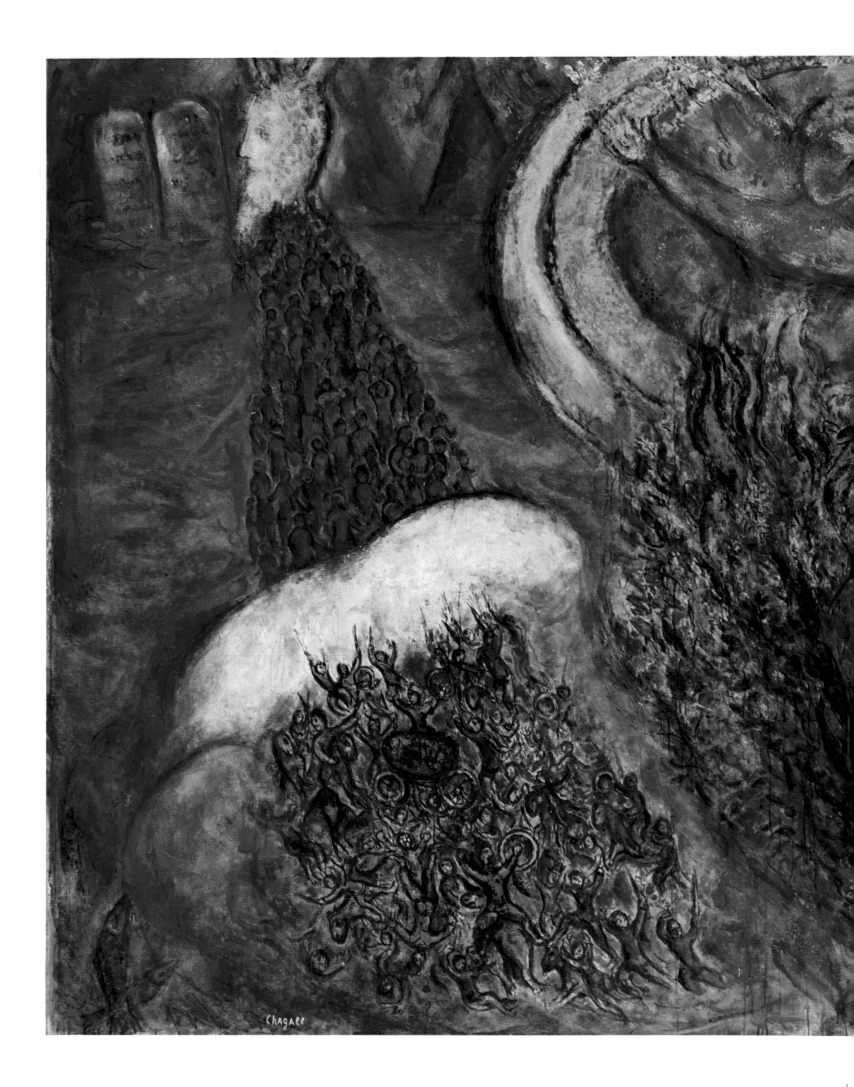

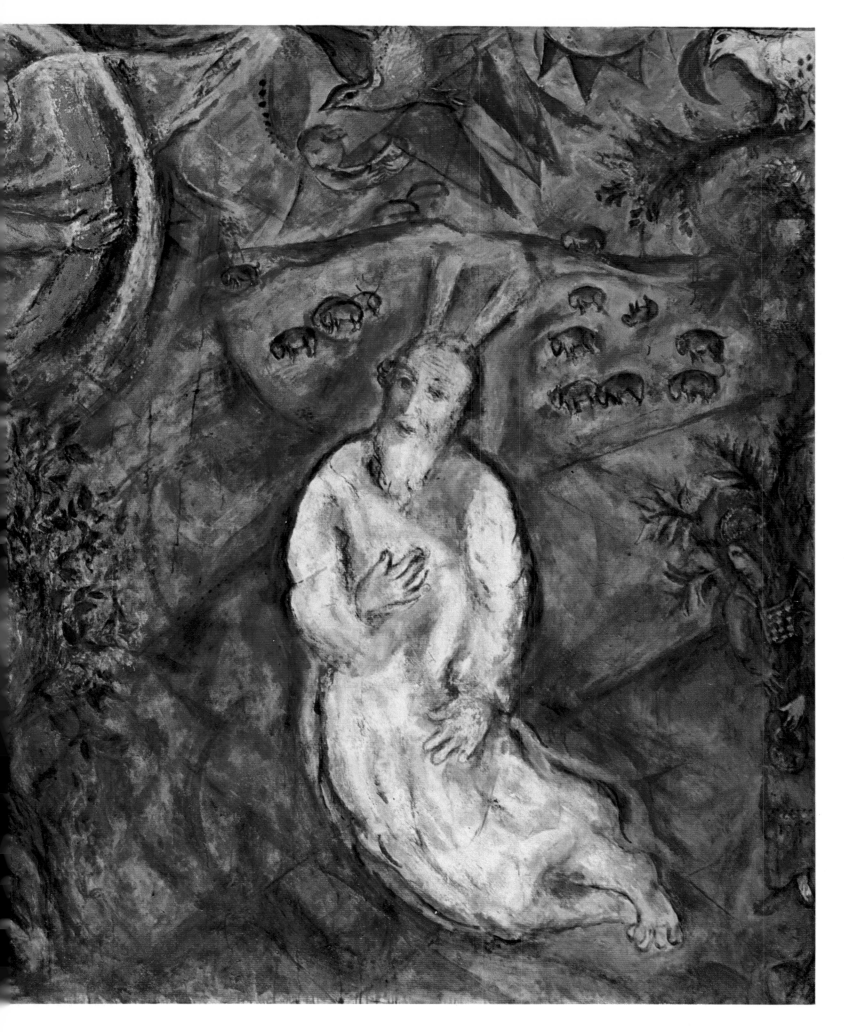

MOSES BEFORE THE BURNING BUSH

And when the Lord sawe that hee turned aside to see, God called unto him out of the mids of the bush, and said, Moses, Moses. And he answered, I am here.

Then hee sayd, Come not hither, put thy shooes off thy feete: for the place whereon thou standest, is holy ground.

Moreover hee sayd, I am the God of thy father, the God of Abraham, the God of Izhak, and the God of Iaakob. Then Moses hid his face: for he was afraid to look upon God.

Then the Lord sayd, I have surely seene the trouble of my people, which are in Egypt, and have heard their cry, because of their taskemasters: for I know their sorowes.

Therefore I am come downe to deliver them out of the hand of the Egyptians, and to bring them out of that land into a good land and a large, into a land that floweth with milke and honie, even into the place of the Canaanites, and the Hittites, and the Amorites, & the Perizzites, and the Hivites, and the Iebusites.

And now loe, the cry of the children of Israel is come unto me, and I have also seene the oppression, wherewith the Egyptians oppresse them.

Come nowe therefore, and I will send thee unto Pharaoh, that thou mayest bring my people the children of Israel out of Egypt.

But Moses sayd unto God, Who am I, that I should goe unto Pharaoh, and that I should bring the children of Israel out of Egypt?

And he answered, Certainely I will bee with thee: and this shal be a token unto thee, that I have sent thee, After that thou hast brought y people out of Egypt, ye shal serve God upon this Mountaine.

Then Moses sayd unto God, Behold, when I shall come unto the children of Israel, and shall say unto them, The God of your fathers hath sent mee unto you: if they say unto me, What is his Name? what shall I say unto them?

And God answered Mofes, I AM THAT I AM. Also he said, Thus shalt thou say unto the children of Israel, I AM hath sent me unto you.

EXODUS III - 2-14

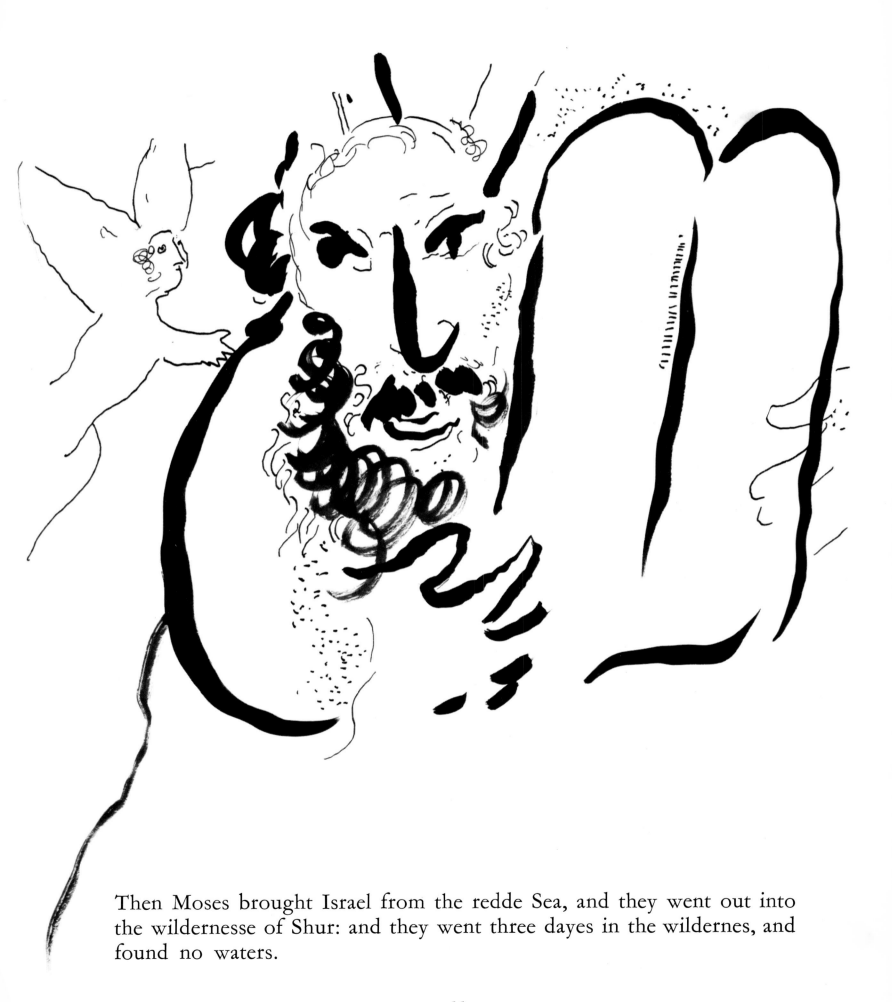

Then Moses brought Israel from the redde Sea, and they went out into the wildernesse of Shur: and they went three dayes in the wildernes, and found no waters.

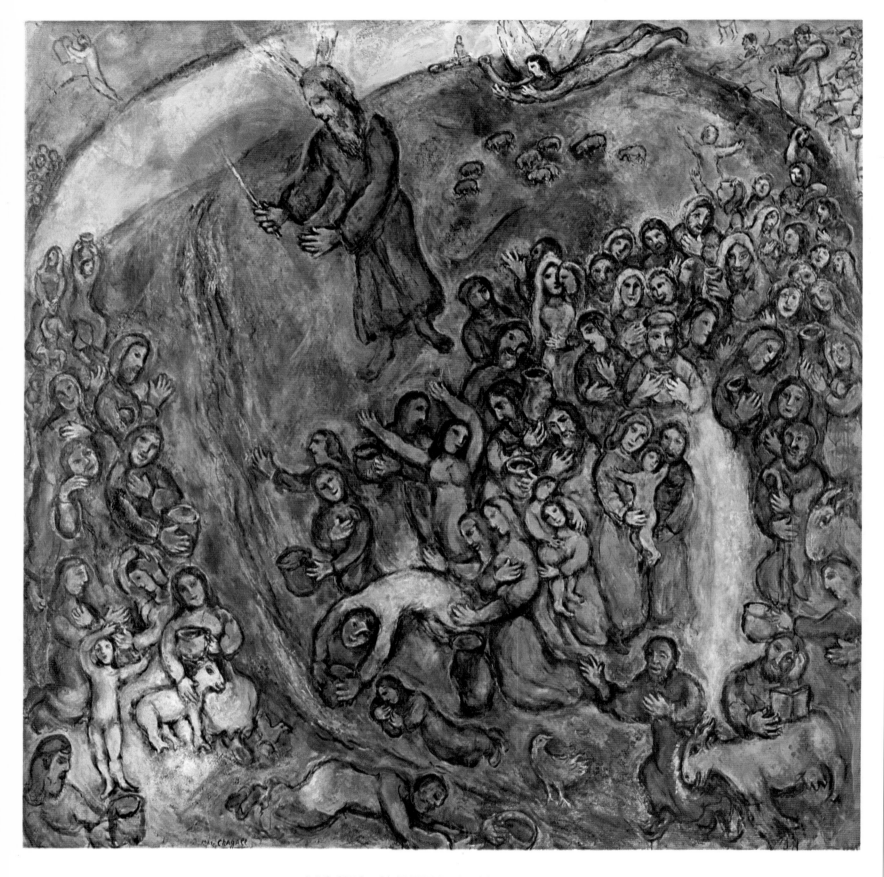

MOSES STRIKING THE ROCK

And when they came to Marah, they coulde not drinke of the waters of Marah, for they were bitter: therefore the name of the place was called Marah.

Then the people murmured against Moses, saying, What shall we drinke?

And he cried unto the Lorde, and the Lord shewed him a tree, which when he had cast into the waters, the waters were sweet: there he made them an ordinance and a lawe, and there he proved them,

And said, If thou wilt diligently hearken, O Ifrael, unto the voyce of the Lorde thy God, and wilt do that, which is right in his sight, & wilt give eare unto his commandements, and keepe all his ordinances, then will I put none of these diesases upon thee, which I brought upon the Egyptians: for I am the Lord that healeth thee.

And they came to Elim, where were twelve fountaines of water, & seventy palme trees, and they camped there by the waters.

EXODUS XV - 22-27

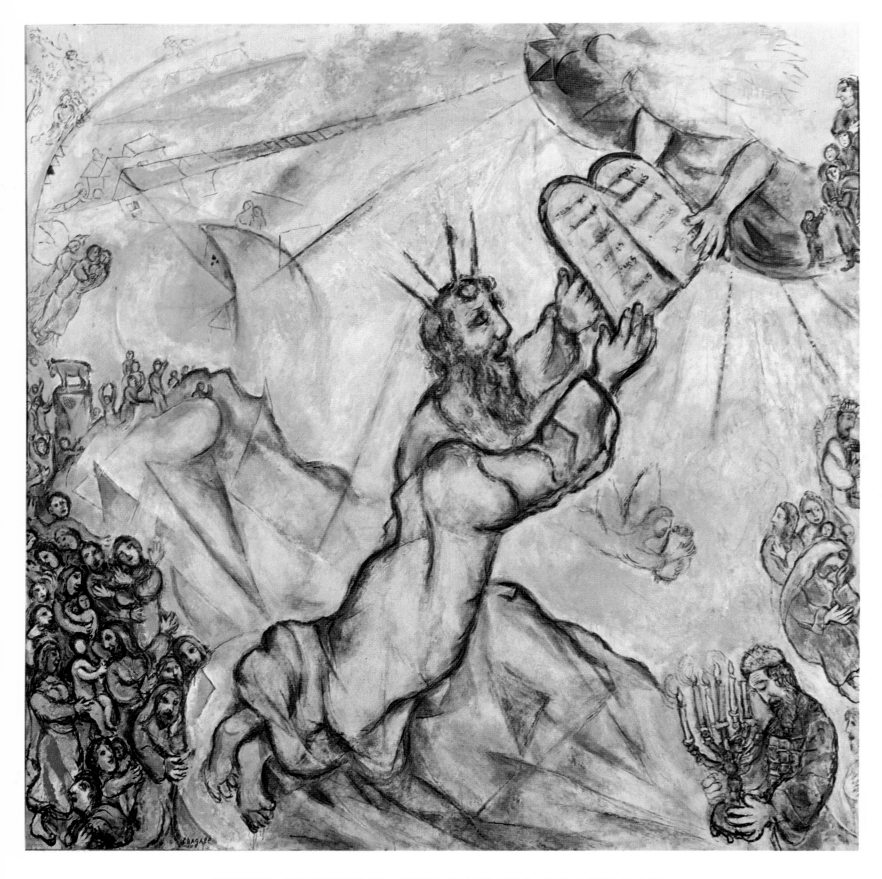

MOSES RECEIVING THE TABLETS OF THE LAW

And the Lord sayd unto Moses, Hewe thee two Tables of stone, like unto the first, and I will write upon the Tables the wordes that were in the first Tables, which thou brakest in pieces.

And bee readie in the morning, that thou mayst come up earely unto the mount of Sinai, and wait there for me in the top of the mount.

But let no man come up with thee, neither let any man be seene thorowout all y mount, neither let the sheepe nor cattell feede before this mount.

Then Moses hewed two Tables of stone like unto the first, and rose up earely in the morning, and went up unto the mount of Sinai, as the Lord had commanded him, and tooke in his hand two Tables of stone.

EXODUS XXXIV - 1-4

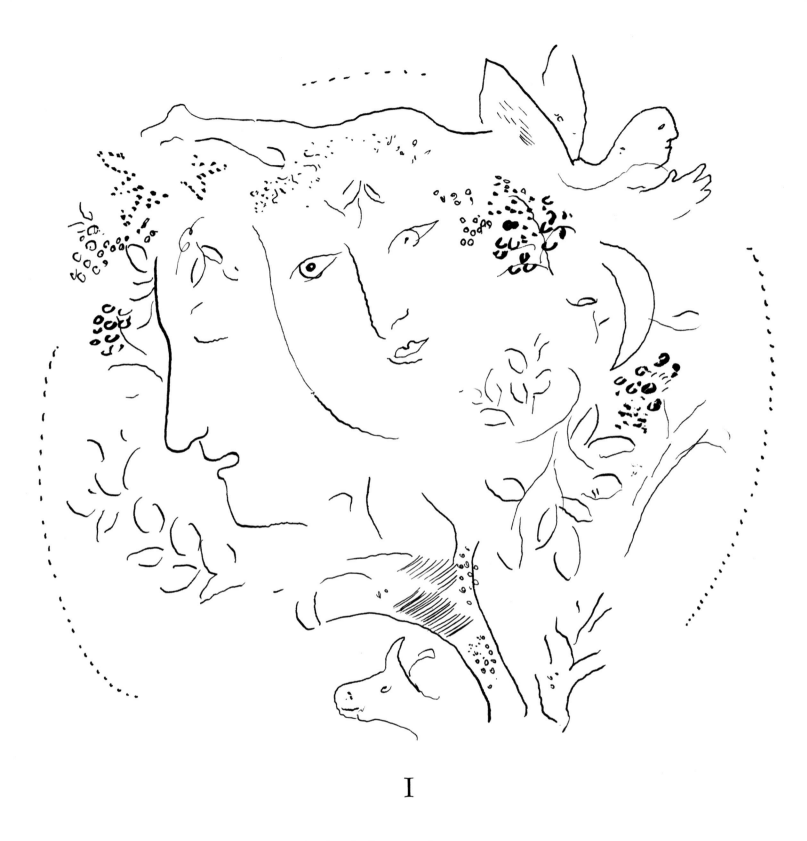

I

The song of songs, which is Salomon's.

Let him kisse me with the kisses of his mouth: for thy love is better then wine.

Because of the savour of thy good ointmets thy name is as an ointment powred out: therefore the virgins love thee.

Draw me: wee will runne after thee: the King hath brought me unto his chambers: we wil reioyce and be glad in thee: we wil remember thy love more then wine: the righteous doe love thee.

I am blacke, O daughters of Ierusalem, but comely, as the tentes of Kedar, and as the curtaines of Salomon.

Regard yee mee not because I am blacke: for the sunne hath looked upon mee. The sonnes of my mother were angry against me: they made me the keeper of the vines: but I kept not mine owne vine.

Shew me, O thou whome my soule loveth, where thou feedest, where thou liest at noone: for why should I be as she that turneth aside to the flockes of thy companions?

If thou knowe not, O thou the fairest among women, get thee foorth by the steps of the flocke, and feede thy kids by the tents of the shepheards.

I have compared thee, O my love, to the troupe of horses in the charets of Pharaoh.

Thy cheekes are comely with rowes of stones, and thy necke with chains. We will make thee borders of golde with studs of silver.

Whiles the King was at his repast, my spikenard gave the smell thereof.

My welbeloved is as a bundle of myrrhe unto me: he shall lie betweene my brestes.

My welbeloved is as a cluster of camphire unto me in the vines of Engedi.

My love, beholde, thou art faire: beholde, thou art faire: thine eyes are like the doves.

My welbeloved, beholde, thou art faire and pleasant: also our bed is greene:

The beames of our house are cedars, our rafters are of firre.

II

I am the rose of the fielde, and the lilie of the valleys.

Like a lilie among the thornes, so is my love among the daughters.

Like the apple tree among the trees of the forest, so is my welbeloved among the sonnes of men: under his shadow had I delight, and sate downe: and his fruite was sweete unto my mouth.

Hee brought mee into the wine celler, and love was his banner over me.

Stay me with flagons, and comfort me with apples: for I am sicke of love.

His left hand is under mine head, and his right hand doeth imbrace me.

I charge you, O daughters of Ierusalem, by the roes and by the hindes of the field, that ye stirre not up, not waken my love, untill she please.

It is the voyce of my welbeloved: behold, he commeth leaping by the mountains, and skipping by the hilles.

My welbeloved is like a roe, or a yong hart: loe, he standeth behinde our wall, looking foorth of the windowes, shewing himselfe through the grates.

My welbeloved spake and saide unto me, Arise, my love, my faire one, & come thy way.

For beholde, winter is past: the raine is changed, and is gone away.

The floures appeare in the earth: the time of the singing of birds is come, and the voyce of the turtle is heard in our land.

The figtree hath brought foorth her young figges: and the vines with their small grapes have cast a savour: arise my love, my faire one, and come away.

My dove, that art in the holes of the rock, in the secret places of the staires, shew me thy sight, let me heare thy voyce: for thy voyce is sweete, and thy sight comely.

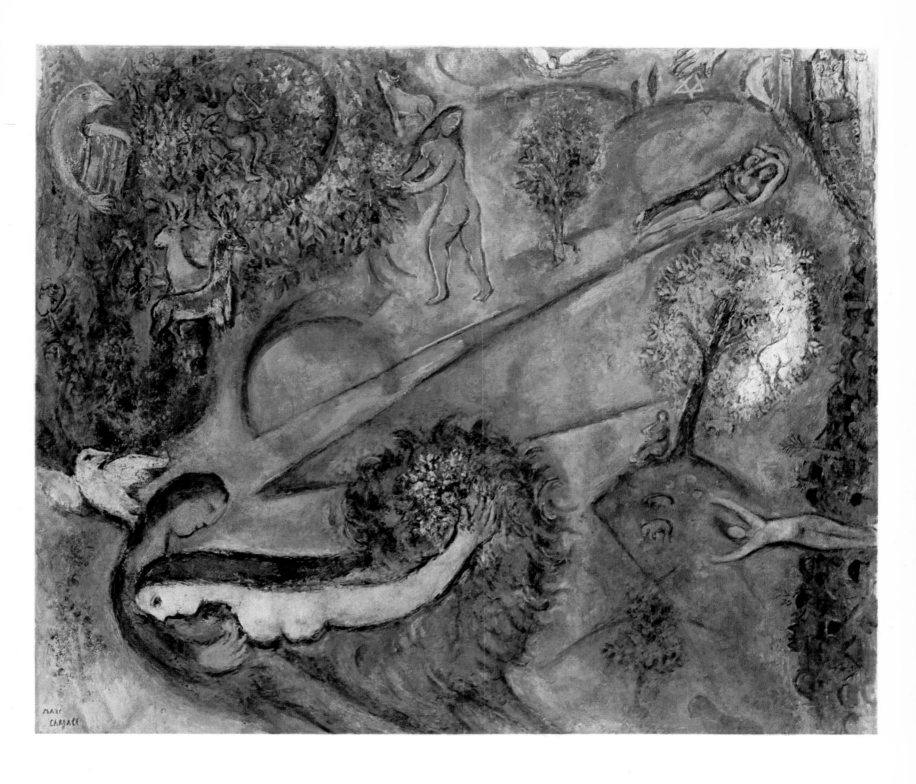

Take us the foxes, the little foxes, which destroy the vines: for our vines have small grapes.

My welbeloved is mine, and I am his: he feedeth among the lilies,

Untill, the day breake and the shadowes flee away: returne, my welbeloved, and bee like a roe, or a yong hart upon the mountaines of Bether.

III

In my bed by night I sought him that my soule loved: I sought him, but I found him not.

I will rise therefore, now, and goe about in the citie, by the streets & by the open places, and wil seeke him that my soule loveth: I sought him, but I found him not.

The watchmen that went about the citie, found mee: to whome I saide, Have you seene him, whom my soule loveth?

When I had past a little from them, then I found him whom my soule loved: I took hold on him & left him not, till I had brought him unto my mothers house into the chamber of her that conceived me.

I charge you, O daughters of Ierusalem, by the roes and by the hindes of the fielde, that ye stirre not up, nor waken my love untill she please.

Who is shee that commeth up out of the wildernesse like pillard of smoke perfumed with mirrhe and incense, and with al the spices of the merchant?

Behold his bed, which is Salomons: threescore strong men are rounde about it, of the valiant men of Israel.

They all handle the sword, and are expert in warre, every one hath his sworde upon his thigh for the feare by night.

King Salomon made himselfe a palace of the trees of Lebanon.

He made the pillars thereof of silver, and the pavement thereof of golde, the hangings thereof of purple, whose middes was paved with the love of the daughters of Ierusalem.

Come forth, ye daughters of Zion, and beholde the King Salomon with the crowne, wherewith his mother crowned him in the day of his marriage, and in the day of the gladnes of his heart.

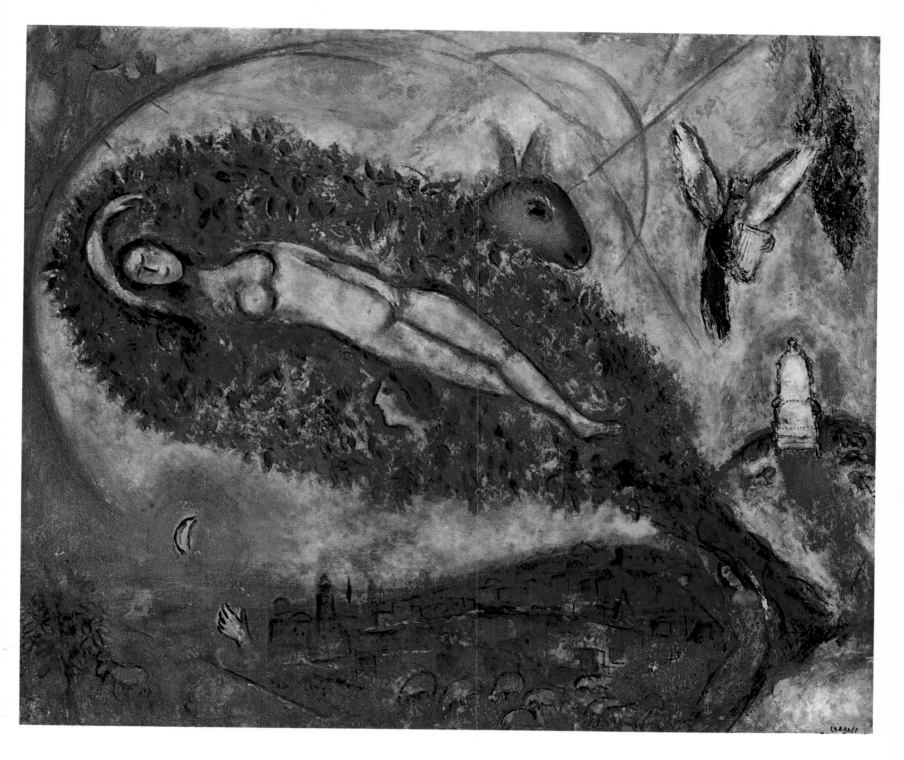

IV

Behold, thou art faire, my loue: beholde, thou art faire: thine eies are like the doues: among thy lockes thine haire is like the flocke of goates, which looke downe from the mountaine of Gilead.

Thy teeth are like a flocke of sheepe in good order, which go up from the washing: which every one bring out twinnes, and none is barren among them.

Thy lips are like a threed of scarlet, and thy talke is comely: thy temples are within thy locks as a piece of a pomegranate.

Thy necke is as the tower of David built for defence: a thousand shields hang therin, and all the targates of the strong men.

Thy two breasts are as two yong roes that are twinnes, feeding among the lilies.

Untill the day breake, and the shadowes flee away, I will go into the mountaine of myrrhe and to the mountaine of incense.

Thou art all faire, my love, and there is no spot in thee.

Come with me from Lebanon, my spouse, even with mee from Lebanon, and looke from the toppe of Amanah, from the top of Shenir and Hermon, from the dennes of the lyons, and from the mountaines of the leopards.

My sister, my spouse, thou hast wounded mine heart: thou hast wounded mine heart with one of thine eyes, and with a chaine of thy necke.

My sister, my spouse, howe faire is thy love? howe much better is thy love then wine? and the savour of thine oyntments then all spices?

Thy lippes, my spouse, droppe as honie combes: honie and milke are under thy tongue, and the savour of thy garment is as the savour of Lebanon.

My sister my spouse is as a garden inclosed, as a spring shut up, and a fountaine sealed up.

Thy plants are as an orchard of pomegranates with sweete fruites, as camphire, spikenard,

Even spikenard, and saffran, calamus, and cynamom with all the trees of incense, myrrhe and aloes, with all the chiefe spices.

O fountaine of the gardens, O well of living waters, and the springs of Lebanon.

Arise, O North, and come O South, and blowe on my garden that the spices thereof may flowe out: let my welbeloved come to his garden, and eate his pleasant fruite.

V

I Am come into my garden, my sister, my spouse: I gathered my myrrhe with my spice: I ate mine honie combe with mine honie, I dranke my wine with my milke: eate, O friends, drinke, and make you mery, O welbeloved.

I sleepe, but mine heart waketh, it is the voyce of my welbeloved that knocketh, *saying*, Open unto mee, my sister, my love, my dove, my unde-filed: for mine head is full of dewe, and my lockes with the droppes of the night.

I have put off my coate, howe shall I put it on? I have washed my feete, how shal I defile them?

My welbeloved put in his hand by the hole of the doore, and mine heart was affectioned toward him.

I rose up to open to my welbeloved, and mine hands did droppe downe myrrhe, and my fingers pure myrrhe upon the handles of the barre.

I opened to my welbeloved: but my welbeloved was gone, and past: mine heart was gone when he did speake: I sought him, but I could not finde him: I called him, but he answered me not.

The watchmen that went about the citie, found me: they smote me and wounded me: the watchmen of the walles tooke away my vaile from me.

I charge you, O daughters of Ierusalem, if you finde my welbeloved, that you tell him that I am sicke of love.

O the fairest among women, what is thy welbeloved more then other welbeloved? what is thy welbeloved more then another lover, that thou doest so charge us?

My welbeloved is white & ruddy, the chiefest of ten thousand.

His head is as fine golde, his locks curled, and blacke as a raven.

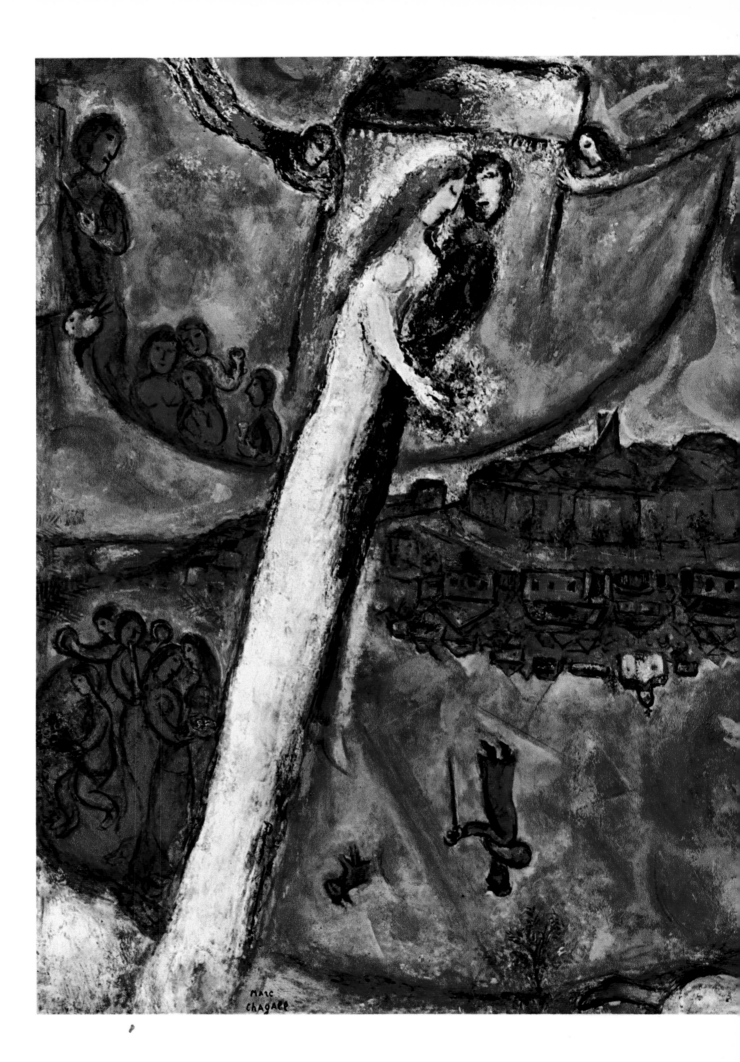

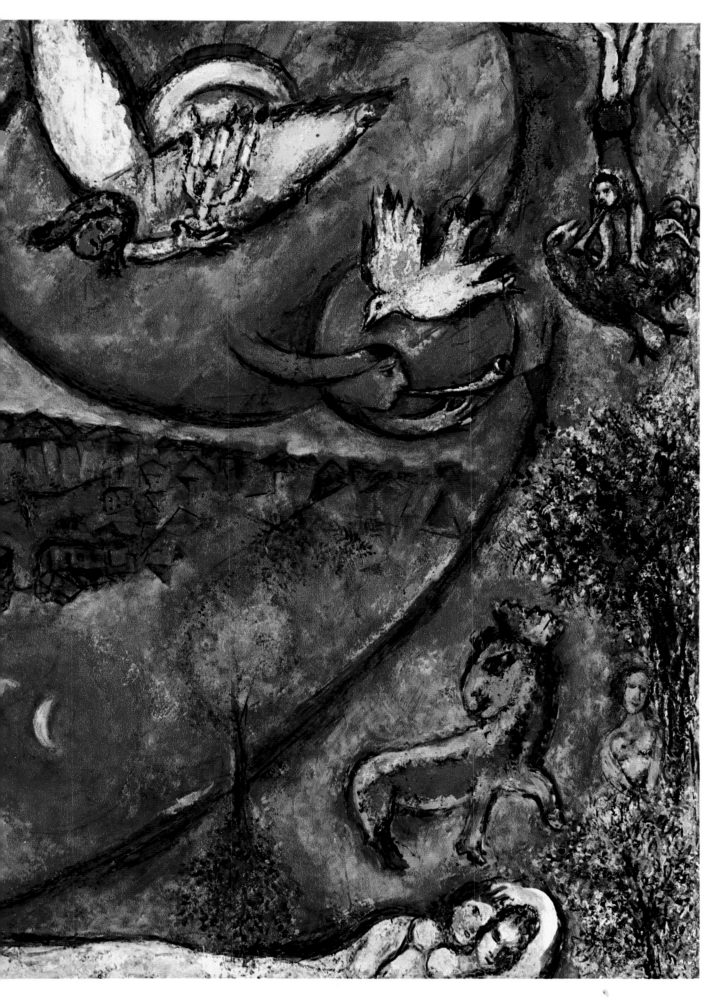

THE SONG OF SONGS

His eyes are like doves upon the rivers of waters, which are washt with milke, and remaine by the full vessels.

His cheekes are as a bed of spices, and as sweete flowers, and his lippes like lilies dropping downe pure myrrhe.

His handes as rings of golde set with the chrysolite, his belly like white yvorie covered with saphirs.

His legges are as pillars of marble, set upon sockets of fine golde: his countenance as Lebanon, excellent as the cedars.

His mouth is as sweete things, and hee is wholy delectable: this is my welbeloved, and this is my lover, O daughters of Ierusalem.

O the fairest among women, whither is thy welbeloved gone? whither is thy welbeloved turned aside, that wee may seeke him with thee?

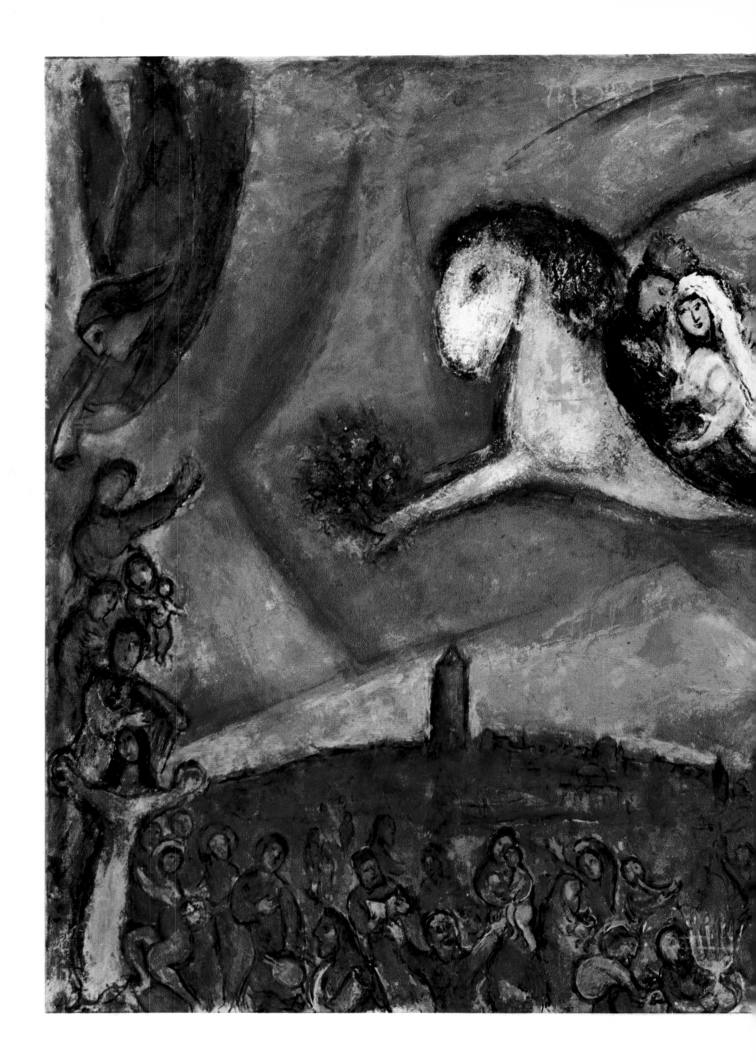

THE SONG OF SONGS

VI

My welbeloved is gone downe into his garden to the beds of spices, to feede in the gardens, and to gather lilies.

I am my welbeloveds, and my welbeloved is mine, who feedeth among the lilies.

Thou art beautifull, my love, as Tirzah, comely as Ierusalem, terrible as an armie with banners.

Turne away thine eyes from me: for they overcome me: thine haire is like a flocke of goates, which looke downe from Gilead.

Thy teeth are like a flocke of sheepe, which goe up from the washing, which every one bring out twins, and none is barren among them.

Thy temples are within thy lockes as a piece of a pomegranate.

There are threescore Queenes and fourescore concubines, and of the damsels without number.

But my dove is alone, and my undefiled, she is the onely daughter of her mother, and she is deare to her that bare her: the daughters have seene her and counted her blessed: even the Queenes and the concubines, and they have praised her.

Who is she that looketh forth as the morning, faire as the moone, pure as the sunne, terrible as an armie with banners!

I went downe to the garden of nuts, to see the fruits of the valley, to see if the vine budded, and if the pomegranates flourished.

I knewe nothing, my soule set mee as the charets of my noble people.

Returne, returne, O Shulamite, returne: returne that we may behold thee. What shall you see in the Shulamite, but as the companie of an armie?

VII

Howe beautifull are thy goings with shoes, O princes daughter! the joyntes of thy thighs are like iewels: the worke of the hand of a cunning workeman.

Thy navel is as a round cup that wanteth not licour: thy belly is as an heape of wheat compassed about with lilies.

Thy two breastes are as two yong roes that are twinnes.

Thy necke is like a towre of yvorie: thine eyes are like the fish pooles in Heshbon by the gate of Bath-rabbim: thy nose is as the towre of Lebanon, that looketh toward Damascus.

Thine head upon thee is as skarlet, and the bush of thine head like purple: the King is tyed in the rafters.

Howe faire art thou, and howe pleasant art thou, O my love, in pleasures!

This thy stature is like a palme tree, and thy brests like clusters.

I said, I wil goe up into the palme tree, I will take holde of her boughes: thy breastes shall now be like the clusters of the vine: and the savour of thy nose like apples,

And the rouse of thy mouth like good wine, which goeth straight to my welbeloved, and causeth the lippes of the ancient to speake.

I am my welbeloveds, and his desire is toward me.

Come, my welbeloved, let us goe foorth into the fielde: let us remaine in the villages.

Let us get up early to the vines, let us see if the vine flourish, whether it hath budded the small grape, or whether the pomegranates flourish: there will I give thee my love.

The mandrakes have given a smell, and in our gates all sweete things, newe and olde: my welbeloved, I have kept them for thee.

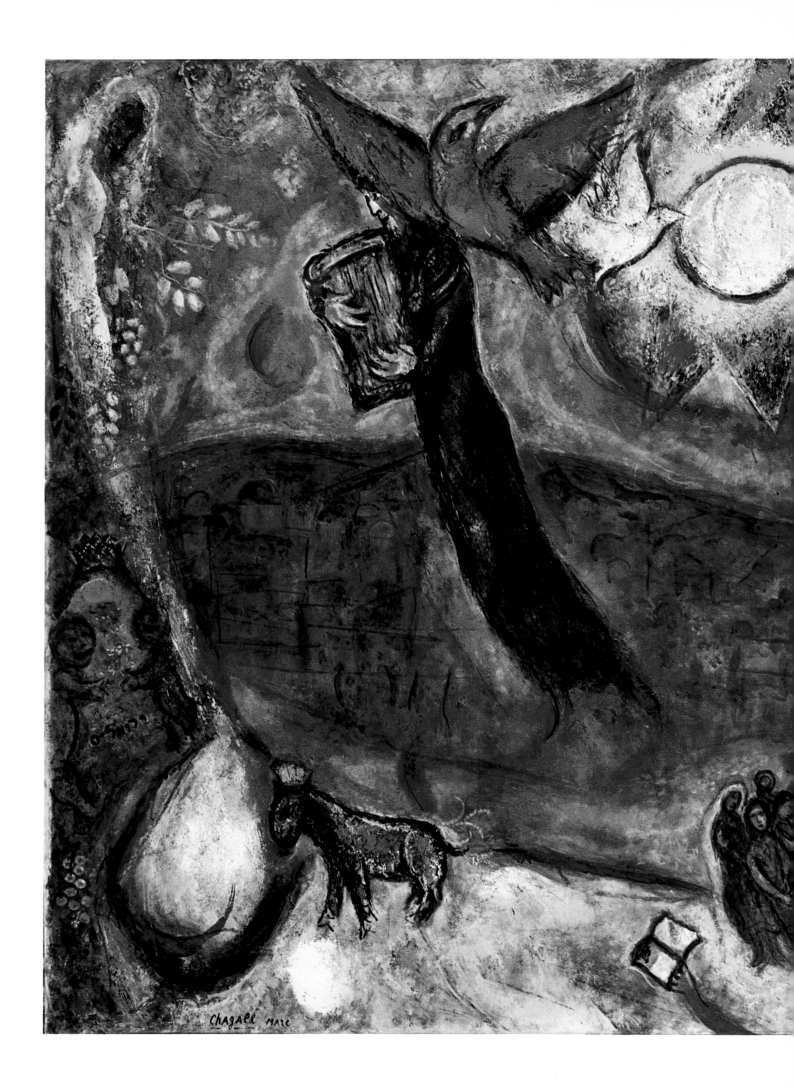

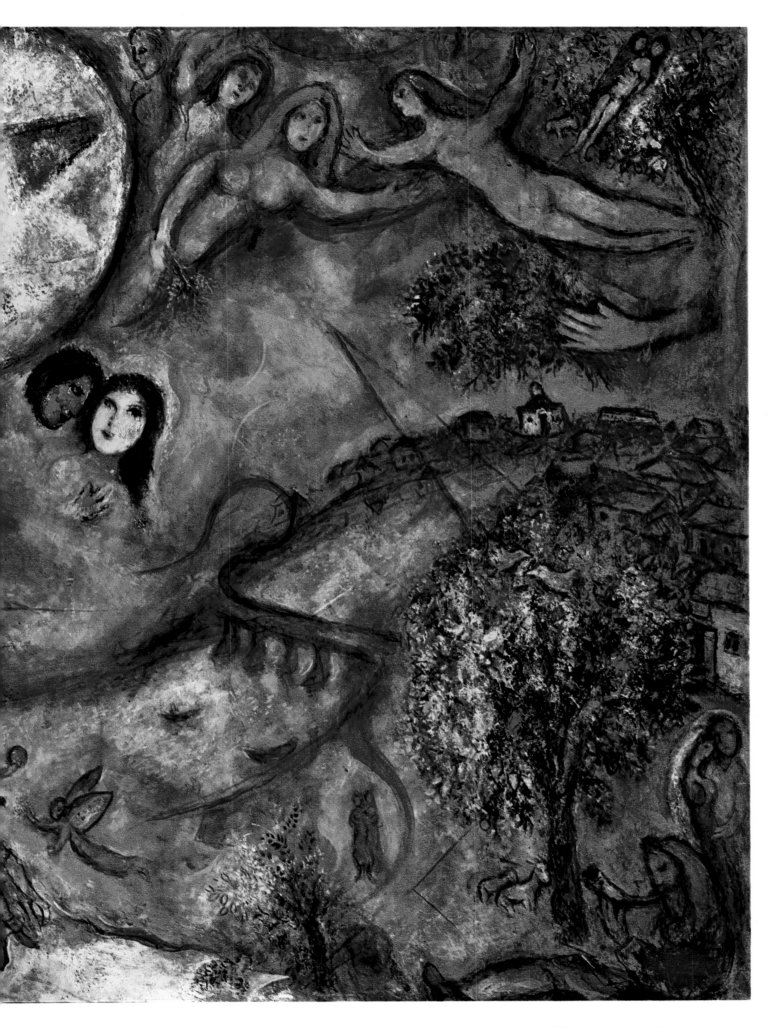

THE SONG OF SONGS

VIII

Oh that thou werest as my brother that sucked the brests of my mother:

I would finde thee without, I would kisse thee, then they should not despise thee.

I wil lead thee and bring thee into my mothers house: there thou shalt teach me: and I wil cause thee to drink spiced wine, and new wine of the pomegranate.

His left hand shalbe under mine head, and his right hand shall embrace me.

I charge you, O daughters of Ierusalem, that you stirre not up, nor waken my love, untill she please.

(Who is this that commeth up out of the wildernesse, leaning upon her welbeloved?) I raysed thee up under an apple tree: there thy mother conceived thee: there she conceived that bare thee.

Set me as a seale on thine heart, and as a signet upon thine arme: for love is strong as death: jelousie is cruel as the grave: the coles thereof are fierie coles, and a vehement flame.

Much water cannot quench love, neither can the floods drowne it: if a man should give all the substance of his house for love, they would greatly contemne it.

Wee have a little sister, and shee hath no breasts: what shal we doe for our sister when she shalbe spoken for?

If she be a wall, we will builde upon her a silver palace: and if she be a doore, wee will keepe her in with bordes of cedar.

I am a wall, and my breastes are as towers: then was I in his eyes as one that findeth peace.

Salomon had a vine in Baal-hamon: hee gave the vineyard unto keepers: every one bringeth for the fruite thereof a thousande pieces of silver.

But my vineyard which is mine, P before me: to thee, O Salomon, appertaineth a thousand pieces of silver, and two hundreth to them that keepe the fruite thereof.

O thou that dwellest in the gardens, the companions hearken unto thy voyce: cause me to heare it.

O my welbeloved, flee away, and be like unto the roe, or to the yong harte upon the mountaines of spices.

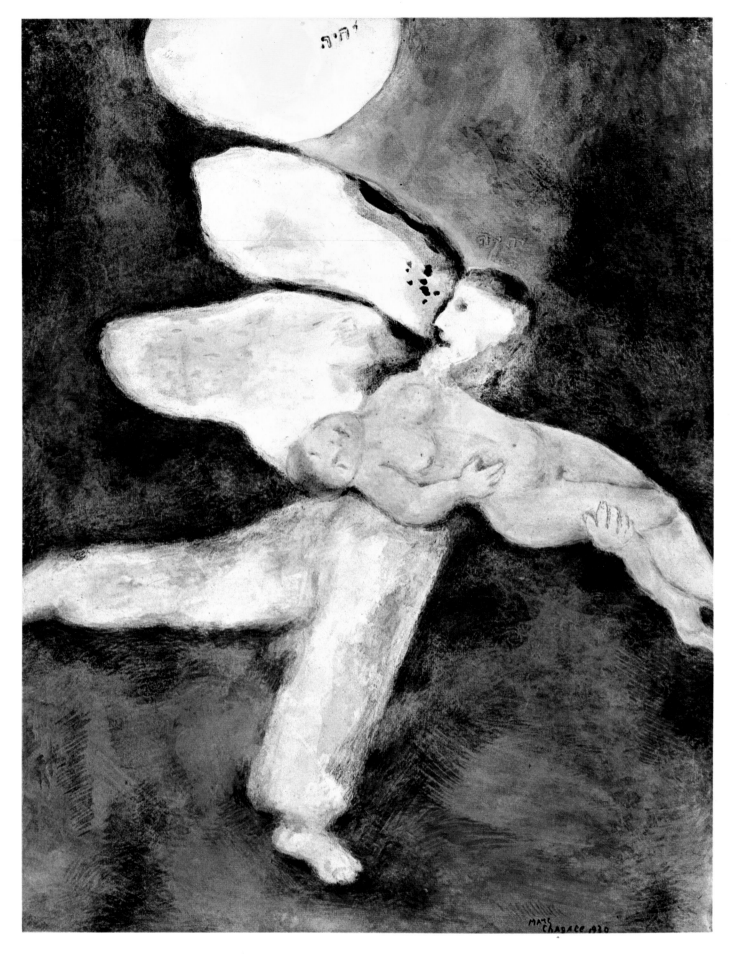

GOD CREATES MAN

One imposes on all subjects the constant rhythm or tension of his own spirit; the other strives to express the theme as an objective fact, discovering through sympathetic imagination the necessary patterns for its basic sense. Chagall here is of this second type, and yet he is all feeling. But the same emotion does not dominate every episode alike. Confronted by the text, he is able to allow free play to his great receptiveness and understanding without loss of his essential qualities — his buoyant fantasy and warm, caressing touch.

The resulting range of the pictures is amazingly rich. I do not have to itemize what is clear enough in the plates — Chagall's capacity to create the sorrowful and gay, the grave and the charming, scenes of the most ingratiating lightness and the awesome apparitions of God. I believe that in this series his greatest achievement is in the images of the patriarchs and prophets, which possess the strongest contrasts, the densest areas of black and gray. In these plates he has responded most deeply perhaps to the major qualities of the text.

If you wish to see how astute and subtle is Chagall in discovering the expressive framework of an action, study in particular the scene of Abraham's Sacrifice, where the knife is adjusted to the faggots on the altar and makes with Abraham's right arm a form like the parted wings of the angel above — a pattern of analogy and contrast which serves at the same time to express the impending action and to tie its elements into a firmer whole. Yet this is only a detail in the fuller, incalculable harmony of the work — so grandly simple and strong — which depends also on the massing of the tones with their rich nuances of dark and light. Throughout the book Chagall is especially inventive in composing the angelic and the human through the correspondences of wings and limbs. The Creation of Man and Joshua as a Warrior are two great examples. The parted wings on a dark ground may serve as the emblem of the whole.

M. Schapiro.

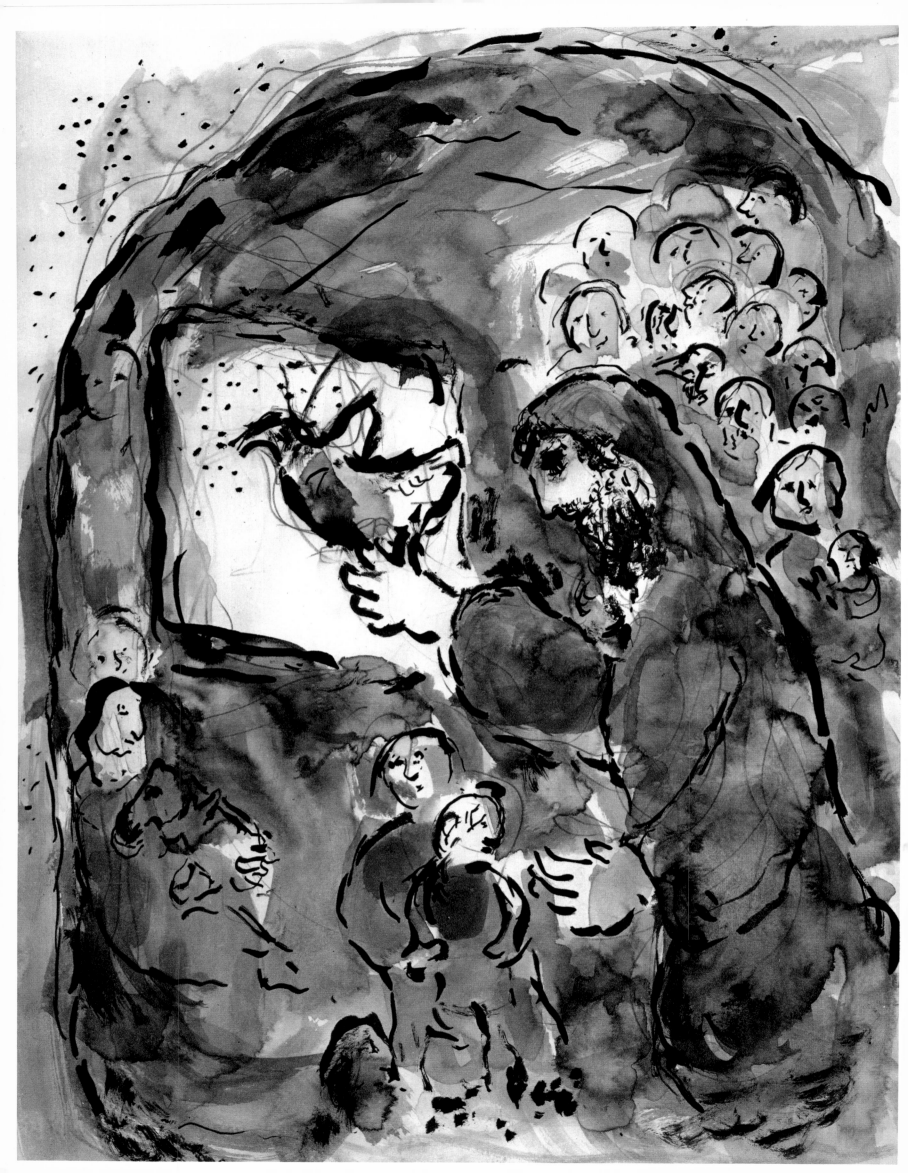

So when men began to bee multiplied up on the earth, and there were daughters borne unto them,

Then the sonnes of God sawe the daughters of men that they were faire, and they tooke them wives of all that they liked.

Therfore the Lord said, My Spirit shal not alway strive woman, because he is but flesh, & his daies shalbe an hudreth & twenty yeres.

There were gyants in the earth in those dayes: yea, and after that the sonnes of God came unto the daughters of men, & they had borne them childre, these were mighty men, which in old time were men of renowme.

When the Lord saw that the wickednes of man was great in the earth, and all the imaginations of the thoughts of his heart were onely evil continually,

Then it repented y Lord, that he had made man in the earth, & he was sory in his heart.

Therefore the Lord said, I will destroy from the earth the man, whom I have created, fro man to beast, to the creeping thing, and to the foule of the heaven: for I repent that I have made them.

But Noah foud grace in the eies of y Lord.

These are the generations of Noah. Noah was a just and upright man in his time: and Noah walked with God.

And Noah begat three sonnes, Shem, Ham, and Iapheth.

The earth also was corrupt before God: for the earth was filled with crueltie.

Then God looked upon the earth, and behold, it was corrupt: for all flesh had corrupt his way upon the earth.

And God said unto Noah, An ende of all flesh is come before mee: for the earth is filled with crueltie through them: and behold, I wil destroy them with the earth.

Make thee an Arke of pine trees: thou shalt make cabines in the Arke, and shalt pitch in within and without with pitch.

And thus shalt y make it: The lenght of the Arke shalbe three hudreth cubits, the bredth of it fifty cubits, & y height of it thirty cubits.

A window shalt thou make in the Arke, and in a cubite shalt thou finish it above, and the doore of the Arke shalt thou set in the side thereof: thou shalt make it with the low, second and thirde roume.

And I, beholde, I will bring a flood of waters upon the earth to destroy al flesh, wherein is the beath of life under the heauen: all that is in the earth, shal perish.

But with thee wil I establish my covenant, and thou shalt goe into the Arke, thou, and thy sonnes, and thy wife, & thy sonnes wives with thee.

And of every living thing, of all flesh two of every sort shalt thou cause to come into the Arke, to keepe them alive with thee: they shal be male and female.

Of the foules after their kind, & of y cattell after their kinde, of every creeping thing of the earth after his kinde, two of every sort shal come unto thee, that thou mayest keepe them alive.

And take thou with thee of al meare that is eaten: and thou shalt gather it to thee, that it may be meate for thee and for them.

Noah therefore did according unto all, that God commanded him: even so did he.

GENESIS VI - 1-22

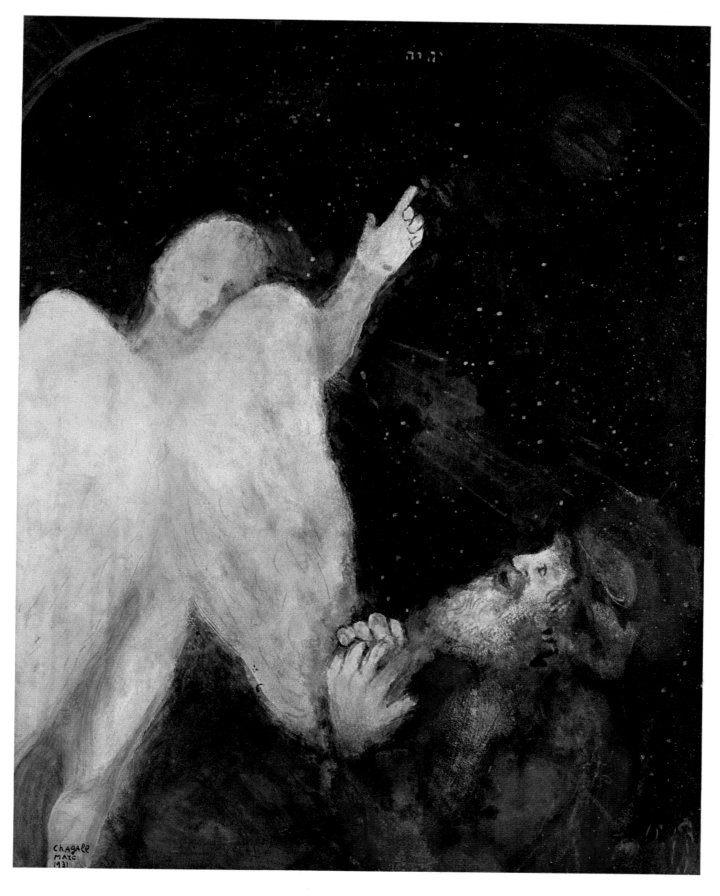

NOAH BEING COMMANDED TO BUILD THE ARK

So after fourty dayes, Noah opened the window of the Arke, which he had made,

And sent foorth a raven, which went out going foorth and returning, untill the waters were dried up upon the earth.

Againe he sent a dove from him, that he might see if the waters were diminished fro off the earth.

But the dove foud no rest for the sole of her foote: therefore she returned unto him into the Arke (for the waters were upon the whole earth) and he put forth his hand, and received her, and tooke her to him into the Arke.

And he abode yet other seven dayes, and againe he sent forth the dove out of the Arke.

And the dove came to him in the evening, & lo, in her mouth was an olive leafe that she had pluckt: whereby Noah knew that the waters were abated from off the earth.

Notwithstanding he waited yet other seven dayes, and sent foorth the dove, which returned not againe unto him any more.

And in the fix hundreth & one yere, in the first day of the first moneth the waters were dried up from off the earth: and Noah removed the covering of the Arke, & looked, and behold, y upper part of the ground was drie.

And in the second moneth, in the seven & twentieth day of the moneth was the earth drie.

GENESIS VIII - 6-14

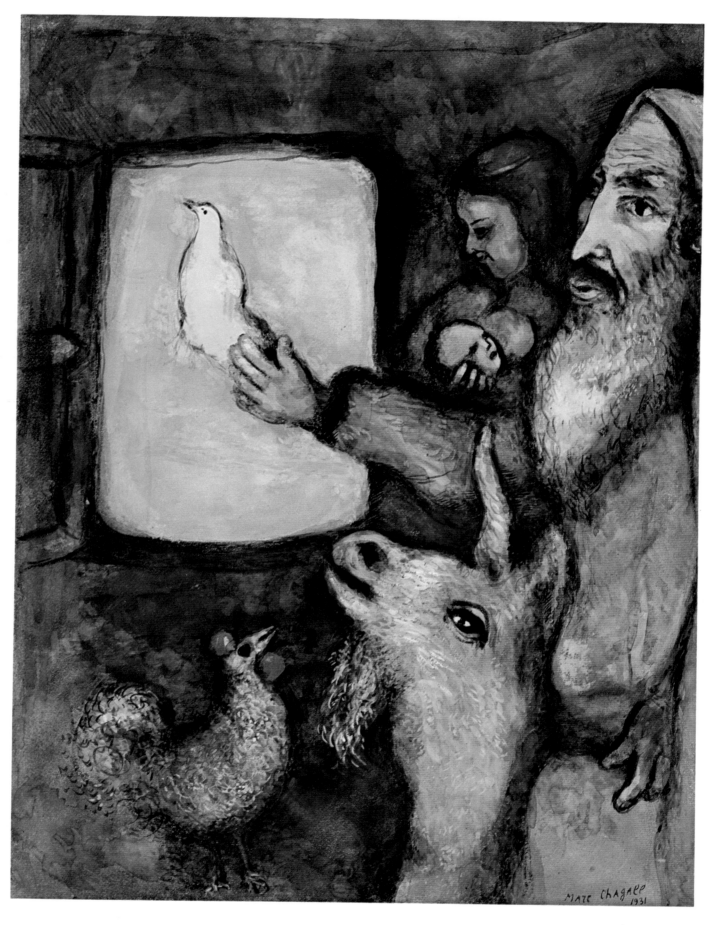

NOAH RELEASES THE DOVE

89

Then God spake to Noah, saying,

Go forth of the Arke, thou & thy wife, and thy sonnes, and thy sonnes wives with thee.

Bring foorth with thee every beast that is with thee, of all flesh, both foule and cattell, & every thing that creepeth and mooveth upon the earth, that they may breed abundantly in the earth, and bring foorth fruit & increase upon the earth.

So Noah came forth, and his sonnes, & his wife, and his sonnes wives with him.

Every beast, evety creeping thing, and every foule, al that moveth upon the earth after their kindes went out of the Arke.

Then Noah built an altar to the Lorde and tooke of every cleane beast, and of every cleane foule, and offered burnt offerings upon the altar.

And the Lord smelled a favour of rest, and the Lord said in his heart, I will hencefoorth curse the ground no more for mans cause: for the imagination of mans heart is evil, even from his youth: neither will I smite any more all things living, as I have done.

Hereafter seed time and harvest, and cold and heate, and sommer and winter, and day and night shal not cease, so long as the earth remaineth.

GENESIS VIII - 15-22

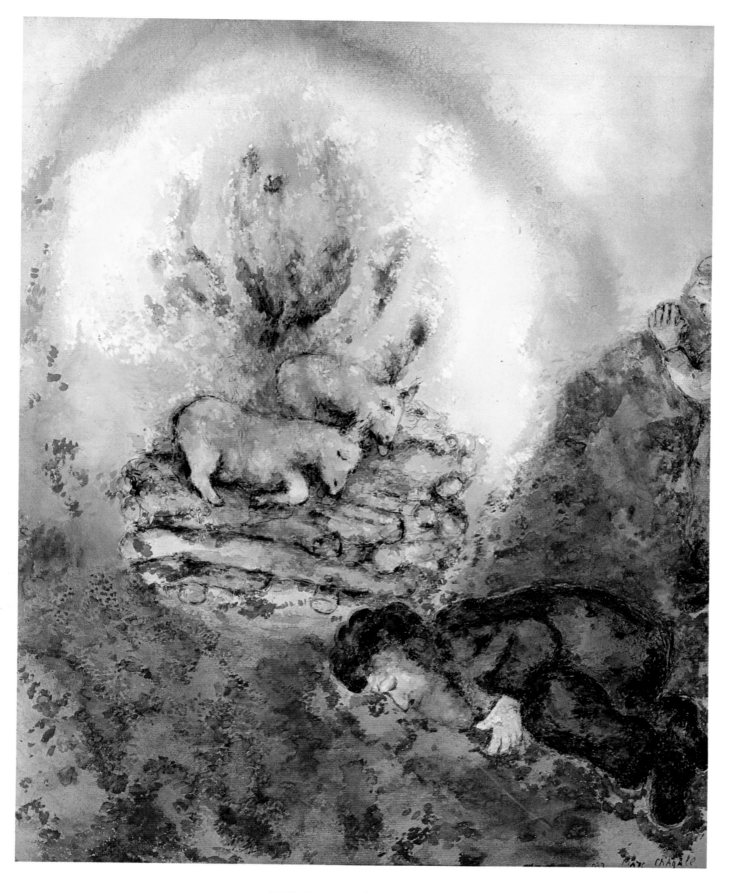

NOAH'S SACRIFICE

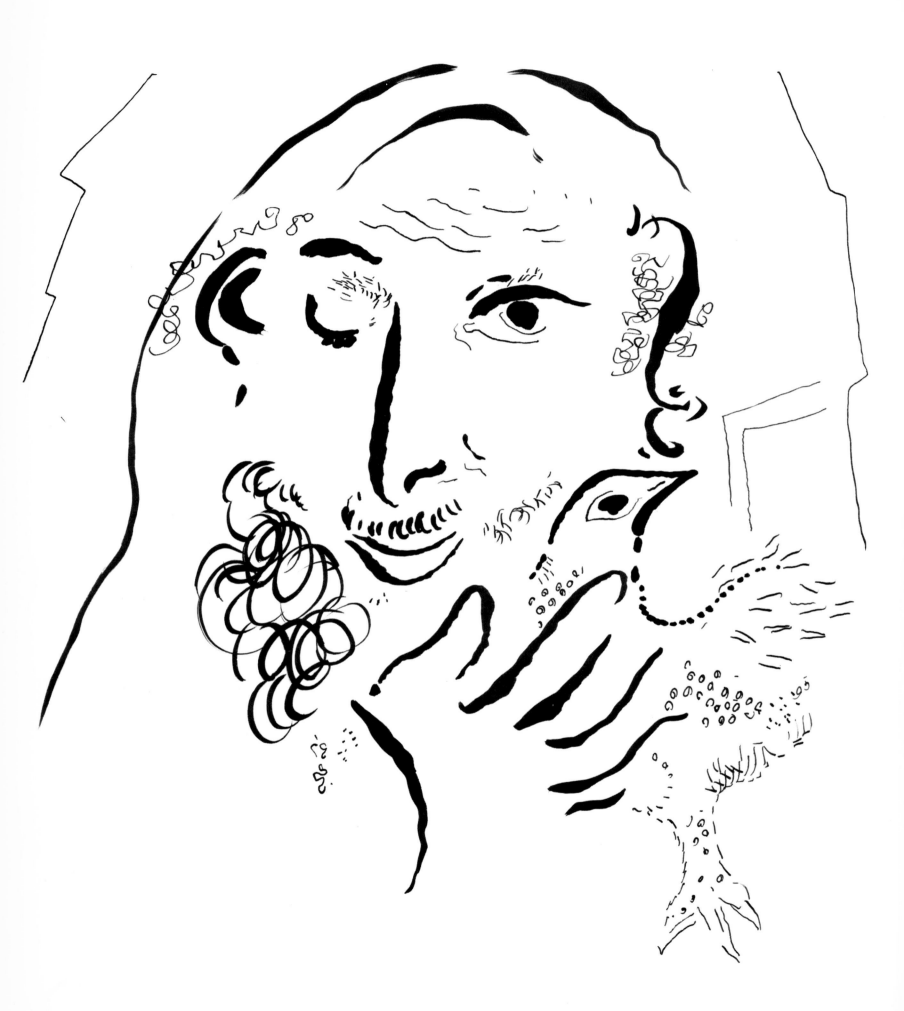

And God blessed Noah and his sonnes, and said to them, Bring foorth fruit and multiply, and replenish the earth.

Also the feare of you, and the dread of you shalbe upon every beast of the earth, & upon every foule of the heaven, upon al that mooveth on the earth, & upo all the fishes of the sea: into your hand are they delivered.

Every thing that mooveth & liveth, shalbe meate for you: as the greene herbe, have I given you all things.

But fleshe with the life thereof, I meane, with the blood thereof, shall ye not eate.

For surely I wil require your blood, wherein your lives are: at the hand of every beast will I require it: and at the hand of man, even at the hand of a mans brother will I require the life of man.

Who so sheadeth mans blood, by man shal his blood be shed: for in the image of God hath he made man.

But bring ye foorth fruit & multiply: growe plentifully in the earth, & increase therein.

GENESIS IX - 1-7

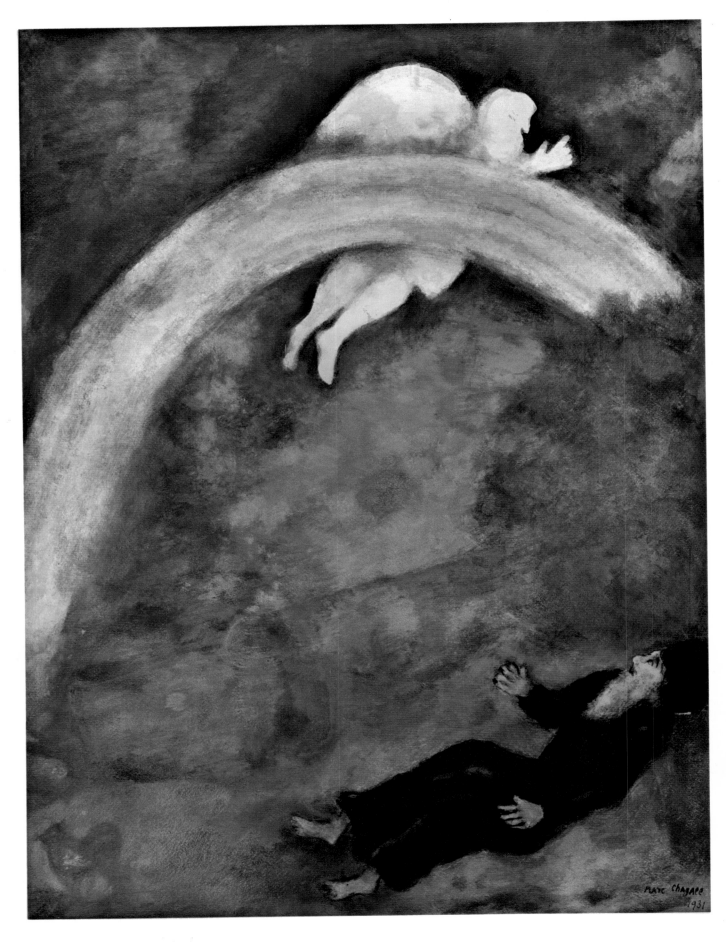

THE RAINBOW, TOKEN OF THE COVENANT
BETWEEN GOD AND THE EARTH

God spake also to Noah & to his sonnes with him, saying,

Beholde, I, even I establish my covenaunt with you, and with your seed after you,

And with every living creature that is with you, with the foule, with the cattell, and with every beast of the earth with you, from all that goe out of the Arke, unto every beast of the earth.

And my covenant wil I establish w you, that from henceforth all flesh shall not be rooted out by the waters of the flood, neither shall there be a flood to destroy y earth any more.

Then God said, This is the token of the covenant which I make betweene me and you, & betweene every living thing, that is with you unto perpetuall generations.

I have set my bowe in the cloude, and it shalbe for a signe of the covenant betweene me and the earth.

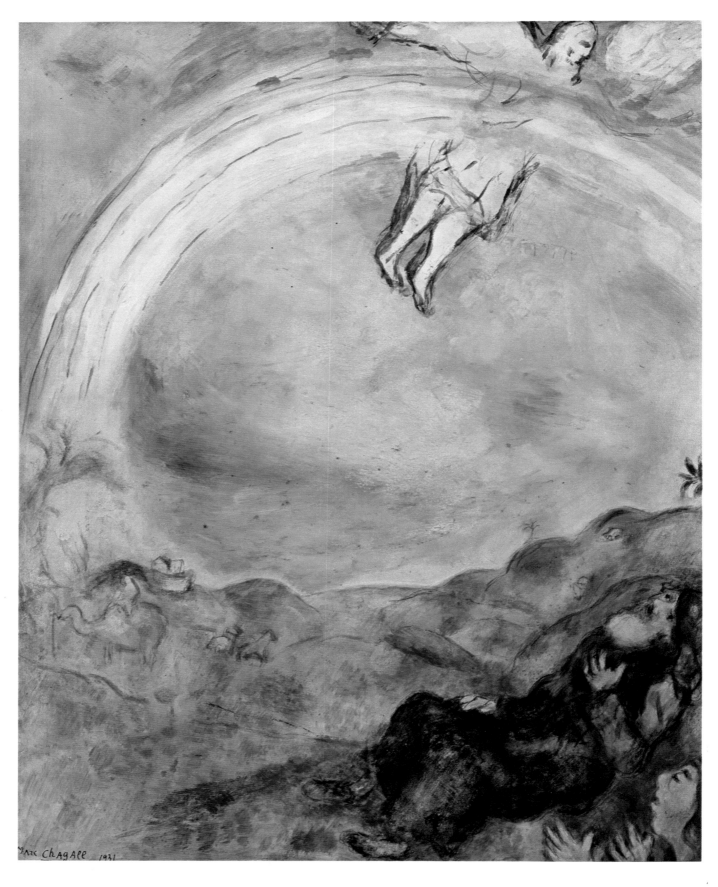

THE RAINBOW, TOKEN OF THE COVENANT
BETWEEN GOD AND THE EARTH

And whe I shal cover the earth w a cloud, and the bowe shall be seen in the cloud,

Then wil I remember my covenant, which is betweene me and you, & betweene every living thing in all flesh, and there shall be no more waters of a flood to destroy all flesh.

Therefore the bowe shall be in the cloude, that I may see it, and remember the everlasting covenant betweene God, and every living thing in all flesh that is upon the earth.

God said yet to Noah, This is the signe of the covenant, which I have established betweene me & all flesh that is upon the earth.

Now the sonnes of Noah going foorth of the Arke, were Shem and Ham & Iapheth. And Ham is the father of Canaan.

These are the three sonnes of Noah, and of them was the whole earth overspred.

GENESIS IX - 8-19

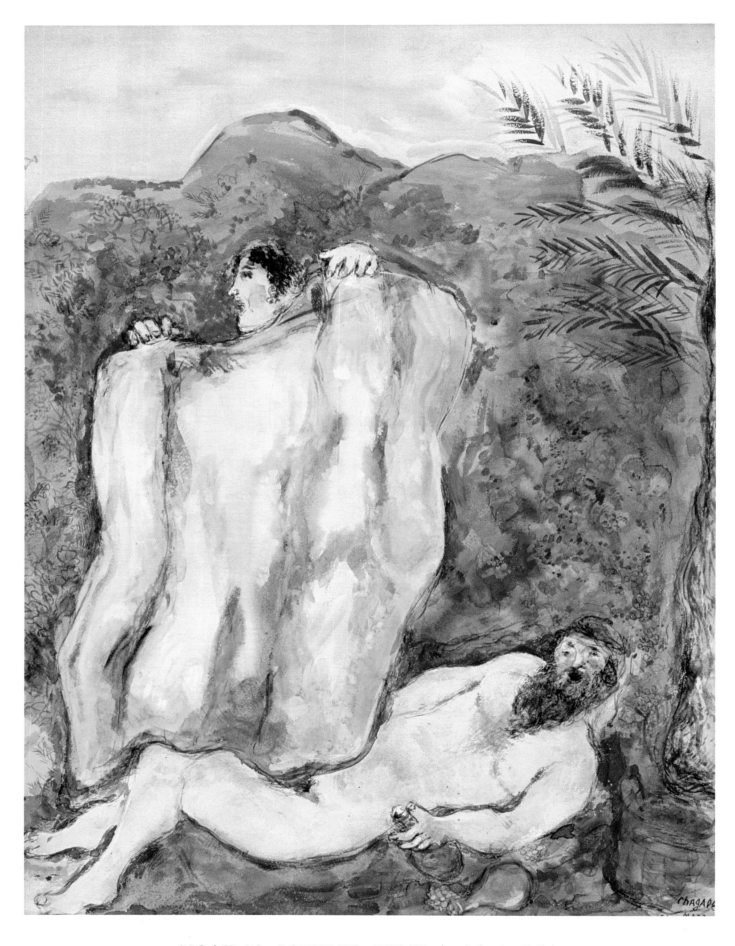

NOAH IS COVERED WITH A GARMENT

Noah also began to be an husband man, & planted a vineyard.

And he drunke of the wine & was drunken, & was uncovered in the mids of his tent.

And when Ham the father of Canaan saw the nakednes of his father, he told his two brethren without.

Then tooke Shem and Iapheth a garment, and put it upon both their shoulders, & went backward, & covered the nakednes of their father with their faces backward: so they saw not their fathers nakednes.

Then Noah awoke from his wine, & knew what his yonger sonne had done unto him,

And said, Cursed be Canaan: a servant of servants shal he be unto his brethren.

He said moreover, Blessed be the Lord God of Shem, and let Canaan be his servant.

God perswade Iapheth, that he may dwel in the tentes of Shem, and let Canaan be his servant.

And Noah lived after the flood three hundreth and fifty yeeres.

So all the dayes of Noah were nine hundreth and fifty yeeres: and he died.

GENESIS IX - 20-29

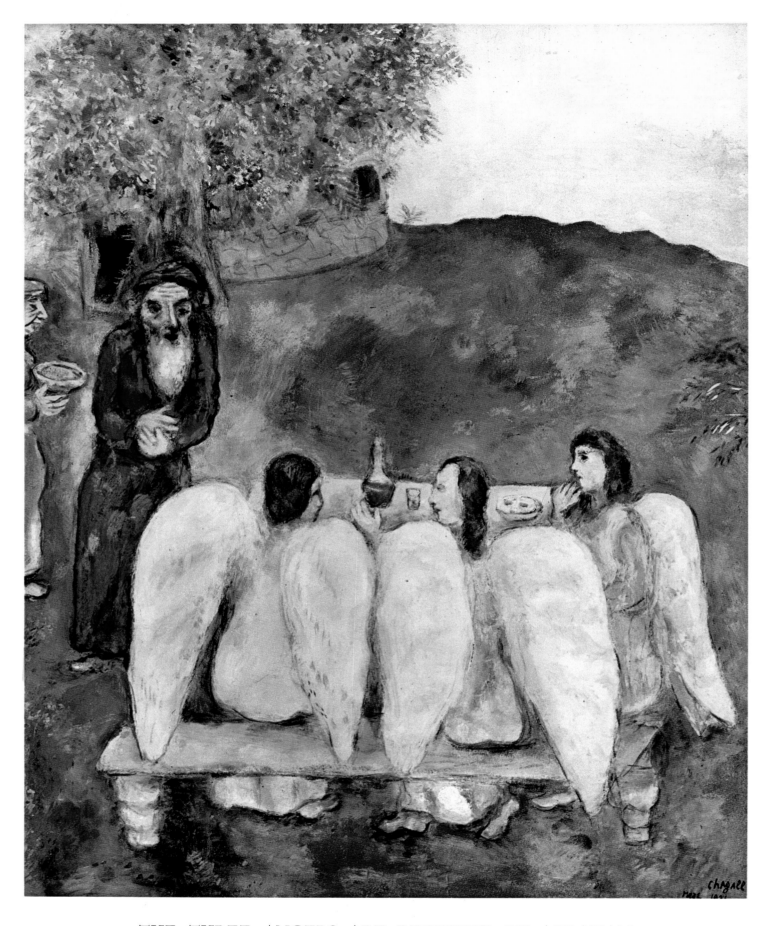

THE THREE ANGELS ARE RECEIVED BY ABRAHAM

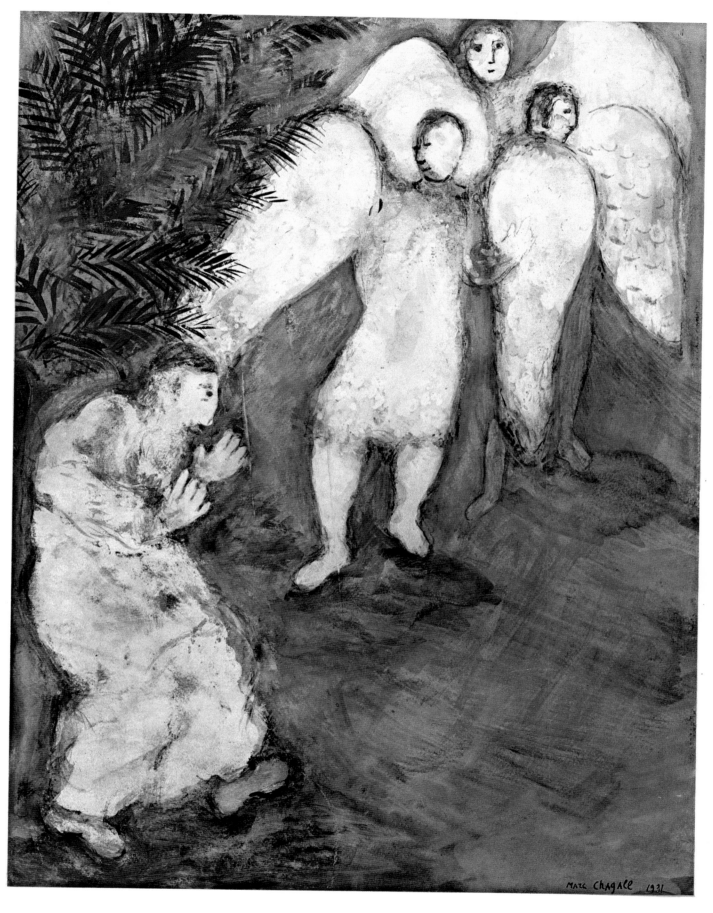

ABRAHAM GUIDING THE THREE ANGELS

Then Lot went up from Zoar, and dwelt in the mountaine with his two daughters: for hee feared to tary in Zoar, but dwelt in a caue, he, and his two daughters.

And the elder sayde unto the yonger, Our father is olde, and there is not a man in the earth to come in unto us after the maner of all the earth.

Come, wee will make our father drinke wine, and lie with him, that we may preserve seede of our father.

So they made their father drinke wine that night, and the elder went and lay with her father: but hee perceived not, neither when she lay downe, neither when she rose up.

And on the morowe the elder sayde to the yonger, Beholde, yesternight lay I with my father: let us make him drinke wine this night also, and go thou, and lye with him, that we may preserve seed of our father.

So they made their father drinke wine that night also, and the yonger arose, and lay with him, but hee perceived not, when shee lay downe, neither when she rose up.

Thus were both the daughters of Lot with childe by their father.

And the elder bare a sonne, and she called his name Moab: the same is the father of the Moabites unto this day.

And the yonger bare a sonne also, and shee called his name Ben-ammi: the same is the father of the Ammonites unto this day.

GENESIS XIX - 30-38

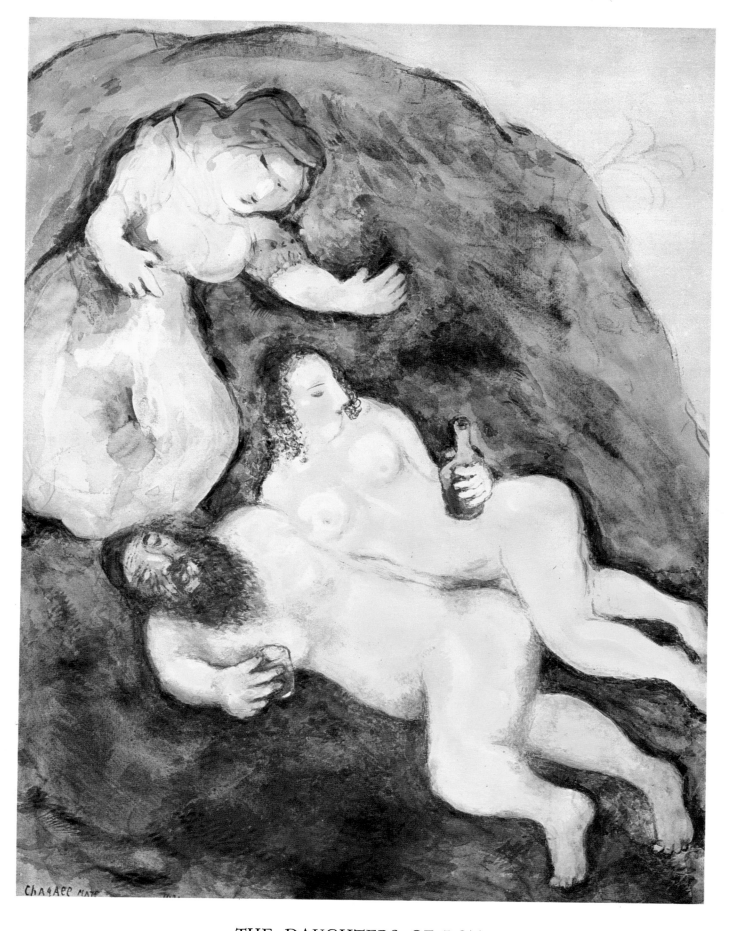

THE DAUGHTERS OF LOT

103

Now the Lord visited Sarah, as he had said, and did unto her according as hee had promised.

For Sarah conceiued, and bare Abraham a sonne in his olde age, at the same season that God tolde him.

And Abraham called his sonnes name that was borne unto him, which Sarah bare him, Izhak.

Then Abraham circumcised Izhak his sonne, when hee was eight dayes olde, as God had commaunded him.

GENESIS XXI - 1-4

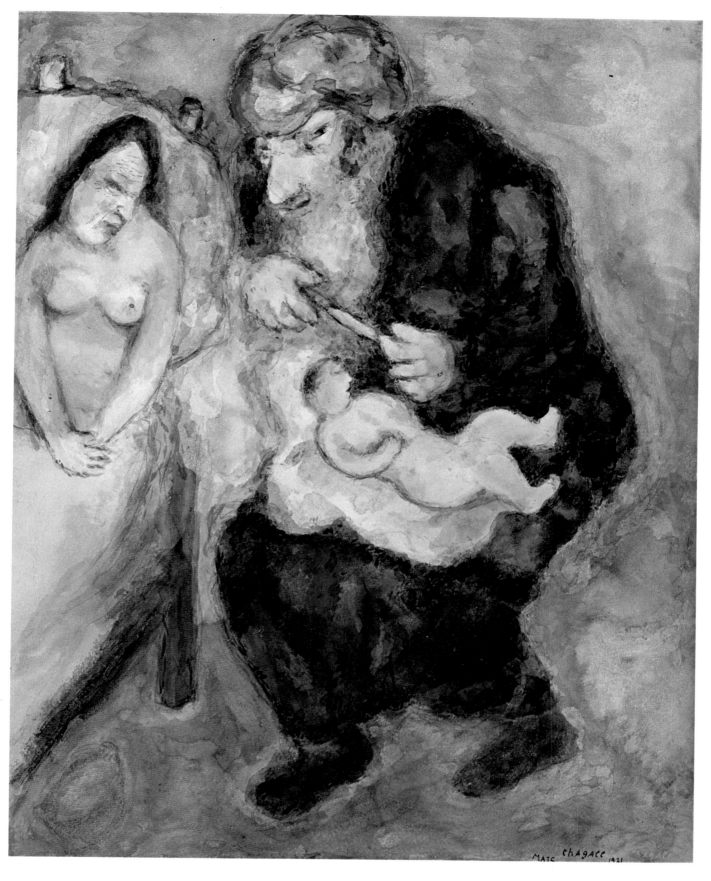

THE CIRCUMCISION ORDAINED BY GOD UNTO ABRAHAM

105

Then Abraham tooke the wood of the burnt offering, and layde it upon Izhak his sonne, and hee tooke the fire in his hand, and the knife: and they went both together.

Then spake Izhak unto Abraham his father, and said, My father. And he answered, Here am I, my sonne. And hee said, Beholde the fire and the wood, but where is the lambe for the burnt offering?

Then Abraham answered, My sonne, God will provide him a lambe for a burnt offring: so they went both together.

And when they came to the place which God had shewed him, Abraham builded an altar there, & couched the wood, and bound Izhak his sonne and layde him on the altar upon the wood.

<div align="right">GENESIS XXII - 6-9</div>

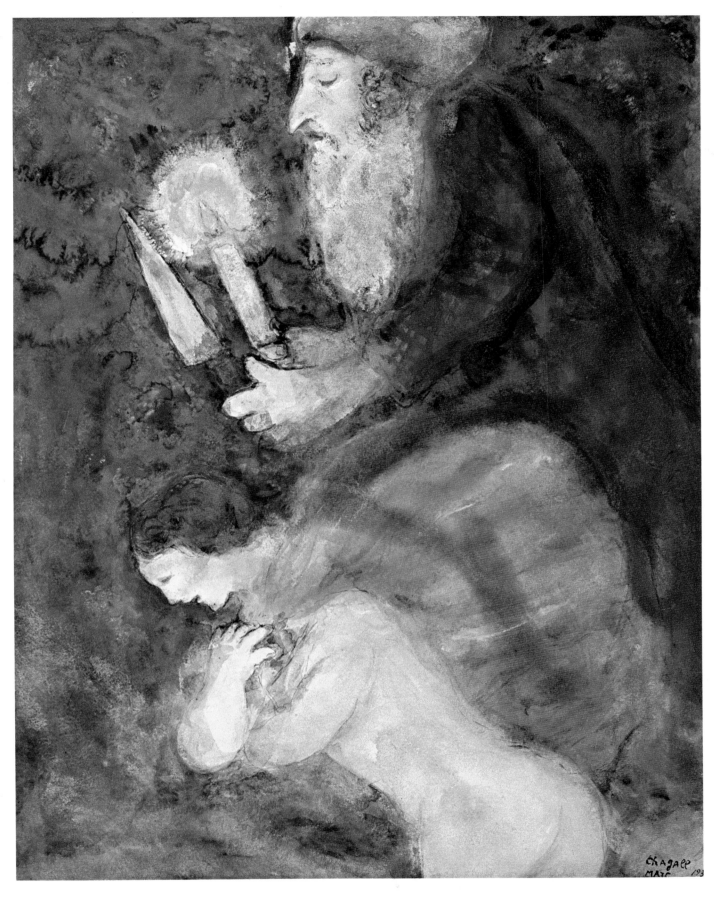

ABRAHAM AND ISAAC ENROUTE TO THE SITE OF THE SACRIFICE

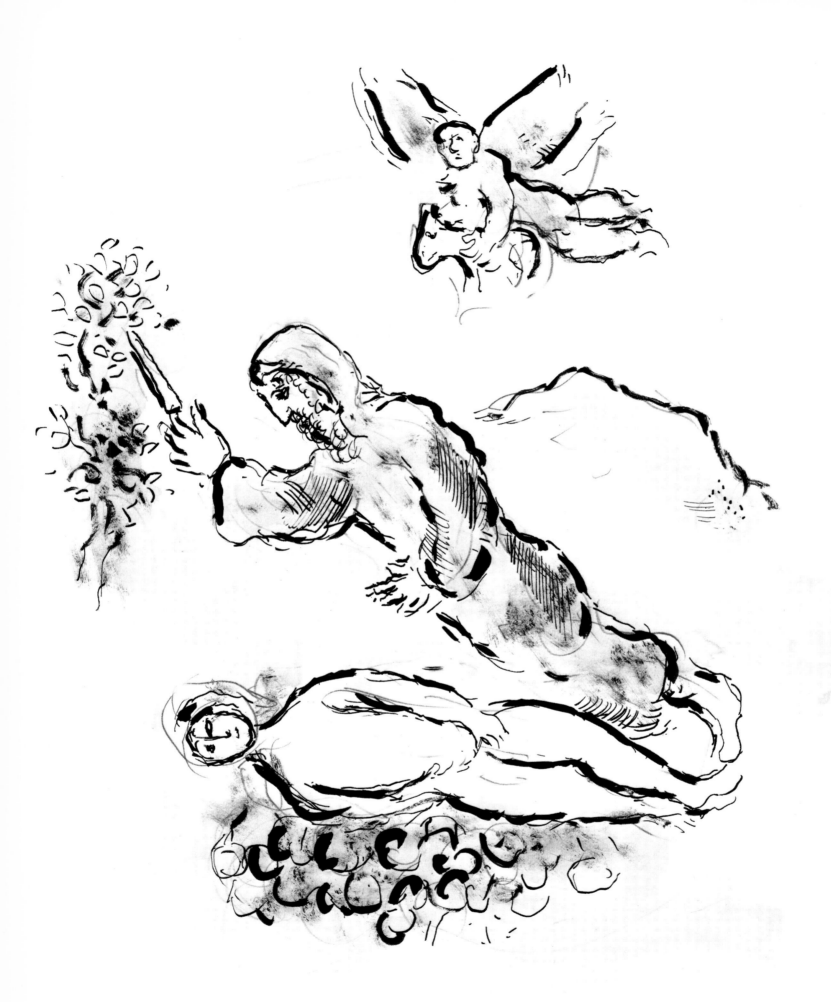

And Abraham stretching foorth his hand, tooke the knife to kill his sonne.

But the Angel of the Lord called unto him from heaven, saying, Abraham, Abraham. And he answered, Here am I.

Then he said, Lay not thine hand upon the childe, neither doe any thing unto him: for nowe I know that thou fearest God, seering for my sake thou hast not spared thine only sonne.

And Abraham lifting up his eyes, looked, and beholde, there was a ramme behinde him caught by the hornes in a bush. Then Abraham went and tooke the ramme, and offred him up for a burnt offering in the stead of his sonne.

And Abraham called the name of that place, Iehovah-ijreh. As it is said this day, In the mount wil the Lord be seene.

And the Angel of the Lord cried unto Abraham from heaven the second time,

And said, By my selfe have I sworne (saith the Lord) because thou hast done this thing, and hast not spared thine onely sonne,

Therefore will I surely blesse thee, and will greatly multiply thy seede, as the starres of the heaven, and as the sand which is upon the sea shore, and thy seede shall possesse the gate of his enemies.

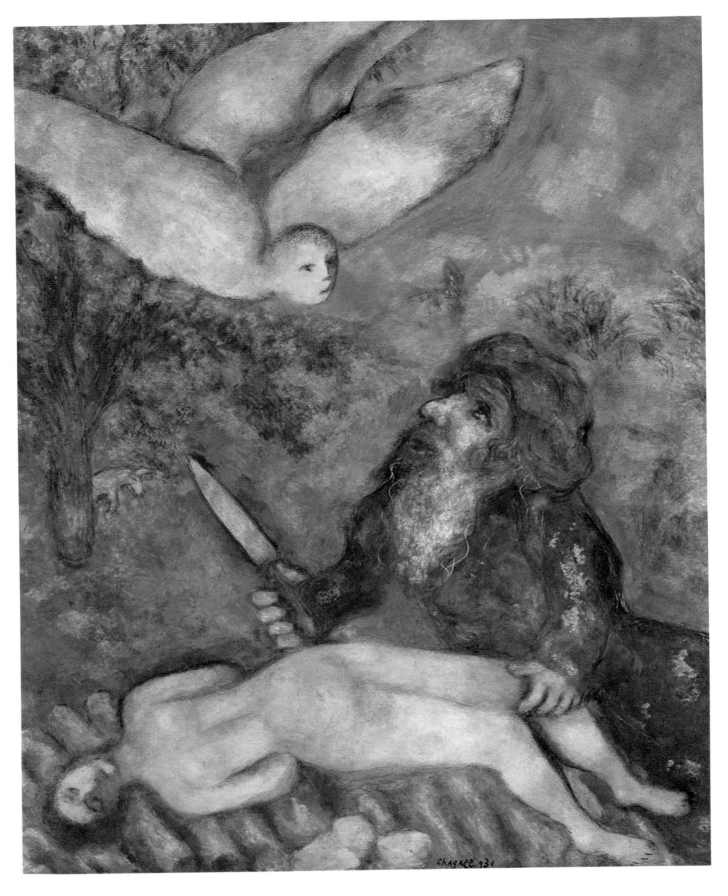

ABRAHAM ABOUT TO IMMOLATE HIS SON

And in thy seede shall all the nations of the earth be blesed, because thou hast obeyed my voyce.

Then turned Abraham againe unto his servants, and they rose up and went together to Beer-sheba: and Abraham dwelt at Beer-sheba.

And after these things one tolde Abraham, saying, Beholde Milcah, shee hath also borne children unto thy brother Nahor:

To wit, Uz his eldest sonne, and Buz his brother, and Kemuel the father of Aram,

And Chesed and Hazo, and Pildash, and Iidlaph, and Bethuel.

And Bethuel begate Rebekah: these eight did Milcah beare to Nahor Abrahams brother.

And his concubine called Reumah, shee bare also Tebah, and Gahan, and Thahash and Maachah.

GENESIS XXII - 10-24

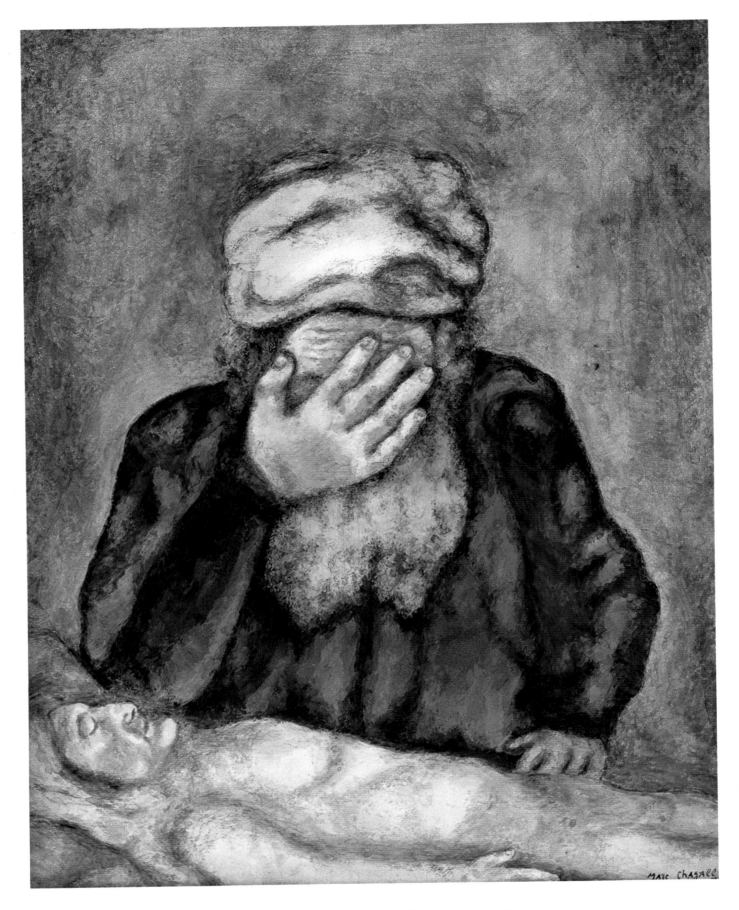

ABRAHAM MOURNING SARAH

When Sarah was an hundreth twentie and seven yeere olde (so long lived she)

Then Sarah died in Kiriath-arba: the same is Hebron in the land of Canaan. And Abraham came to mourne for Sarah and to weepe for her.

Then Abraham rose up from the fight of his corps, and talked with the Hittites, saying,

I am a stranger, and a forriner among you, give me a possession of buriall with you, that I may bury my dead out of my sight.

GENESIS XXIII - 1-4

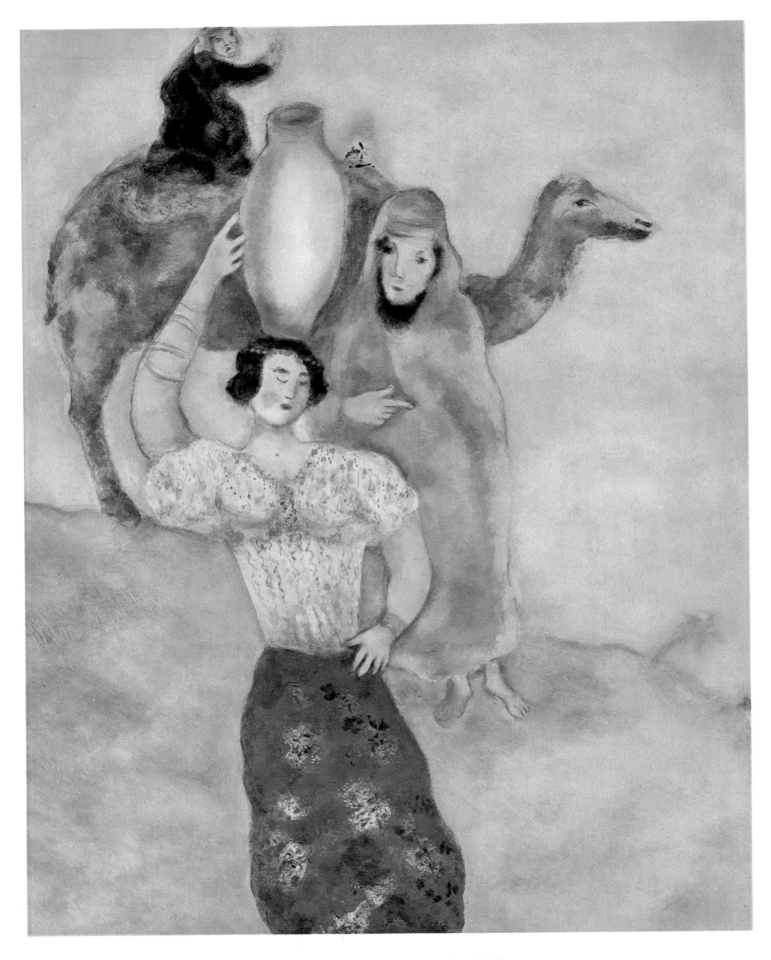

ELIEZER AND REBECCA

Loe, I stand by the well of water, whiles the mens daughters of this citie come our to draw water.

Grant therefore that the mayd, to whom I say, Bowe downe thy pitcher, I pray thee, that I may drinke: if she say, Drinke, & I will give thy camels drinke also: may be she that thou hast ordeined for thy servaunt Izhak: and thereby shall I knowe that thou hast shewed mercy on my master.

And nowe yer hee had left speaking, behold, Rebekah came out, the daughter of Bethuel, sonne of Milcah the wife of Nahor Abrahams brother, and her pitcher upon her shoulder.

(And the mayd was very faire to looke upon, a virgine and unknowen of man) and she went downe to the well, and filled her pitcher, and came up.

Then the servant ranne to meere her, and saide, Let me drinke, I pray thee, a litle water of thy pitcher.

And shee saide, Drinke sir: and she hasted, and let downe her pitcher upon her hand and gave him drinke.

And when she had given him drinke, shee saide, I will draw water for thy camels also untill they haue drunken ynough.

And shee powred out her pitcher into the trough speedily, and ranne againe unto the well to draw water, and she drew for all his camels.

So the man wondred at her, and helde his peace, to know whether the Lorde had made his iourney prosperous or not.

GENESIS XXIV - 13-21

These are the generations of Iaakob: wen Ioseph was seventeene yeere olde, hee kept sheepe with his brethren, and the childe was with the sonnes of Bilhah, and with the sonnes of Zilpah, his fathers wives. And Ioseph brought unto their father their evill saying.

Nowe Israel loved Ioseph more then all his sonnes, because he begate him in his old age, and he made him a coat of many colours.

So when his brethren sawe that their father loved him more then all his brethren, then they hated him, and could not speake peaceably unto him.

And Ioseph dreamed a dreame, and tolde his brethren, who hated him so much the more.

For he sayd unto them, Heare, I pray you, this dreame which I haue dreamed.

Beholde now, wee were binding sheaves in the middes of the field: and loe, my sheafe arose and also stood upright, and behold, your sheaves compassed round about, and did reverence to my sheafe.

Then his brethren sayd to him, What, shalt thou reigne over us, and rule us? or shalt thou have altogether dominion over us? And they hated him so much the more, for his dreames, and for his words.

GENESIS XXXVII - 2-8

116

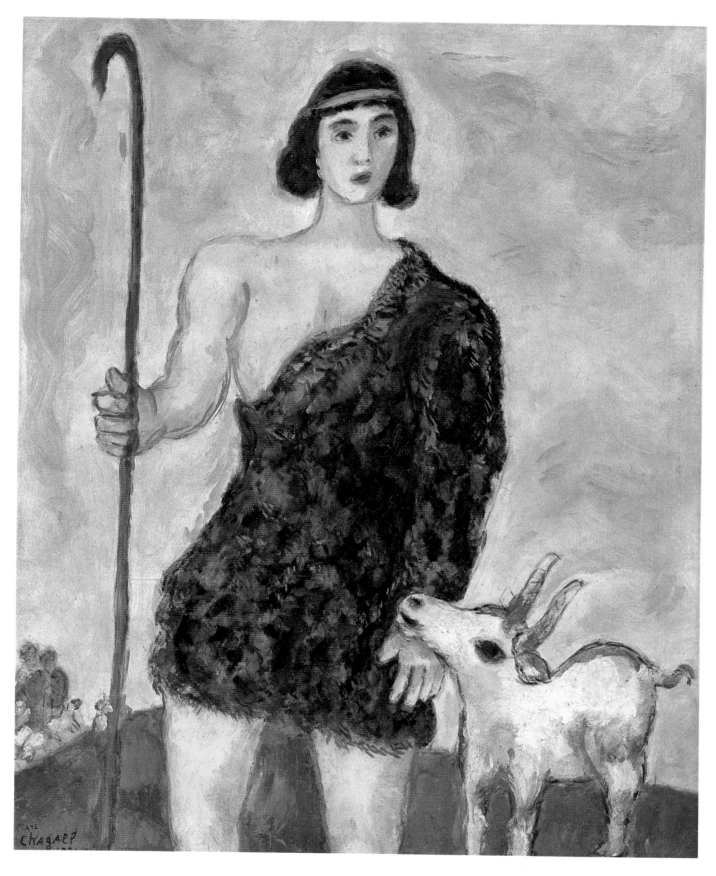

THE SHEPHERD JOSEPH

Then the Midianites marchant men passed by, and they drewe foorth, and lift Ioseph out of the pit, and sold Ioseph unto the Ishmeelites for twentie pieces of silver: who brought Ioseph into Egypt.

Afterwarde Reuben returned to the pit, and behold, Ioseph was not in the pit: then he rent his clothes,

And returned to his brethren, and said, The child is not yonder, and I, whither shall I goe?

And they tooke Iosephs coate, and killed a kid of the goates, and dipped the coate in the blood.

So they sent that particoloured coate, and they brought it unto their father, and saide, This have we found: see now, whether it bee thy sonnes coate, or no.

Then he knewe it, and saide, it is my sonnes coate: a wicked beast hath devoured him: Ioseph is surely torne in pieces.

And Iaakob rent his clothes, and put sackecloth about his loynes, and sorowed for his sonne a long season.

Then all his sonnes & all his daughters rose up to comfort him, but he would not be comforted, but said, Surely I will goe downe into the grave unto my sonne mourning: so his father wept for him,

And the Midianites sold him into Egypt unto Potiphar an Eunuch of Pharaohs, and his chiefe steward.

GENESIS XXXVII - 28-36

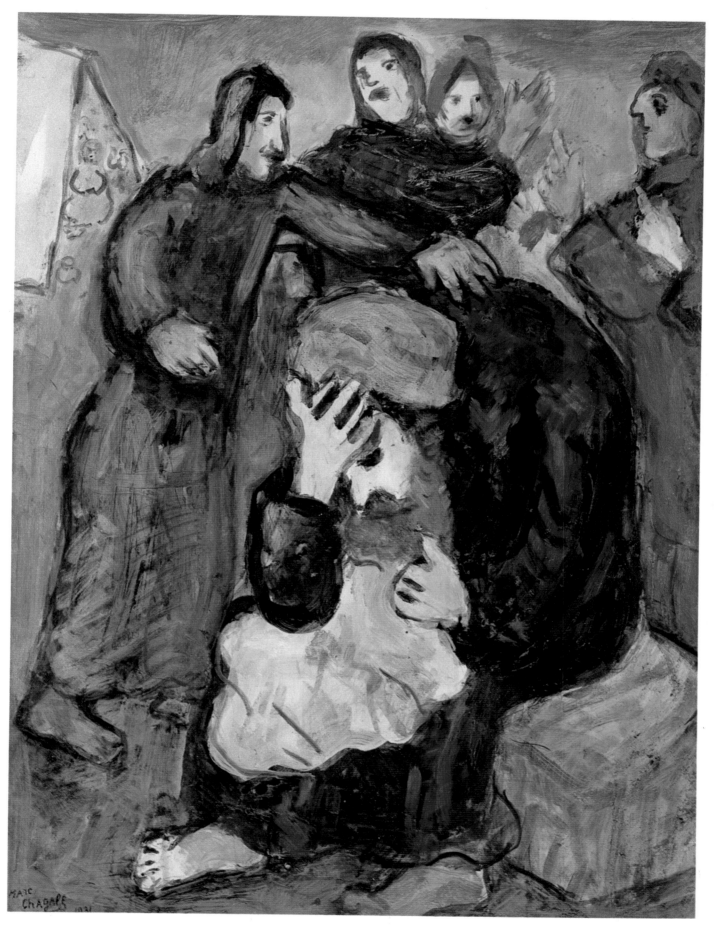

JACOB WEEPS OVER JOSEPH'S TUNIC

Now therefore after these things, his masters wife cast her eyes upon Ioseph, and said, Lye with me.

But he refused and said to his masters wife, Behold, my master knoweth not what be hath in the house with me, but hath committed all that he hath, to mine hand.

There is no man greater in this house then I: neither hath he kept any thing from mee, but onely thee, because thou art his wife: how then can I doe this great wickednesse, and fo sinne against God?

And albeit she spake to Ioseph day by day, yet he hearkned not unto her, to lie with her, or to be in her company.

Then on a certaine day Ioseph entred into the house, to doe his busines: and there was no man of the houshold in the house:

Therefore shee caught him by his garment, saying, Sleepe with me: but hee left his garment in her hand and fled, and got him out.

GENESIS XXXIX - 7-12

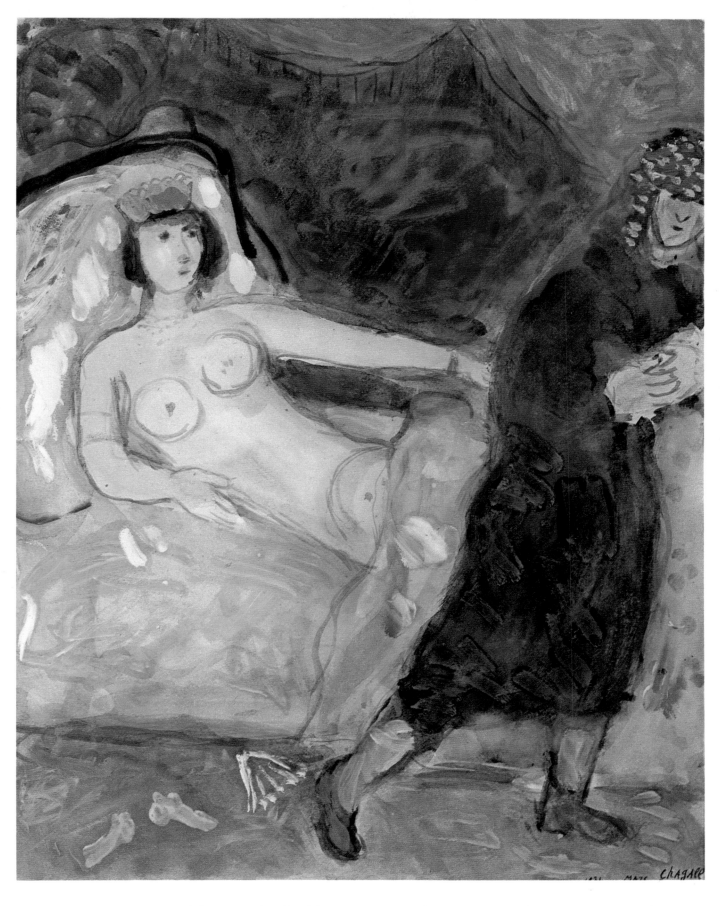

JOSEPH AND THE WIFE OF POTIPHAR

Then Ioseph answered Pharaoh, Both Pharaohs dreames are one. God hath slewed Pharaoh, what he is about to doe.

The seven good kine are seven yeeres, and the seven good eares are seven yeeres: this is one dreame.

Likewise the seven thinne and evilfavoured kine, that came out after them, are seven yeeres: and the seven emptie eares blasted with the East winde, are seven yeeres of famine.

This is the thing which I have saide unto Pharaoh, that God hath shewed unto Pharaoh, what he is about to doe.

Beholde, there come seven yeeres of great plentie in all the land of Egypt.

Againe, there shall arise after them seven yeeres of famine, so that all the plentie shall be forgotten in the land of Egypt, and the famine shall consume the land:

Neither shall the plentie be knowen in the land, by reason of this famine that shall come after: for it shalbe exceeding great.

And therefore the dreame was doubled unto Pharaoh the second time, because the thing is established by God, and God hasteth to performe it.

Nowe therefore let Pharaoh provide for a man of understanding and wisedome, and set him over the land of Egypt.

GENESIS XLI - 25-33

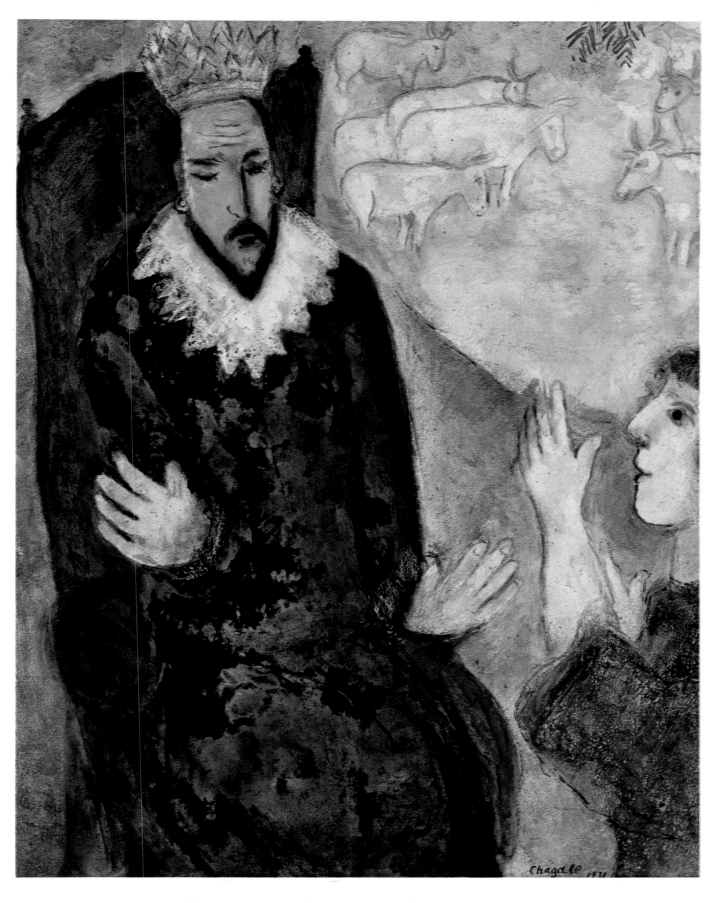

JOSEPH EXPLAINS PHARAOH'S DREAMS

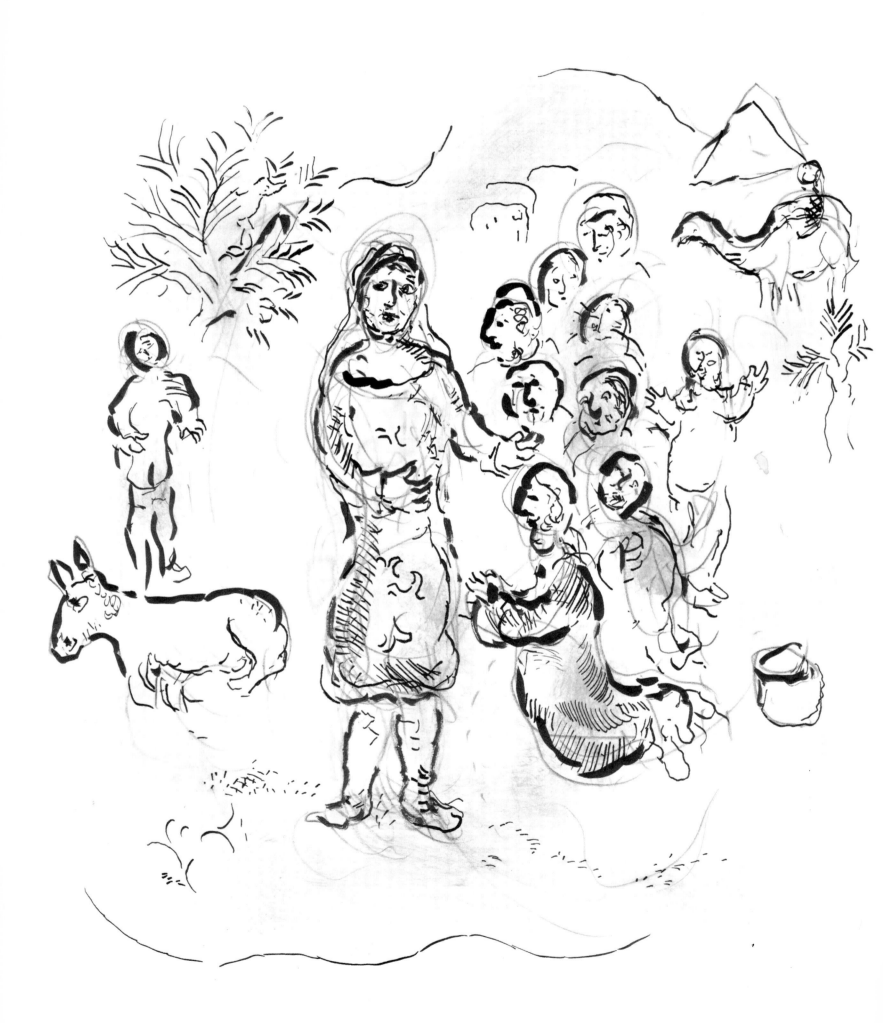

Then Ioseph coulde not refraine himselfe before all that stood by him, but he cried, Have forth every man from me. And there taried not one with him, while Ioseph uttered himselfe unto his brethren.

And hee wept and cryed, so that the Egyptians heard: the house of Pharaoh heard also.

Then Ioseph saide to his brethren, I am Ioseph: doeth my father yet live? But his brethren could not answere him, fort hey were astonished at his presence.

Againe, Ioseph said to his brethren, Come neere, I pray you, to mee. And they came neere. And hee said, I am Ioseph your brother, whom ye solde into Egypt.

Now therefore be not sad, neither grieved with your selves, that ye solde me hither: for God did send me before you for your preservation.

For nowe two yeeres of famine have bene through the lande, and five yeeres are behinde, wherein neither shall bee earing nor harvest.

Wherefore God sent me before you to preserve your posteritie in this land, and to save you alive by a great deliverance.

Nowe then you sent mee not hither, but God, who hath made me a father unto Pharaoh, and lorde of all his house, and ruler throughout all the land of Egypt.

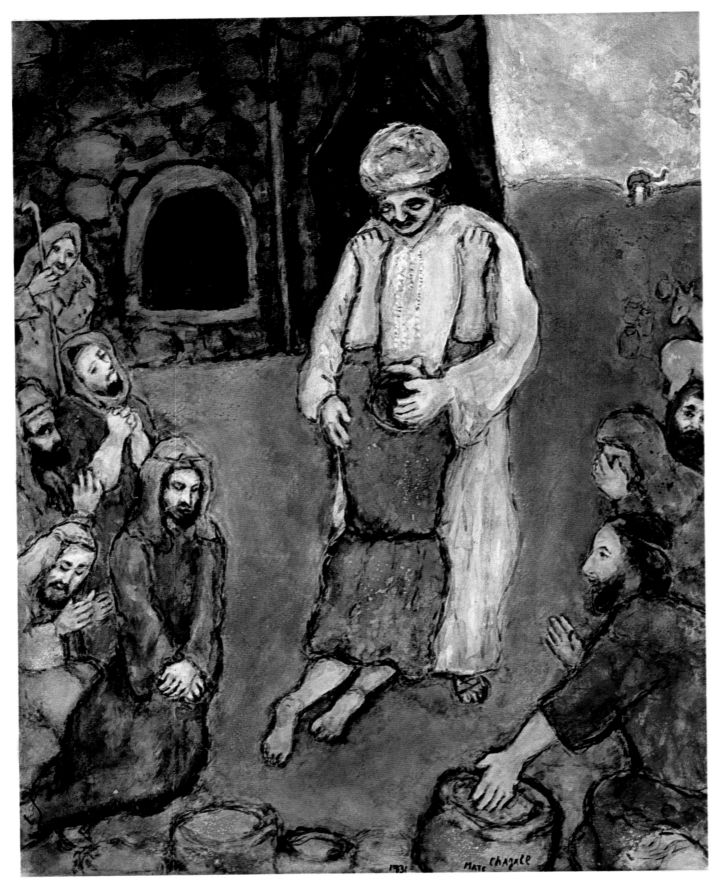

JOSEPH RECOGNIZED BY HIS BROTHERS

Haste you and goe up to my father, and tell him, Thus saith thy sonne Ioseph, God hath made me Lord of all Egypt: come downe to me, tary not.

And thou shalt dwel in the land of Goshen, and shalt be neere mee, thou and thy children, and thy childrens children, and thy sheepe, and thy beasts, and al that thou hast.

Alfo I will noursih thee there (for yet remaine five yeeres of famine) lest thou perish through povertie, thou and thy housholde, and all that thou hast.

And beholde, your eyes do see, and the eyes of my brother Beniamin, that my mouth speaketh to you.

Therefore tel my father of all mine honour in Egypt, and of all that ye have seene, and make haste, and bring my father hither.

Then hee fell on his brother Beniamins necke, and wept, and Beniamin wept on his necke.

Moreover, hee kissed all his brethren, and wept upon them: and afterward his brethren talked with him.

GENESIS XLV - 1-15

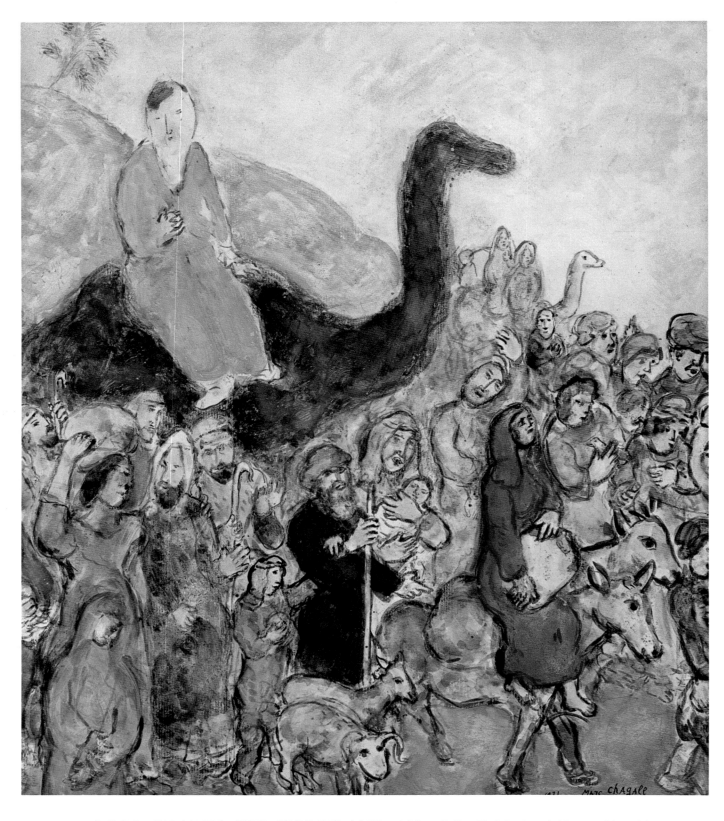

JACOB LEAVES HIS HOMELAND TO GO DOWN TO EGYPT

Then Israel tooke his journey with al that hee had, and came to Beer-sheba, and offered sacrifice unto the God of his father Izhak.

And God spake unto Israel in a vision by night, saying, Iaakob, Iaakob. Who answered, I am here.

Then he said, I am God, the God of thy father, feare not to go downe into Egypt: for I will there make of thee a great nation.

I will go downe with thee into Egypt, and I wil also bring thee up againe, and Ioseph shall put his hand upon thine eyes.

Then Iaakob rose up from Beer-sheba: and the sonnes of Israel caried Iaakob their father, and their children, and their wives in the charets, which Pharaoh had sent to carie him.

And they tooke their cattel & their goods, which they had gotten in the lande of Canaan, and came into Egypt, both Iaakob and all his seede with him,

His sonnes & his sonnes sonnes with him, his daughters and his sonnes daughters, and all his seed brought he with him into Egypt.

GENESIS XLVI - 1-7

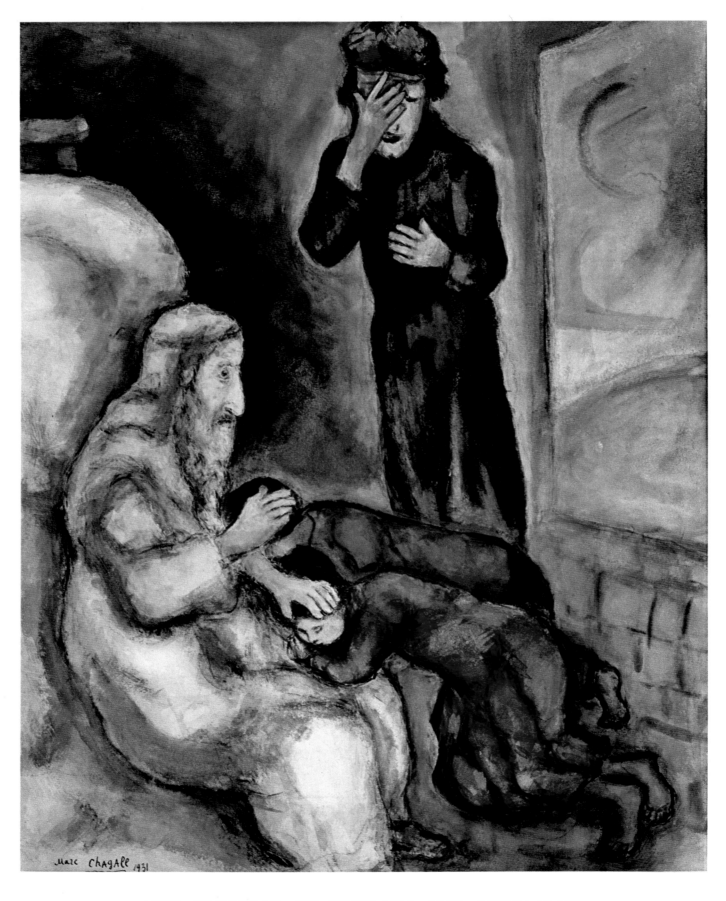

THE BLESSING OF EPHRAIM AND MENASSAH

Then Israel beheld Iosephs sonnes and said, Whose are these?

And Ioseph sayde unto his father, They are my sonnes, which God hath given me here. Then he said, I pray thee, bring them to mee, that I may blesse them:

(For the eyes of Israel were dimme for age, for that he could not well see) Then he caused them to come to him, and hee kissed them and embraced them.

And Israel sayde unto Ioseph, I had not thought to have seene thy face: yet loe, God hath shewed me also thy seede.

And Ioseph tooke them away fro his knees, and did reverence downe to the ground.

Then tooke Ioseph them both, Ephraim in his right hand towarde Israels left hand, and Manasseh in his left hande towarde Israels right hand, so he brought them unto him.

But Israel stretched out his right hand, and layde it on Ephraims head, which was the yonger, and his lefthande upon Manassehs head (directing his handes of purpose) for Manasseh was the elder.

GENESIS XLVIII - 8-14

Then the daughter of Pharaoh came downe to wash her in the river, and her maidens walked by the rivers side: and when she sawe the arke among the bulrushes, shee sent her mayd to fet it.

Then she opened it, and saw it was a child: and behold, the babe wept: so she had compassion on it, and sayd, This is one of the Ebrewes children.

Then sayd his sister unto Pharaohs daughter, Shall I goe and call unto thee a nurse of the Ebrew women to nurse thee the child?

And Pharaohs daughter sayd to her, Goe. So the maide went and called the childes mother,

To whom Pharaohs daughter sayd, Take this child away, and nurse it for me, & I will reward thee. Then the woman tooke the child and nursed him.

Nowe the childe grewe, and she brought him unto Pharaohs daughter, and hee was as her sonne, and she called his name Moses, because, sayd she, I drewe him out of the water.

EXODUS II - 5-10

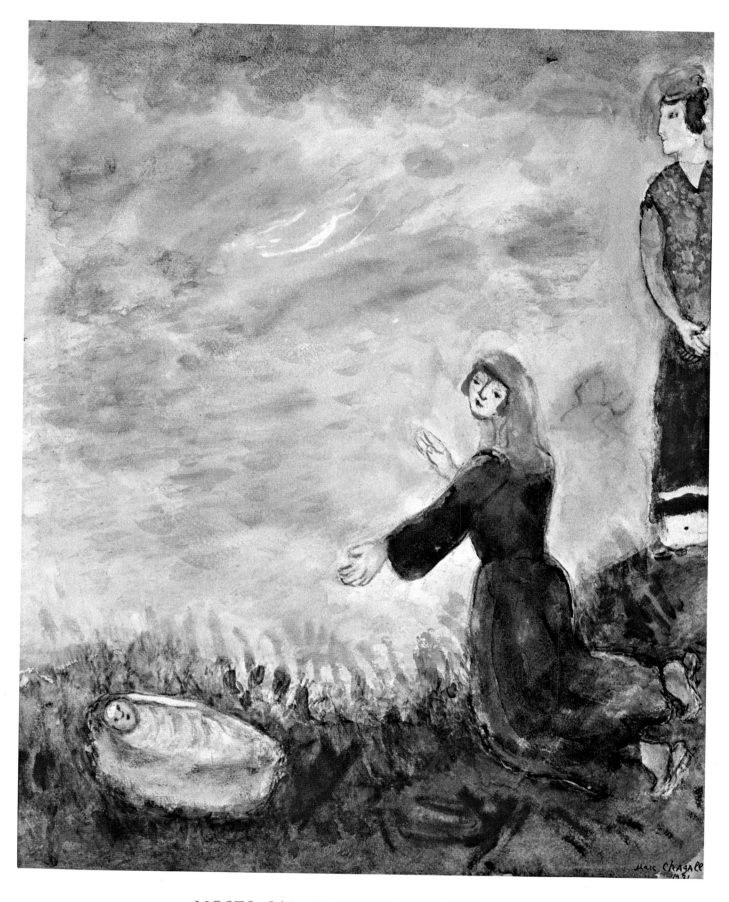

MOSES SAVED FROM THE WATERS

And the Lord said unto him, What is that in thine hand? And he answered, A rod.

Then said he, Cast it on the ground. So hee cast it on the ground, and it was turned into a serpent: and Moses fled from it.

Againe the Lord said unto Moses, Put forth thine hand, and take it by the taile. Then he put foorth his hand and caught it, and it was turned into a rod in his hand.

Doe this that they may beleeve, that the Lord God of their fathers, the God of Abraham, the God of Izhak, and the God of Iaakob hath appeared unto thee.

EXODUS IV - 2-5

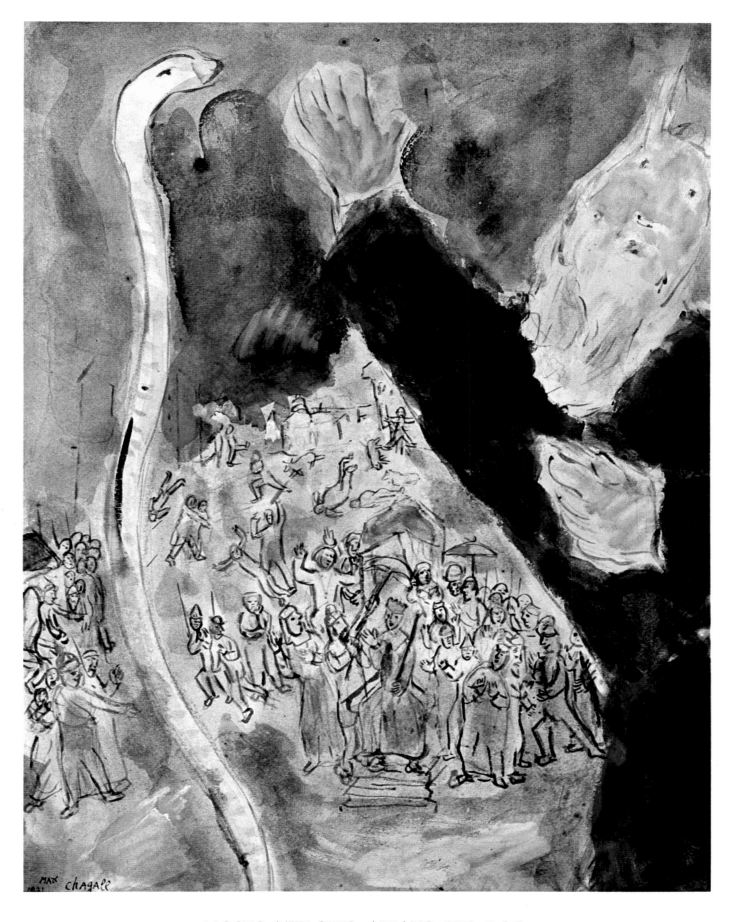

MOSES THROWS AWAYS HIS ROD

Then the Lord said unto Aaron, Go meet Moses in the wildernes. And he went & met him in the Mount of God, and kissed him.

Then Moses told Aaron all the wordes of the Lord, who had sent him, & all the signes wherewith he had charged him.

So went Moses and Aaron, and gathered all the Elders of the children of Israel.

And Aaron told all the wordes, which the Lord had spoken unto Moses, and he did the miracles in the sight of the people,

And the people beleeved, and when they heard that the Lorde had visited the children of Israel, and had looked upo their tribulation, they bowed downe, and worshipped.

<div align="right">EXODUS IV - 27-31</div>

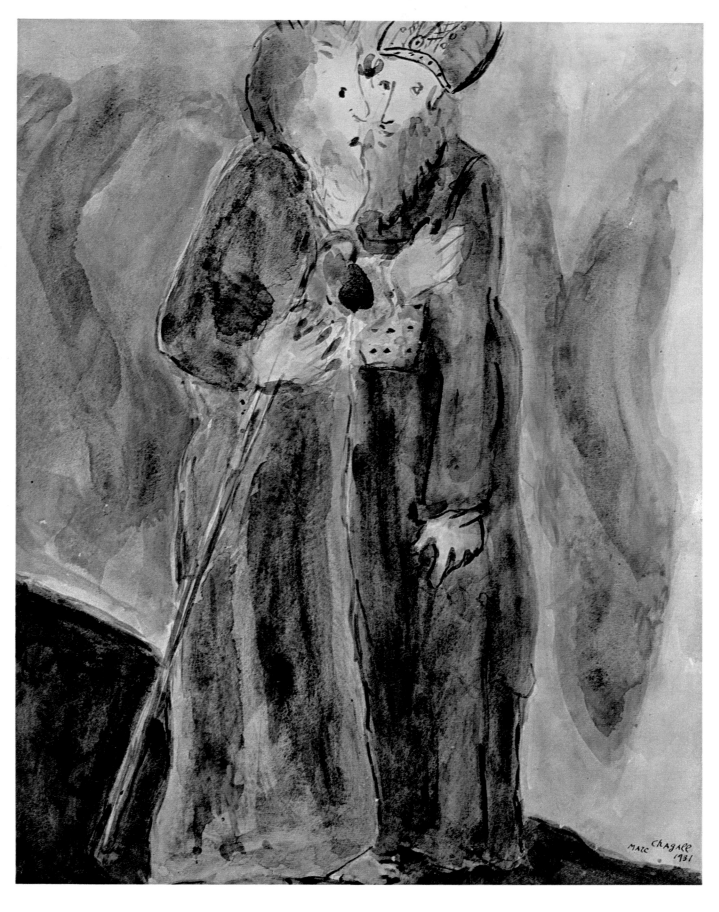

MOSES AND AARON

Then afterward Moses and Aaron went and sayd to Pharaoh, Thus saieth the Lord God of Israel, Let my people goe, that they may celebrate a feast unto me in the wildernesse.

And Pharaoh sayd, Who is the Lord, that I should heare his voyce, and let Israel goe? I know not the Lord, neither will I let Israel goe.

And they sayd, Wee worship the God of the Ebrewes: wee pray thee, let us goe three dayes iourney in the desert, and sacrifice unto the Lord our God, lest he bring upon us the pestilence or sword.

Then sayd the King of Egypt unto them, Moses and Aaron, why cause ye the people to cease from their workes? get you to your burdens.

Pharaoh sayd furthermore, Beholde, much people is now in the land, & ye make them leave their burdens.

Therefore Pharaoh gave commandement the same day unto the taske-masters of the people, and to their officers, saying,

Yee shall give the people no more strawe, to make bricke (as in time past) but let them goe and gather them strawe themselves:

Notwithstanding lay upon them the number of bricke, which they made in time past, diminish nothing thereof: for they be idle, therefore they cry, saying, Let us goe to offer sacrifice unto our God.

Lay more work upon the men, and cause them to do it, & let them not regard vaine words.

Then went the taskemasters of the people and their officers out, & told the people, saying, Thus saieth Pharaoh, I will give you no more straw.

Go your selves, get you straw where ye can find it, yet shall nothing of your labour be diminished.

Then were the people scattered abroad throughout all the land of Egypt, for to gather stubble in stead of straw.

And the taskemasters hasted them, saying, Finish your dayes worke every dayes taske, as ye did when ye had strawe.

And the officers of the children of Israel, which Pharaohs taskemasters had set over them, were beaten, and demanded, Wherefore have ye not

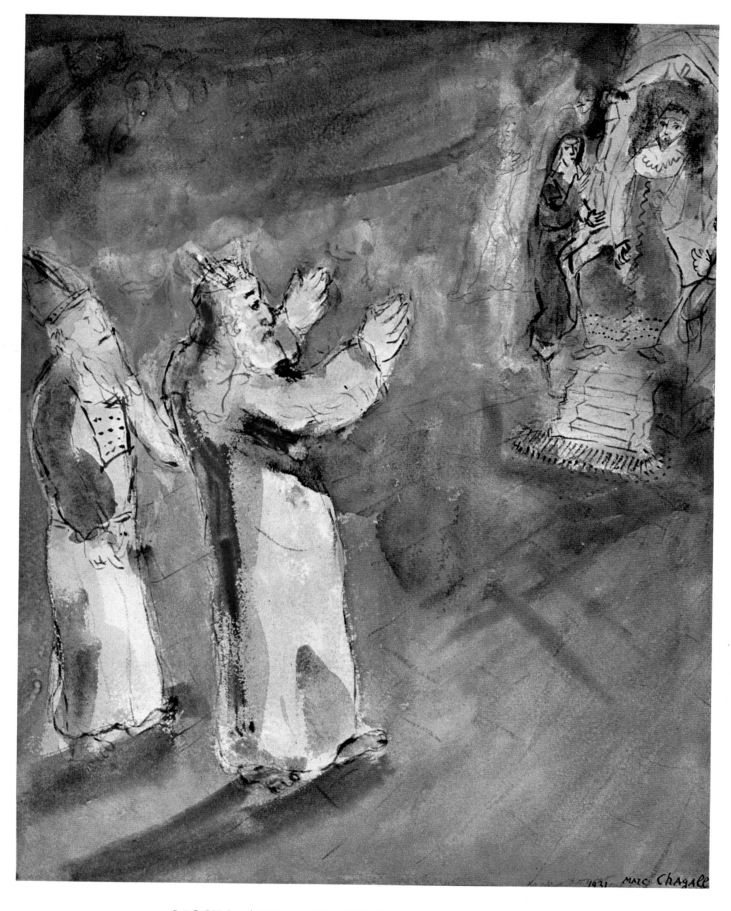

MOSES AND AARON BEFORE PHARAOH

fulfilled your taske in making bricke yesterday and to day, as in times past?

Then the officers of the children of Israel came, and cryed unto Pharaoh, saying, Wherefore dealest thou thus with thy servants?

There is no strawe given to thy servaunts, and they say unto us, Make bricke: and loe, thy servantes are beaten, and thy people is blamed.

But he sayd, Ye are too much idle: therefore ye say, Let us go to offer sacrifice to the Lord.

Go therefore now & worke: for there shall no straw be given you, yet shall ye deliver the whole tale of bricke.

Then the officers of the children of Israel sawe themeslves in an evil case, because it was said, Ye shall diminish nothing of your bricke, nor of every dayes taske.

And they met Moses and Aaron, which stoode in their way as they came out from Pharaoh,

To whom they said, The Lord looke upon you and iudge: for ye haue made our savour to stinke before Pharaoh, and before his servants, in that ye have put a sworde in their hand to slay us.

Wherefore Moses returned to the Lord, & said, Lord, why hast thou afflicted this people? wherefore hast thou thus sent me?

For since I came to Pharaoh to speake in thy Name, he hath vexed this people, & yet thou hast not delivered thy people.

EXODUS V - 1-23

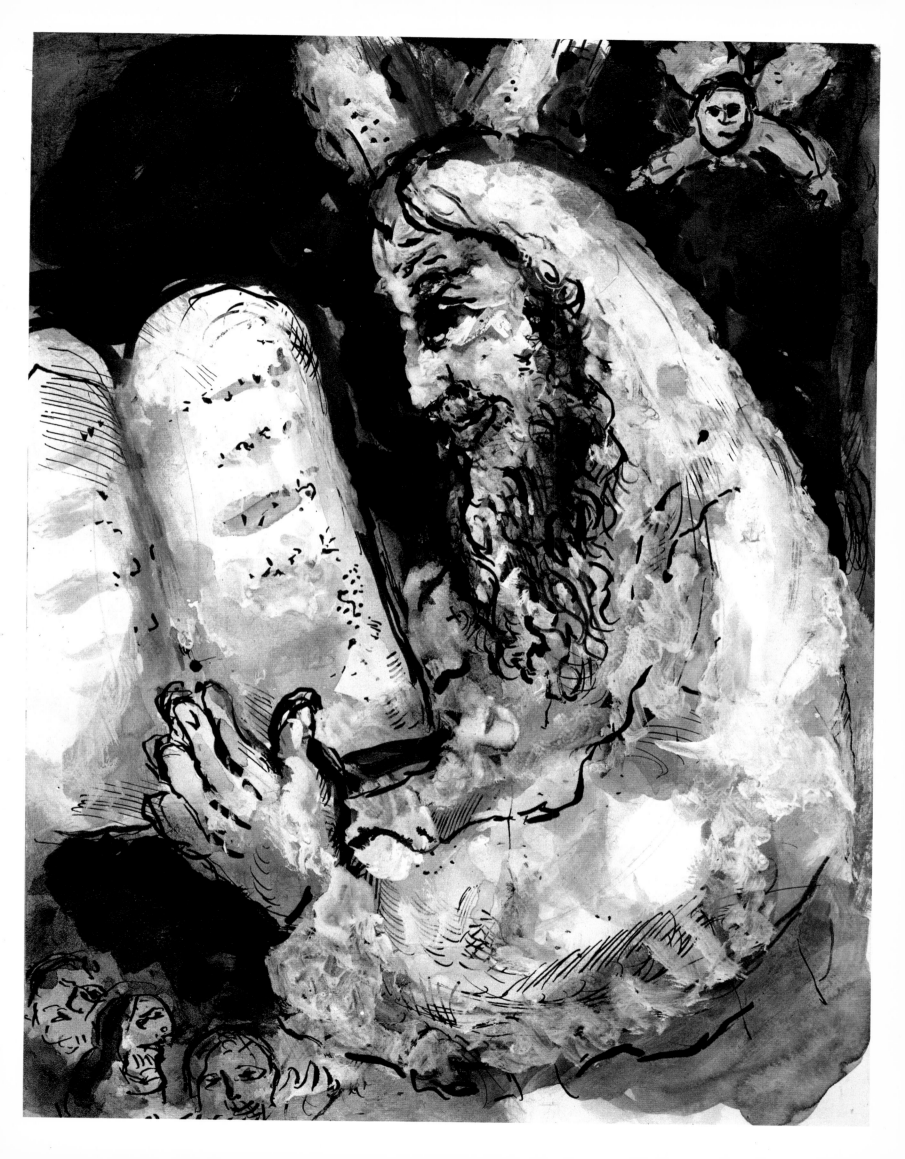

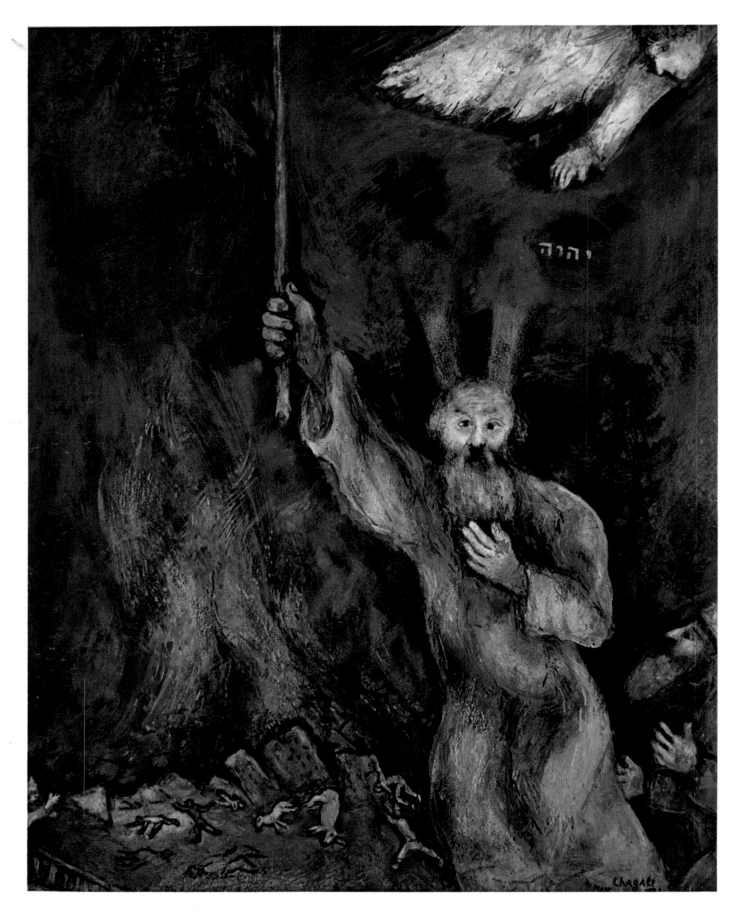

MOSES AND SPREADS DARKNESS

Againe, the Lorde sayde unto Moses, Stretch out thine hande towarde heaven, that there may be upon the lande of Egypt darkenesse, even darkenesse that may bee felt.

Then Moses stretched foorth his hande towarde heaven, and there was a blacke darkenesse in all the land of Egypt three dayes.

No man saw another, neither rose up from the place where he was for three dayes: but all the children of Israel had light where they dwelt.

EXODUS X - 21-23

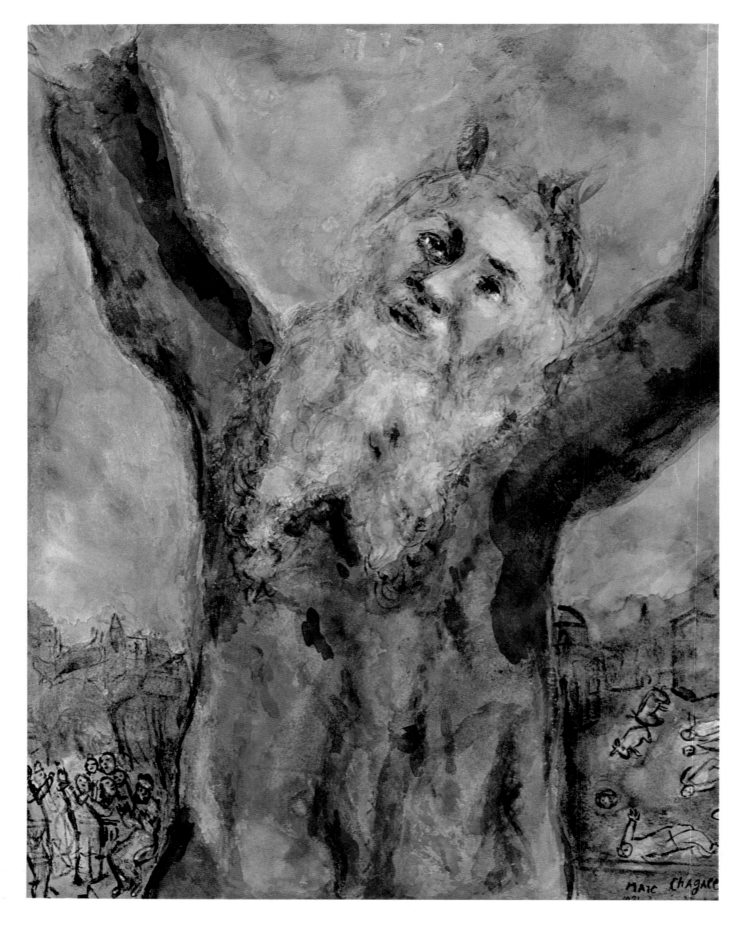

MOSES SPREADS DEATH AMONG THE EGYPTIANS

Also Moses sayd, Thus sayth the Lord, About midnight will I go out into the middes of Egypt.

And all the first borne in the lande of Egypt shall die, from the first borne of Pharaoh that sitteth on his throne, unto the first borne of the mayd servaunt, that is at the mill, and all the first borne of beasts.

Then there shall be a great crie thorowout all the land of Egypt, such as was never none like, nor shalbe.

But against none of the children of Israel shall a dogge moove his tongue, neither against man nor beast, that ye may know that the Lord putteth a difference betweene the Egyptians and Israel.

And all these thy servauntes shall come downe unto me, and fall before me, saying, Get thee out, and all the people that are at thy feet, and after this will I depart. So hee went out from Pharaoh very angry.

EXODUS XI - 4-8

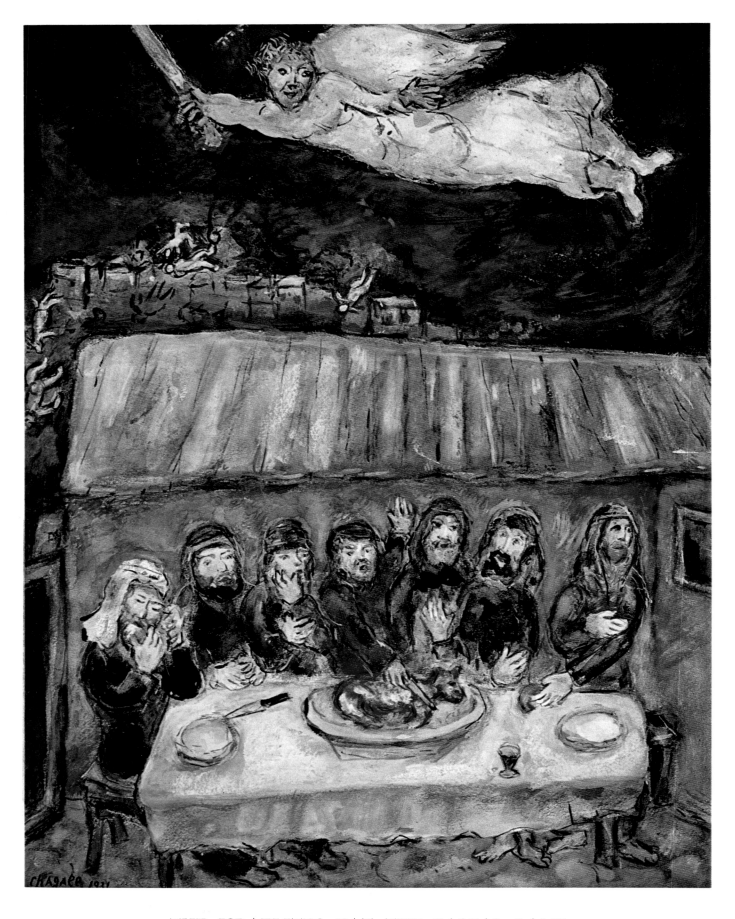

THE ISRAELITES EAT THE PASCAL LAMB

Then the Lorde spake to Mofes & to Aaron in the land of Egypt, saying,

This moneth shall be unto you the beginning of moneths: it shall be to you the first moneth of the yere.

Speake ye unto all the Congregation of Israel, saying, In the tenth of this moneth let every man take unto him a lambe, according to the house of the fathers, a lambe for an house.

And if the housholde bee too little for the lambe, he shall take his neighbour, which is next unto his house, according to the number of the persons: every one of you, according to his eating shall make your count for the lambe.

<div align="right">EXODUS XII - 1-4</div>

Nowe when Pharaoh had let the people goe, God caried them not by the way of the Philistims countrey, though it were neerer: (for God sayd, Lest the people repent when they see warre, and turne againe to Egypt)

But God made the people to goe about by the way of the wildernesse of the red sea: and the children of Israel went up armed out of the land of Egypt.

(And Moses tooke the bornes of Ioseph with him: for hee had made the children of Israel sweare, saying, God will surely visite you, and ye shall take my bones away hence with you)

So they tooke their iourney from Succoth, and camped in Etham in the edge of the wildernesse.

And the Lorde went before them by day in a pillar of a cloud to leade them the way, and by night in a pillar of fire to give them light, that they might go both by day and by night.

He tooke not away the pillar of the cloud by day, hor the pillar of fire by night from before the people.

EXODUS XIII - 17-22

THE EXODUS FROM EGYPT

And Moses stretched foorth his hand upon the sea, and the Lorde caused the sea to run backe by a strong East winde all the night, and made the sea drie lande: for the waters were divided.

Then the children of Israel went through the mids of the sea upon the dry ground, and the waters were a wall unto them on their right hand, and on their left hand.

And the Egyptians pursued and went after them to the mids of the sea, even al Pharaohs horses, his charets, and his horsemen.

Now in the morning watch, when the Lord looked unto the hoste of the Egyptians out of the fiery and cloudie pillar, he strooke the hoste of the Egyptians with feare.

For hee tooke off their charet wheeles, and they drave them with much a doe so that the Egyptians every one said, I will flee from the face of Israel: for the Lorde fighteth for them against the Egyptians.

Then the Lorde saide to Mofes, Stretche thine hande upon the sea, that the waters may returne upon the Egyptians, upon their charets and upon their horsemen.

Then Moses stretched forth his hand upon the Sea, and the sea returned to his force early in the morning, & the Egyptians fled against it: but the Lord overthrewe the Egyptians in the mids of the sea.

So the water returned and covered the charets and the horsemen, even all the hoste of Pharaoh that came into the sea after them: there remained not one of them.

But the children of Israel walked upon dry land thorow the mids of the sea, and the waters were a wal unto them on their right hand, and on their left.

EXODUS XIV - 21-29

THE ISRAELITES CROSS THE RED SEA

151

For Pharaohs horses went with his charets and horsemen into the Sea, and the Lorde brought the waters of the Sea upon them: but the children of Israel went on drie lande in the mids of the Sea.

And Miriam the prophetesse, sister of Aaron tooke a timbrell in her hand, and all the women came out after her with timbrels and daunces.

And Miriam answered the men, Sing yee unto the Lord: for he hath triumphed gloriousy: the horse and his rider hath he overthrowen in the Sea.

EXODUS XV - 19-21

MIRIAM DANCING

153

And all the Congregation of the children of Israel departed from the wildernesse of Sin, by their iourneys at the commaundement of the Lord, and camped in Rephidim, where was no water for the people to drinke.

Wherefore the people contended with Moses, and saide, Give us water that we may drinke. And Moses said unto them, Why contend ye with me? Wherefore doe ye tempt the Lord?

So the people thirsted there for water, and the people murmured against Moses, & sayd, Wherefore hast thou thus brought us out of Egypt to kill us and our children and our cattell with thirst?

And Moses cried to the Lorde, saying, What shall I doe to this people? for they be almost ready to stone me.

And the Lord answered to Moses, Goe before the people, and take with thee of the Elders of Israel: and thy rod, wherewith thou smotest the river, take in thine hand, & goe:

Behold, I will stande there before thee upon the rocke in Horeb, & thou shalt smite on the rocke, and water shal come out of it, that the people may drinke. And Moses did so in the sight of the Elders of Israel.

And he called the name of the place, Massah and Meribah, because of the contention of the children of Israel, and because they had tempted the Lord, saying, Is the Lorde among us, or no?

EXODUS XVII - 1-7

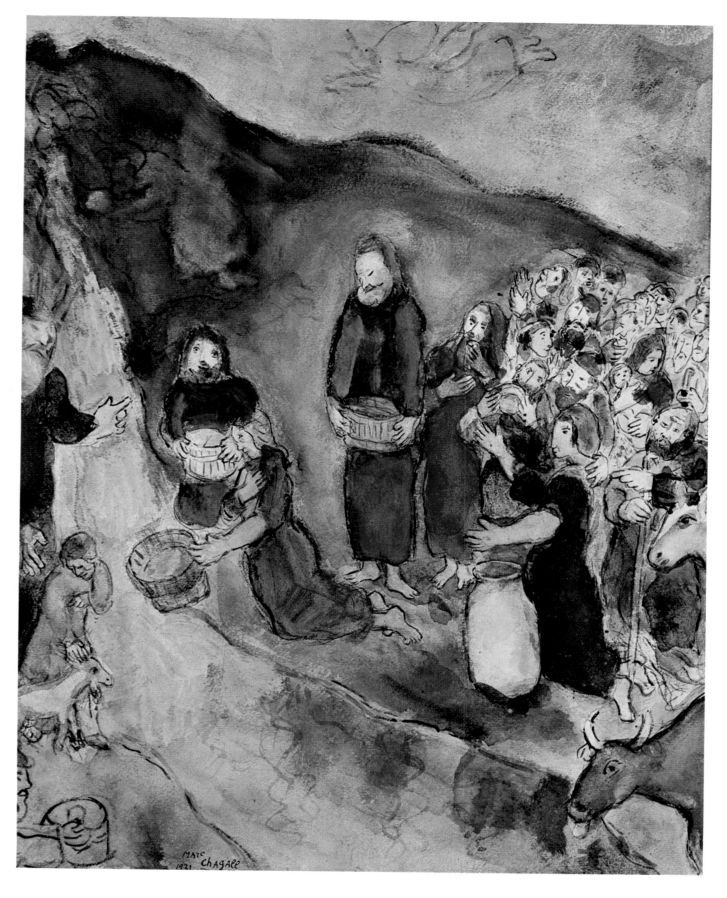

MOSES AND THE ROCK IN HOREB

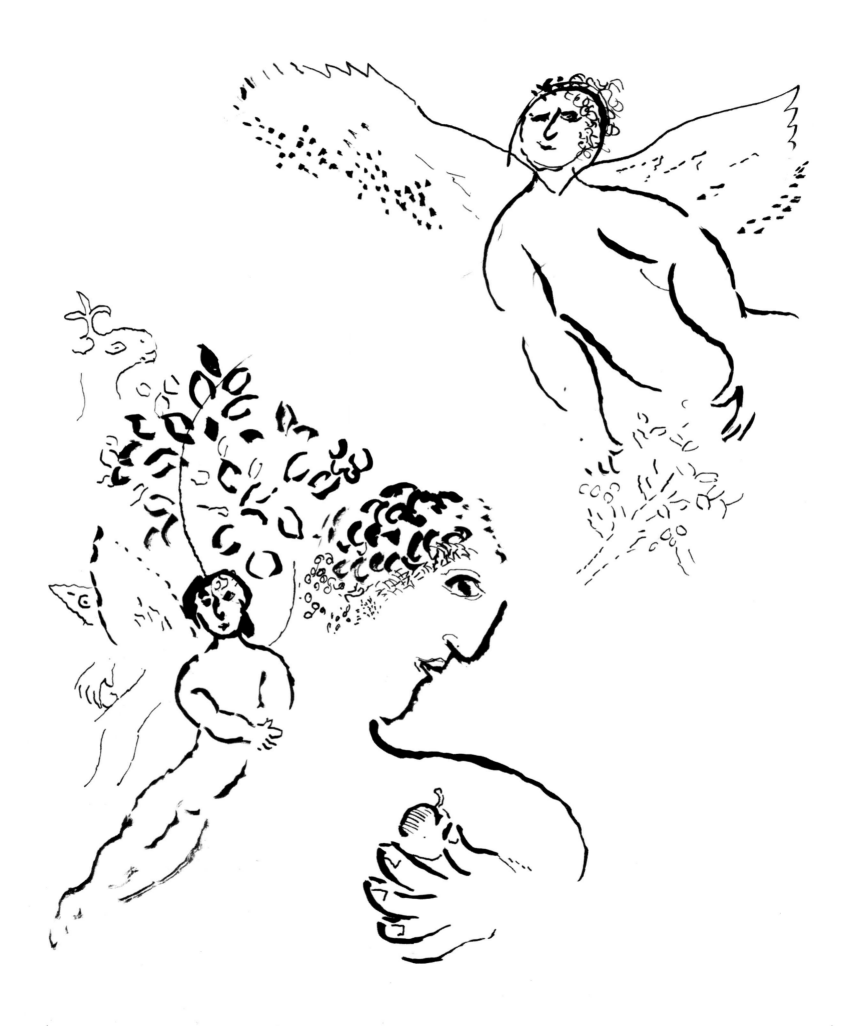

And the Lorde spake unto Moses, saying,

Behold, I have called by name Bezaleel, the sonne of Uri, the fonne of Hur of the tribe of Iudah,

Whom I have filled with the Spirit of God, in wisedom, & understanding & in knowledge and in all workemanship,

To find out curious works to worke in gold, and in silver, and in brasse,

Also in the arte to set stones, and to carve in timber, & to worke in all maner of workemanship.

And behold, I have ioyned with him Aholiab the sonne of Ahisamach of the tribe of Dan, and in the hearts of all that are wise hearted, have I put wisedom to make all that I have commanded thee:

That is, the Tabernacle of the Congregation, and the Arke of the Testimonie, and the Mercieseate that shall be thereupon, with all instruments of the Tabernacle:

Also the Table and the instruments therof, & the pure Candlesticke with all his instruments, and the Altar or perfume:

Likewise the Altar of burnt offering with all his instruments, & the Laver with his foote:

Alfo the garments of the ministration, and the holy garments for Aaron the Priest, and the garments of his sonnes, to minister in the Priests office,

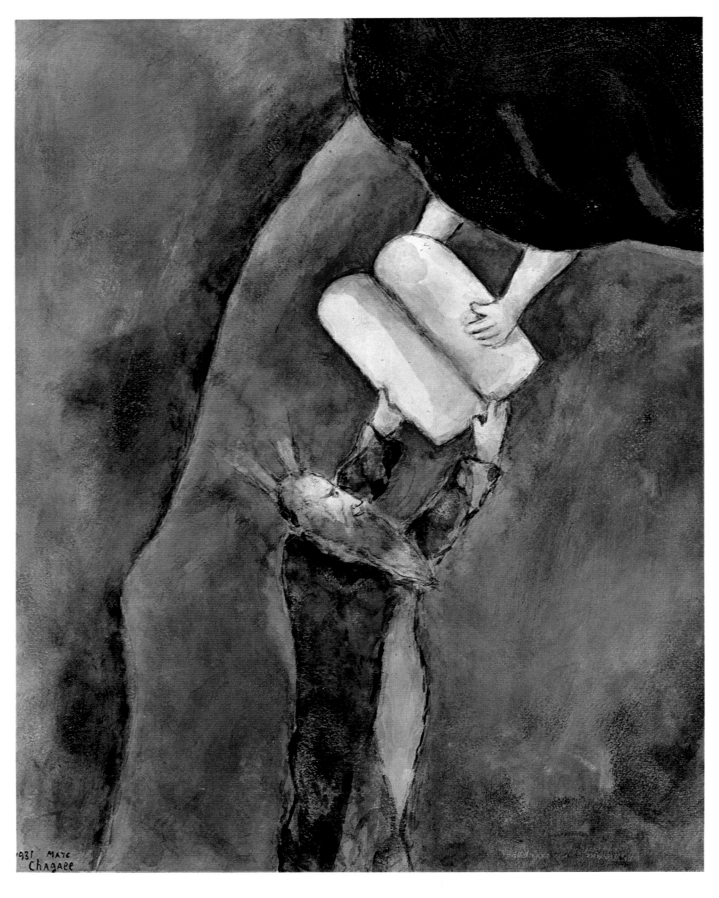

MOSES RECEIVES THE TABLETS OF THE LAW

And the anointing oyle, and sweete perfume for the Sanctuarie: according to al that I have commanded thee, shall they do.

Afterward the Lorde spake unto Moses, saying,

Speake thou also unto the children of Israel, and say, Notwithstanding keepe ye my Sabbaths: for it is a signe betweene me and you in your generations, that yee may know that I the Lord doe sanctifie you.

Ye shall therefore keepe the Sabbath: for it is holy unto you: he that defileth it, shal die the death: therefore whosoever worketh therein, the same person shall be even cut off from among his people.

Sixe dayes shall men worke, but in the seventh day is the Sabbath of the holy rest to the Lord: whosoever doeth any worke in the Sabbath day, shall die the death.

Wherefore the children of Israel shall keep the Sabbath, that they may observe the rest throughout their generations for an everlasting covenant.

It is a signe betweene mee and the children of Israel for ever: for in fixe dayes the Lord made the heaven and the earth, and in the seventh day he ceased, and rested.

Thus (when the Lord had made an ende of communing with Moses upon mount Sinai) he gave him two Tables of the Testimonie, even tables of stone, written with the finger of God.

EXODUS XXXI - 1-18

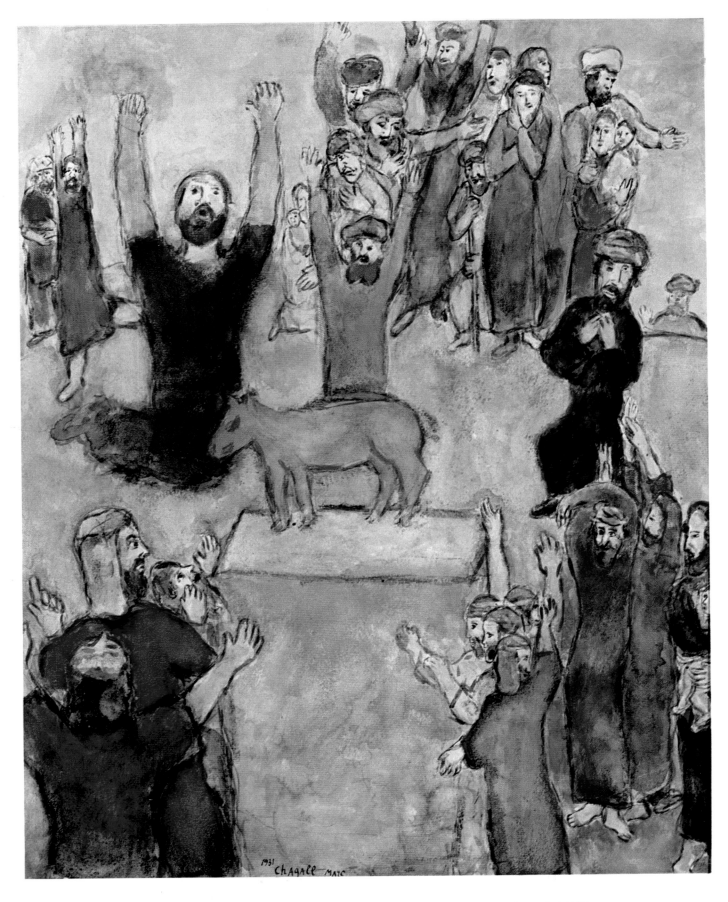

THE HEBREWS WORSHIP THE GOLDEN CALF

But when the people sawe, that Moses taried long or hee came downe from the mountaine, the people gathered themselves together against Aaron, and sayd unto him, Up, make us gods to goe before us: for of this Moses (the man that brought us out of the land of Egypt) we know not what is become of him.

And Aaron said unto them, Plucke off the golde earings, which are in the eares of your wives, of your sonnes, and of your daughters, and bring them unto me.

The all the people pluckt from themselves the golde earings which were in their eares, and they brought them unto Aaron.

Who received them at their handes, and fashioned it with the graving toole, & made of it a molten calfe: then they said, These be thy gods, O Israel, which brought thee out of the land of Egypt.

When Aaron sawe that, hee made an Altar before it: and Aaron proclaimed, saying, To morow shalbe the holy day of the Lord.

So they rose up the next day in y morning, and offred burnt offrings, and brought peace offrings: also the people sate them downe to eate and drinke, and rose up to play.

Then the Lord said unto Moses, Go, get thee downe: for thy people which thou hast brought out of the land of Egypt, hath corrupted their wayes.

EXODUS XXXII - 1-7

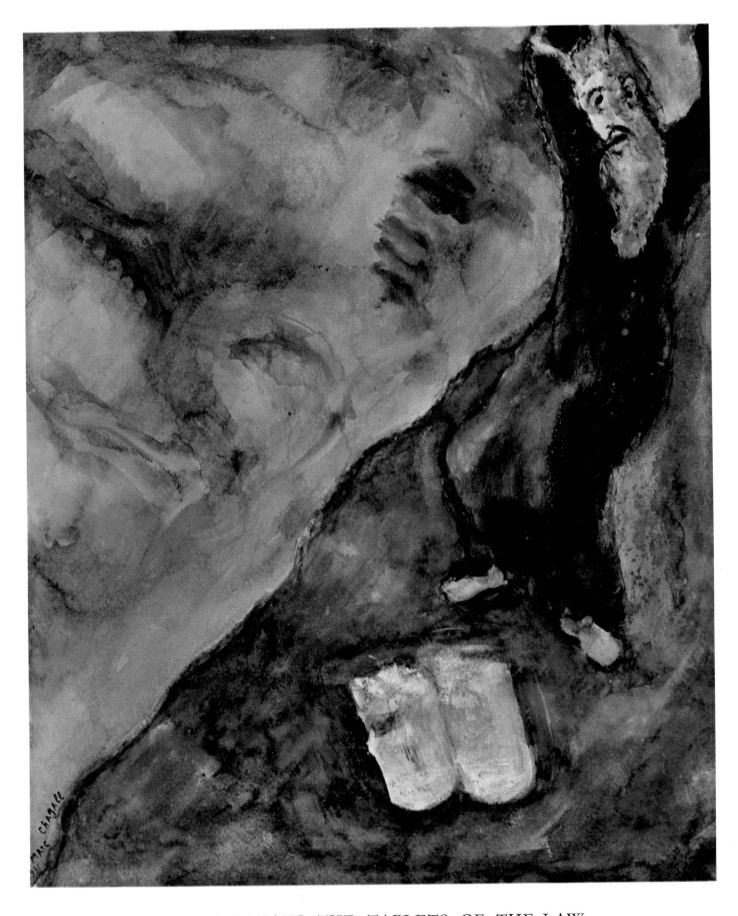

MOSES BREAKS THE TABLETS OF THE LAW

So Moses returned and went downe from the mountaine with the two Tables of the Testimonie in his hand: the Tables were written on both their sides, even on the one side and on the other were they written.

And these Tables were the worke of God, and this writing was the writing of God graven in the Tables.

And when Ioshua heard the noyse of the people, as they showted, he sayd unto Moses, There is a noyse of warre in the hoste.

Who answered, it is not the noyse of them that have the victory, nor the noyse of them that are overcome: but I do heare the noyse of sinsing.

Nowe, assoone as he came neere unto the hoste, he sawe the calfe and the dauncing: so Moses wrath waxed hote, & he cast the Tables out of his hands, & brake them in pieces beneath the mountaine.

After, he tooke the calfe, which they had made, and burned it in the fire, and ground it unto powder, and strowed it upon the water, and made the children of Israel drinke of it.

EXODUS XXXII - 15-20

And the Lord spake unto Moses, saying,

Speake unto Aaron, and say unto him, When thou lightest the lampes, the seven lampes shal give light toward the forefront of the Candlesticke.

And Aaron did so, lighting the lampes thereof toward the forefront of the Candlesticke, as the Lord had commanded Moses.

And this was the worke of the Candlestick, even of golde beaten out with the hammer, both the shaft, and the flowres thereof was beaten out with the hammer: according to the paterne, which the Lord had shewed Moses, so made he the Candlesticke.

<div align="right">NUMBERS VIII - 1-4</div>

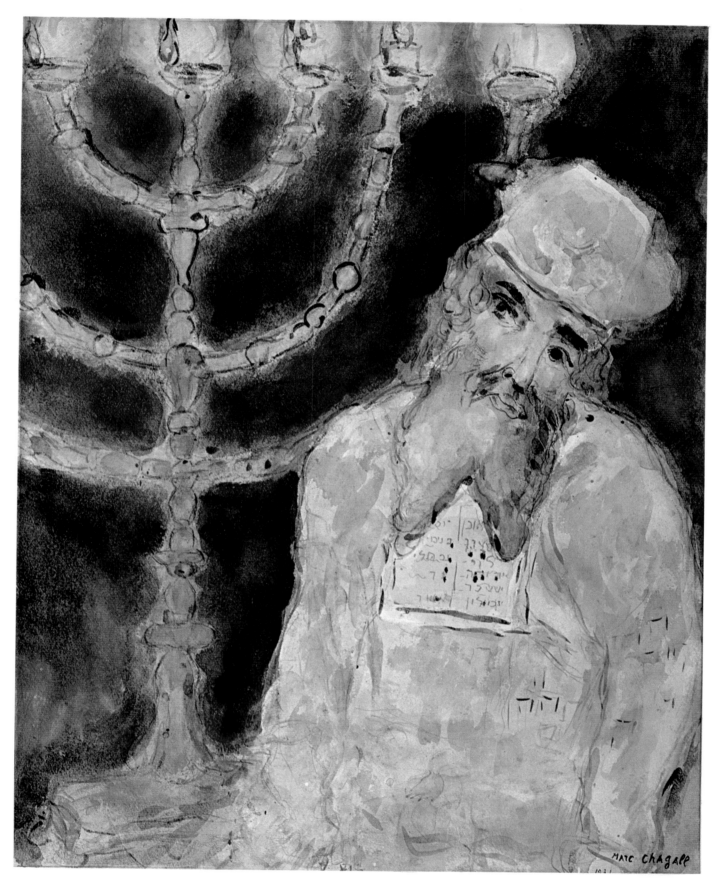

AARON IN FRONT OF THE CANDELABRA

Nowe after the death of Moses the servaunt of the Lord, the Lord spake unto Joshua the sonne of Nun, Moses minister, saying,

Moses my servaunt is dead: now therefore arise, goe over this Iorden, thou, and all this people, unto the lande which I give them, that is, to the children of Israel.

Every place that the sole of your foot shall tread upon, have I given you, as I sayd unto Moses.

From the wildernesse and this Lebanon even unto the great river, the river Perath: all the land of the Hittites, even unto the great sea toward the going downe of the Sunne, shalbe your coast.

There shall not a man be able to withstand thee all the dayes of thy life: as I was with Moses, so wil I be with thee: I will not leave thee, nor forsake thee.

Be strong and of a good courage: for unto this people shalt thou divide the lande for an inheritance, which I sware unto their fathers to give them.

Onely be thou strong, and of a most valiant courage, that thou mayst observe and do according to all the Lawe which Moses my servant hath commanded thee: thou shalt not turne away from it to the right hand, nor to the left, that thou mayest prosper whither soever thou goest.

Let not this booke of the Lawe depart out of thy mouth, but meditate therin day & night, that thou mayest observe and doe according to all that is written therein: for then shalt thou make thy way prosperous, and then shalt thou have good successe.

Have not I commaunded thee, saying, Be strong and of a good courage, feare not nor be discouraged? for I the Lorde thy God will be with thee, whither soever thou goest.

JOSHUA I - 1-9

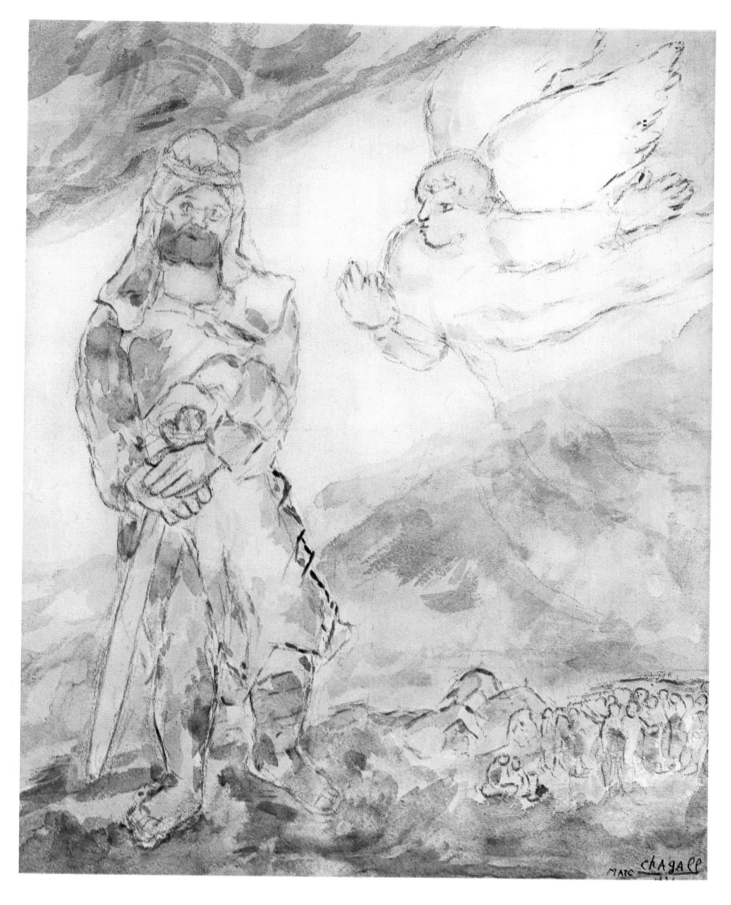

JOSHUA

Chagall makes the book of Genesis contemporary; he reintroduces us to it, and here once again the poetry palpitates like the air around a tree that is enchanted by birds. Today is the day when the first human act is performed, when Adam and Eve are surprised for the first time, when they first are unhappy. For, in spite of everything, Chagall's man is fed by the divine light, as though constantly saved by a process of photosynthesis whose effect is evident in one place by the variation and the unexpectedness of colors escaping from the drawings, in another in the recapturing of the light by means of a spontaneous game that negates the rules in order to invent its own more subtle ones. It is not as an illustrator that Chagall approaches the Bible. Nourished by the ancient poetry, he brings back to his contemporaries the permanence, the vigor, the youth, the prophetic presence, causing the latent fire within him to be seen by others, this fire which is enlarged by the movement of a brush.

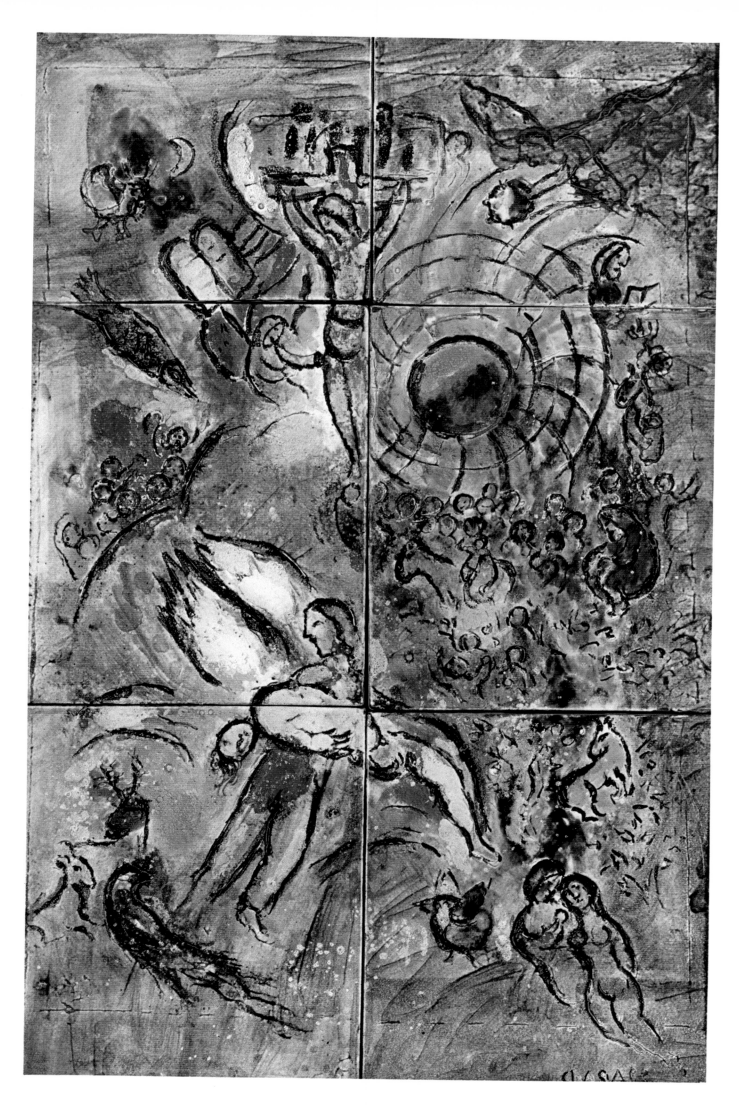

CERAMIC

Contradicting history, utilizing it and passing beyond it, with seeming effortlessness, Chagall devotes all his effort to restoring the full meaning to the words of the legend, to that which should be read, told, recounted, shown, taught. He is a navigator along the invisible border between the here and the beyond, a walker on air; he treads the skies, the prairies, and the seas that the poor clouds hide from us, and he steps on them in order to make a stepping stone for the figures who populate this invisible place and through whom he gives full vent to his feelings. In Chagall's circular time, one has to ascend or descend in order to find the origin, the alpha-omega point where God makes man, is made man, crucifies, separates, unites, gives life, spreads love, compensates for error, where everything occurs at the same time, where the bird flies in the sacred yellow next to the pages of the Holy Book, where the fieyr wings of the angel beat the blue wind of the earth. Here, I can once again see "The Creation of Man"; everything is ready, prefigured rather than figured; it is the moment when the Creator gives his creature the liberty, the joy, and the suffering that come from being His intimate.

Robert Marteau

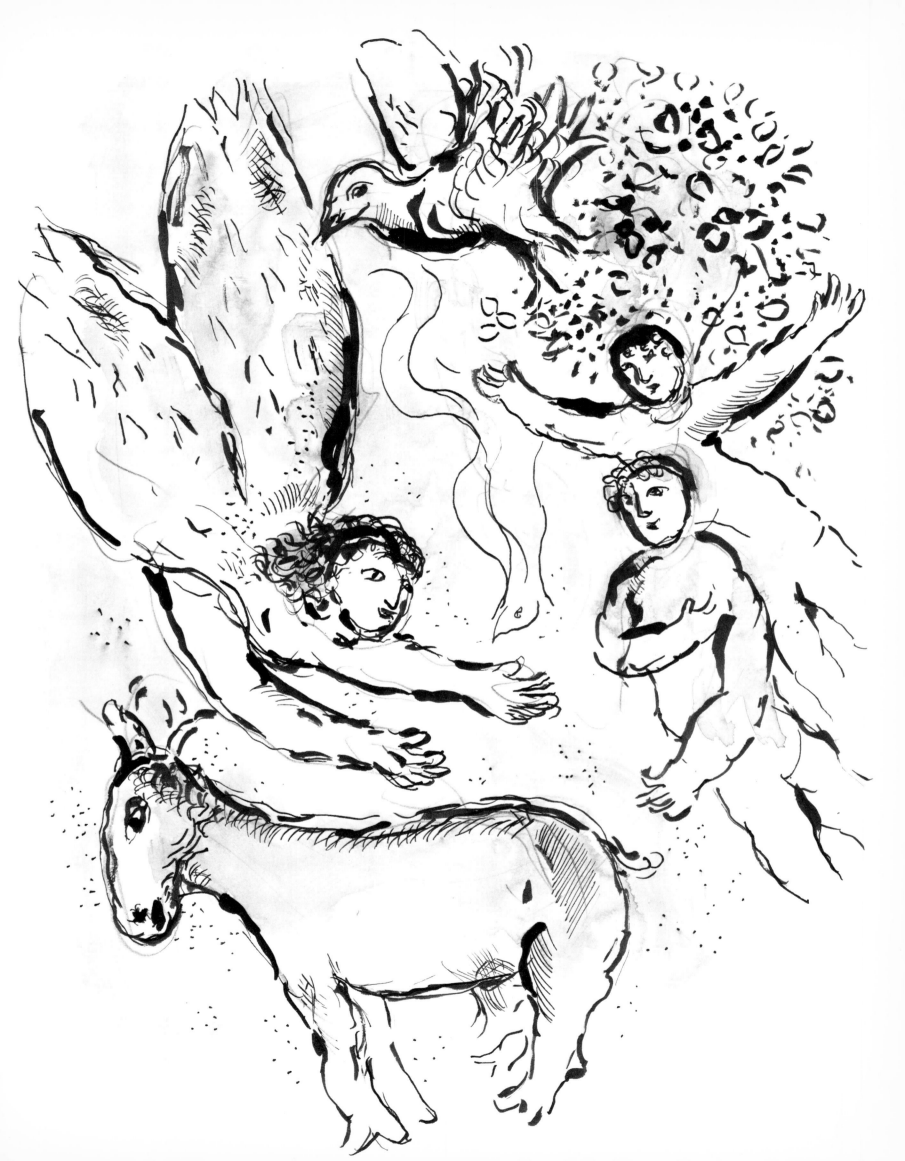

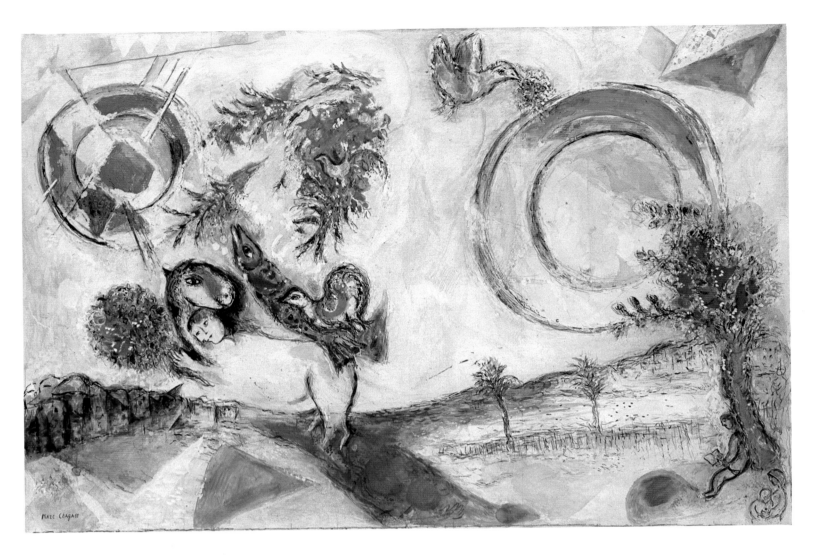

TAPESTRY (CARTOON)

How beautifull upon the mountaines are the feet of him that declareth
and publisheth peace! that declareth good tidings, and publisheth salva-
tion, saying unto Zion, Thy God reigneth!

The voice of thy watchmen shall be heard: they shall lift up their voice,
and shout together: for they shall see eye to eye, when the Lord shall
bring againe Zion.

O ye desolate places of Jerusalem, be glad, and rejoyce together: for the
Lord hath comforted his people: he hath redeemed Jerusalem.

The Lord hath made bare his holy arme in the sight of all the Gentiles,
and all the endes of the earth shall see the salvation of our God.

ISAIAH LII - 7-10

172

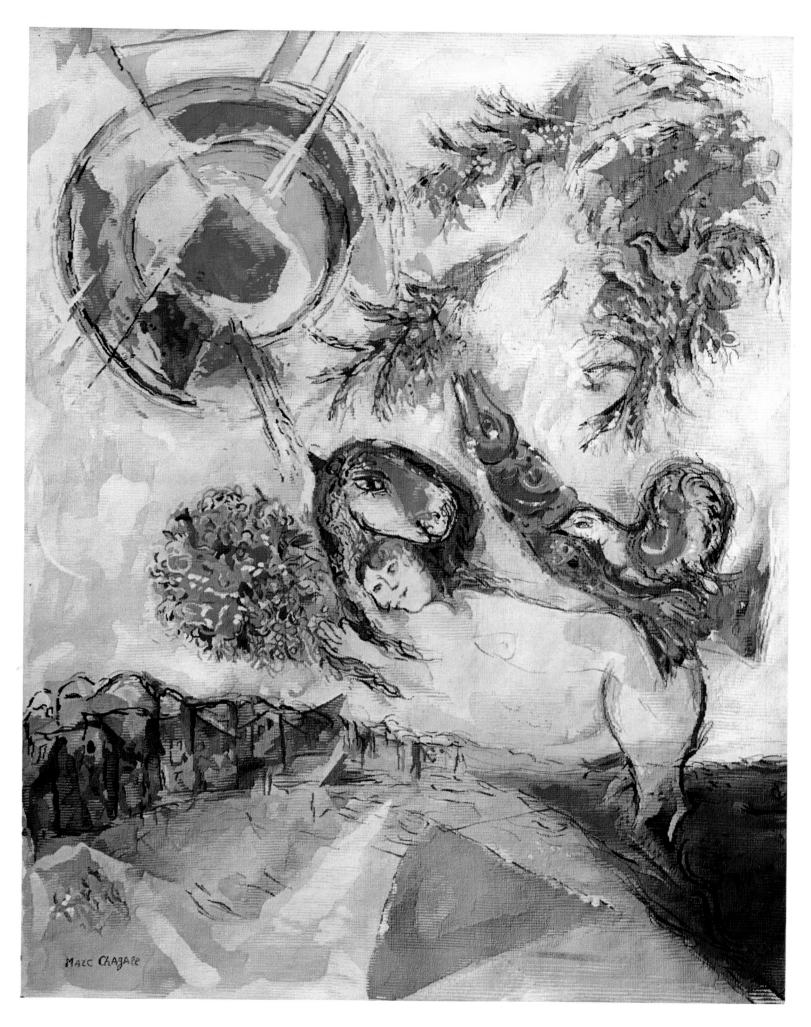

TAPESTRY (DETAIL)

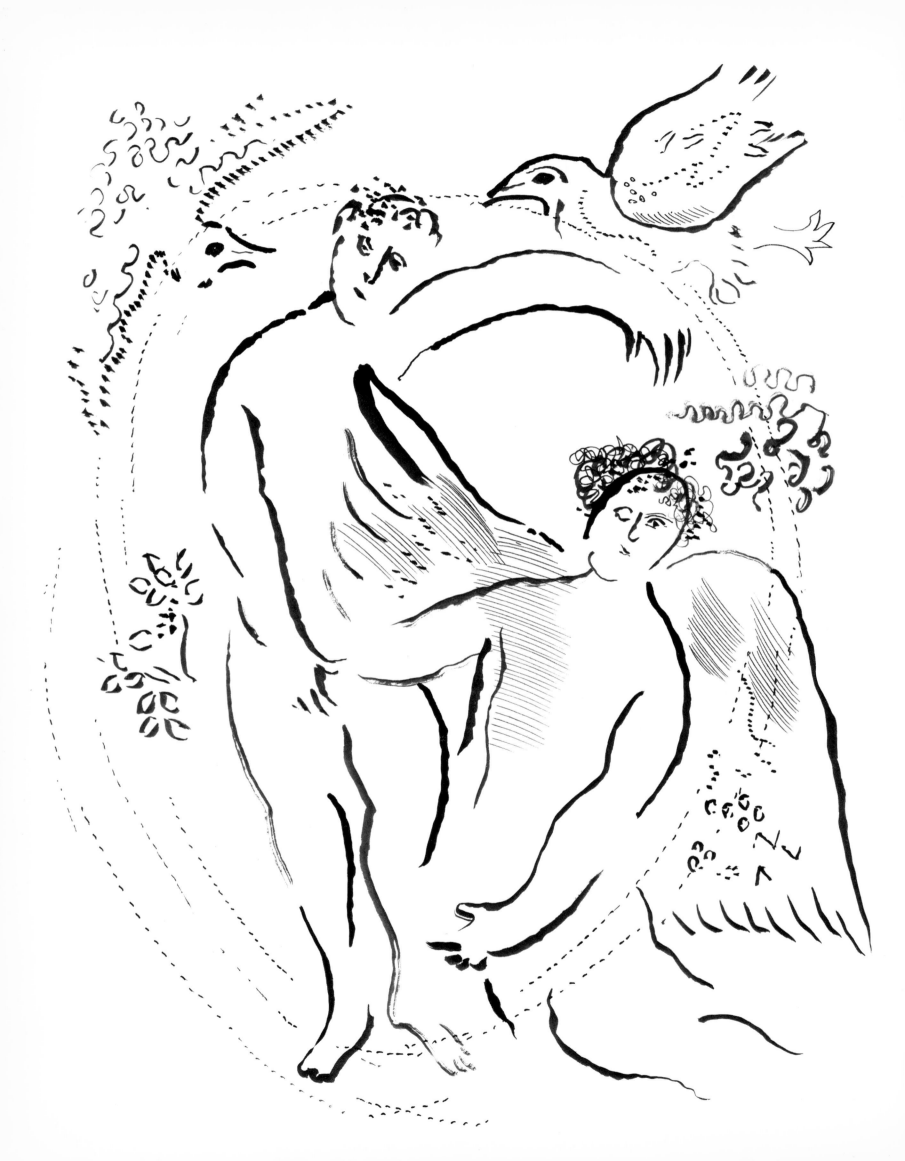

Then stoode up Elias the Prophet as a fire, and his word burnt like a lampe.

Hee brought a famine upon them, and by his zeale hee diminished them: (for they might not away with the commaundements of the Lord.)

By the worde of the Lorde he shut the heaven, and three times brought hee the fire from heaven.

O Elias, howe honourable art thou by thy wonderous deedes! who may make his boast to be like thee!

Which hast raised up the dead from death, and by the word of the most High out of the grave:

Wchich hast brought Kings unto destruction, and the honourable from their seate:

Which heardest the rebuke of the Lorde in Sina, and in Horeb the judgement of the vengeance:

Which diddest anoint Kings that they might recompense, and Prophets to be thy successours:

Which wast taken up in a whirlewinde of fire, and in a charet of firie horses:

Which wast appointed to reprove in due season, and to pacifie the wrath of the Lords iudgement before it kindled, and to turne the hearts of the fathers unto the children, and to set up the tribes of Iacob.

Bleffed were they that saw thee, and slept in love: for we shall live.

When Elias was covered with the storme, Eliseus was filled with his spirit: while he lived, he was not mooved for any prince, neither could any bring him into subiection.

ECCLESIASTES XLVIII - 1-12

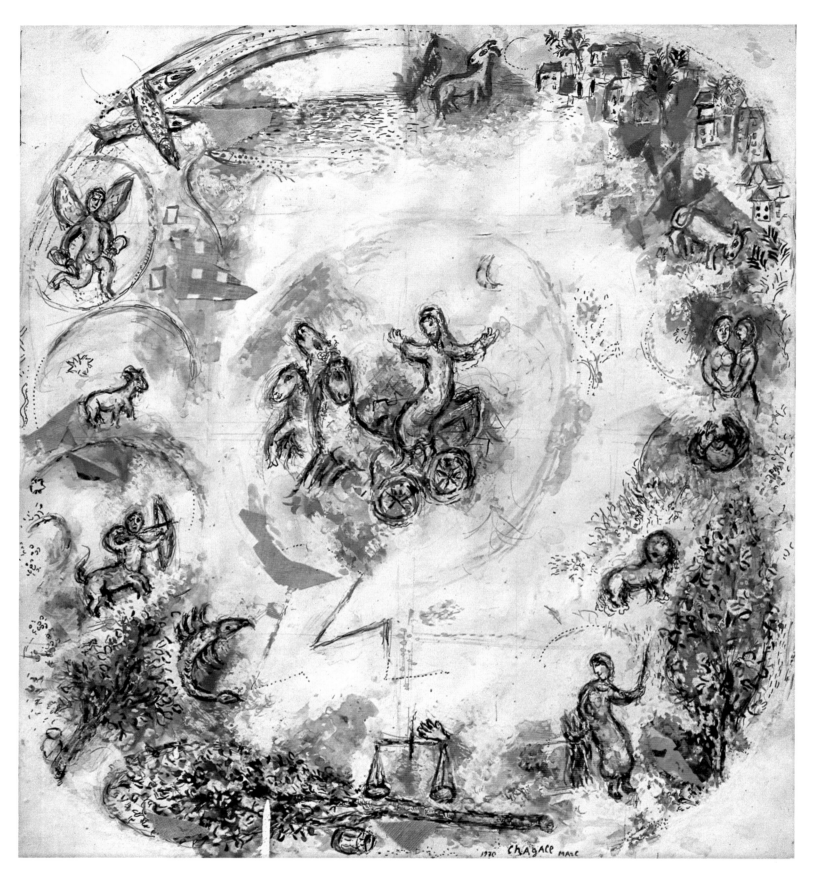

THE PROPHET ELIJAH (CARTOON FOR A MOSAIC)

And when the Lord would take up Eliiah into heaven by a whirle winde, Eliiah went with Elisha from Gilgal.

Then Eliiah said to Elisha, Tarie here, I pray thee: for the Lorde hath lent me to Beth-el. But Elisha said, As the Lord liveth, and as thy soule liveth, I will not leave thee. So they came downe to Beth-el.

And the children of the Prophets that were at Beth-el, came out to Elisha, and sayde unto him, Knowest thou that the Lorde will take thy master from thine head this day? And he saide, Yea, I knowe it: hold ye your peace.

Againe, Eliiah saide unto him, Elisha, tarie here, I pray thee: for the Lord hath sent mee to Iericho. But he saide, As the Lorde liveth, and as thy soule liveth, I will not leave thee. So they came to Iericho.

And the children of the Prophets that were at Iericho, came to Elisha, and sayde unto him, Knowest thou, that the Lorde will take thy master from thine head this day? And hee sayde, Yea, I knowe it: holde ye your peace.

Moreover, Eliiah said unto him, Tary, I pray thee, here: for the Lorde hath sent me to Iorden. But he said, As the Lord liveth, & as thy soule liveth, I wil not leave thee. So they went both together.

And fifty men of the sonnes of the Prophets went and stoode on the other side a farre off, and they two stood by Iorden.

Then Eliiah tooke his cloke, and wrapt it together, and smote the waters, and they were divided hither and thither, and they twaine went over on the dry land.

Nowe when they were passed over, Eliiah saide unto Elisha, Aske what I shall doe for thee before I bee taken from thee. And Elisha saide, I pray thee, let thy Spirit be double upon me.

And hee saide, Thou hast asked an harde thing: yes if thou see mee when I am taken from thee, thou shalt have it so: and if not, it shall not be.

And as they went walking and talking, behold, there appeared a charet of fire, and horses of fire, and did separate them twayne. So Eliiah went up by a whirlewinde into heaven.

KINGS II - I-II

CHRIST ON THE CROSS

KING DAVID

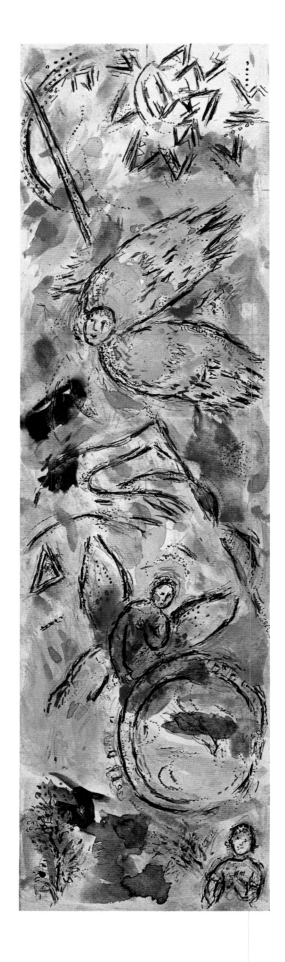

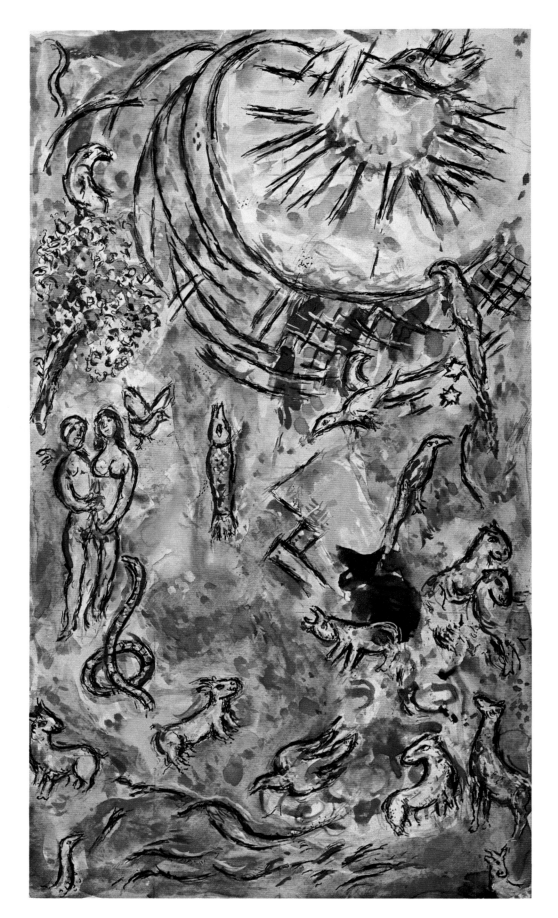

THE CREATION OF THE WORLD (CARTOONS FOR WINDOWS)

MOSES

In the beginning God created y heaven & the earth.

And the earth was without forme & voyde, and darkenes was upon the deepe, & the Spirit of God moved upon the waters.

Then God saide, Let there be light: And there was light.

And God saw the light that it was good, and God separated the light from the darknes.

And God called the light, Day, and the darknes, he called Night. So the evening and the morning were the first day.

Againe God said, Let there be a firmament in the middes of the waters: and let it separate the waters from the waters.

Then God made the firmament, and separated the waters, which were under the firmament, from the waters which were above the firmament: and it was so.

And God called the firmament, Heaven. So the evening and the morning were the second day.

God said againe, Let the waters under the heaven be gathered into one place, and let the dry land appeare: and it was so.

And God called the dry land, Earth, and hee called the gathering together of the waters, Seas: and God saw that it was good.

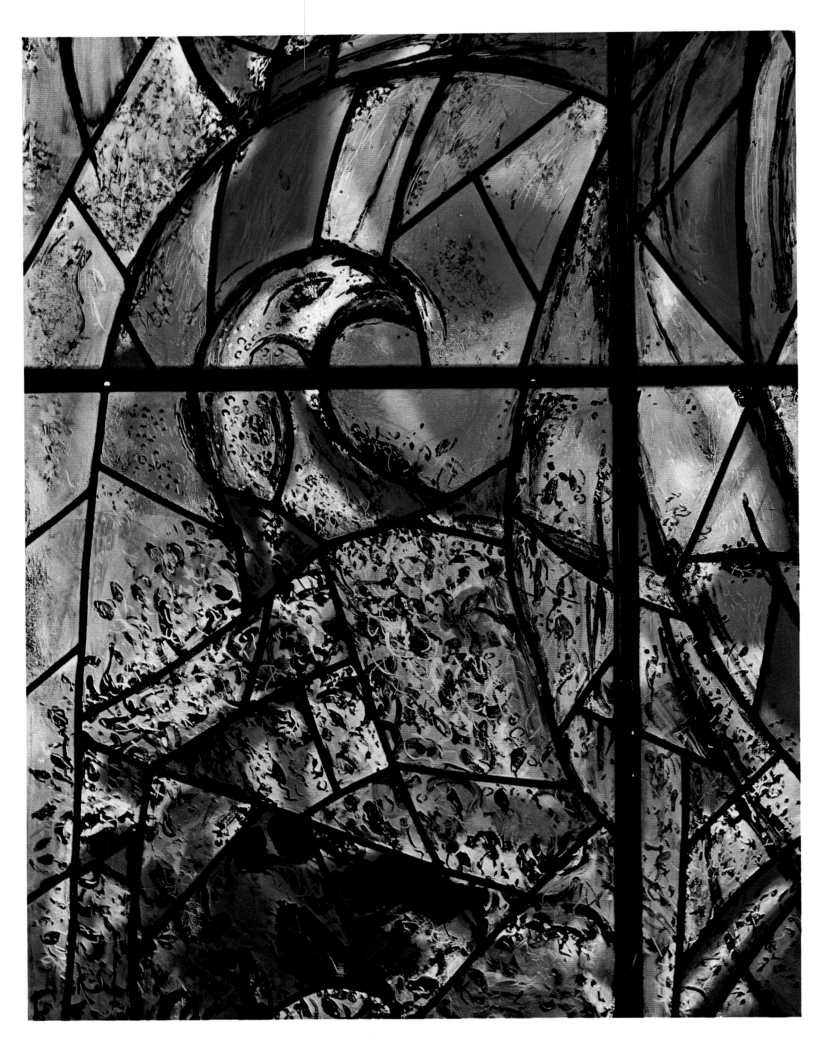

THE CREATION OF THE WORLD (WINDOW, DETAIL)

Then God saide, Let the earth bud foorth the bud of the herbe, that feedeth feede, the fruitful tree, which beareth fruite according to his kinde, which hath his feede in it selfe upon the earth: and it was so.

And the earth brought forth the bud of the herbe, that feedeth feede according to his kinde, also the tree that beareth fruite, which hath his feede in it selfe according to his kinde: and God saw that it was good.

So the evening and the morning were the third day.

And God said, Let there be lights in the firmament of the heaven, to separate y day from the night, and let them be for signes, and for seasons, and for dayes and yeeres.

And let them be for lights in the firmament of the heaven to give light upon the earth: and it was so.

God then made two great lights: the greater light to rule the day, and the lesse light to rule the night: he made also the starres.

And God set them in the firmament of the heaven, to shine upon the earth.

And to rule in the day, and in the night, and to separate the light from the darknes: and God saw that it was good.

So the evening and the morning were the fourth day.

Afterward God saide, Let the waters bring foorth in abundance every creeping thing that hath life: and let the foule fly upon the earth in the open firmament of the heaven.

Then God created the great whales, & every thing living & moving, which the waters brought foorth in abundance according to their kind, & every fethered foule according to his kinde: and God saw that it was good.

Then God blessed them, saying, Bring forth fruite and multiply, and fill the waters in the seas, and let the foule multiply in the earth.

So the evening and the morning were the fift day.

Moreover God said, Let the earth bring forth the living thing according

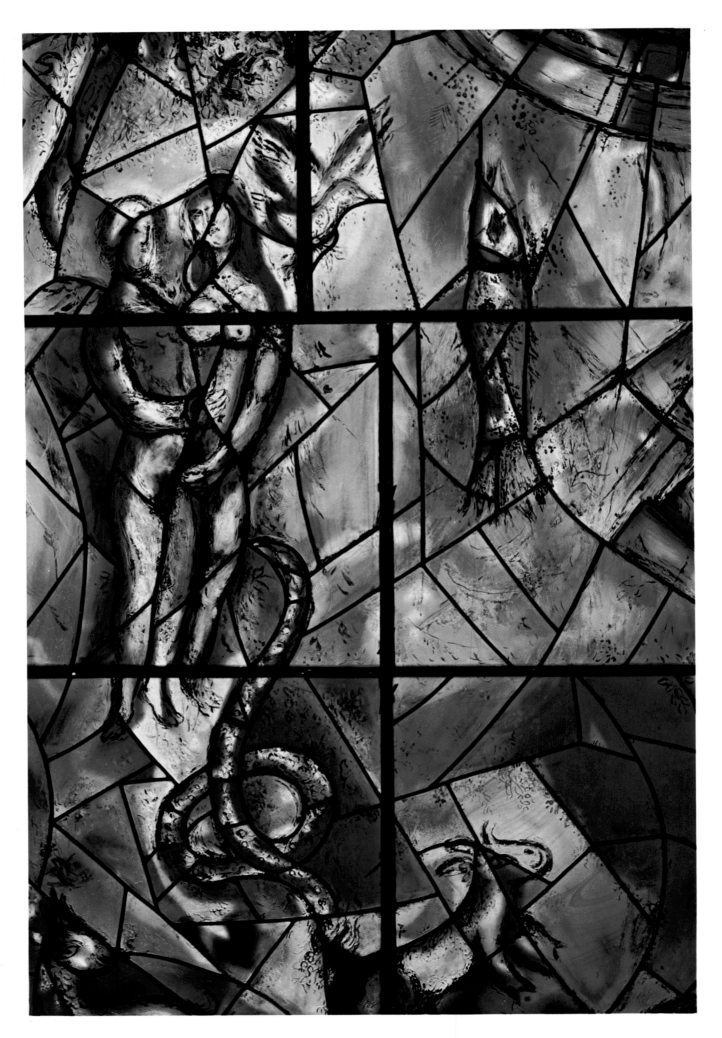

THE CREATION OF THE WORLD (WINDOW, DETAIL)

to his kind, cattell, & that which creepeth, and the beast of the earth, according to his kinde: and it was so.

And God made the beast of the earth according to his kinde, and the cattell according to his kinde, and every creeping thing of the earth according to his kind: and God saw that it was good.

Furthermore God said, Let us make man in our image according to our likenes, and let them rule over the fish of the sea, & over the foule of the heaven, and over the beasts, and over all the earth, and over every thing that creepeth and mooveth on the earth.

Thus God created the man in his image: in the image of God created he him: he created them male and female.

And God blessed them, and God saide to them, Bring foorth fruite and multiply, and fill the earth, and subdue it, and rule over the fish of the sea, and over the foule of the heaven, and over every beast that moveth upon the earth.

And God saide, Beholde, I have given unto you every herbe bearing feede, which is upon all the earth, and every tree, wherein is the fruite of a tree bearing seede: that shall be to you for meate.

Like wife to every beast of the earth, and to every foule of the heaven, & to every thing that moveth upon the earth, which hath life in it selfe, every greene herbe shalbe for meat: and it was so.

And God sawe all that he had made, and loe, it was very good. So the evening and the morning were the sixt day.

GENESIS I - 1-31

THE CREATION OF THE WORLD (WINDOW, DETAIL)

THE CREATION OF THE WORLD (WINDOW, DETAIL)

By limiting myself to one of several possible approaches to examining Chagall's biblical illustrations, I have avoided discussing the richness of Chagall's work, because to comment on that aspect of such a body of work would require a much longer study. In addition to our personal preferences, we would have to know the artist's own preferences. But not everything is revealed; the artist, of course, need not give us the reasons for his choices of themes and motifs. Obviously, such a wealth of subject-matter raises the problem of what might be termed "the philosophy of illustration." To solve it, we would need to think ourselves into the solitude of the painter confronting his blank page. Chagall's solitude was total, for there was nothing to help him summon up from the darkness of a bygone age the shapes of these men and women. There could be no question of copying; all had to be created. And how exacting must have been the task of delineating the Prophets and giving each distinctive traits! One trait, however, all these Prophets have in common: all are "Chagallian"; all bear the imprint of their creator. For a student of the philosophy of imagery, every illustration in this book could serve as a reference work for studying the operation of the creative imagination.

Gaston Bachelard

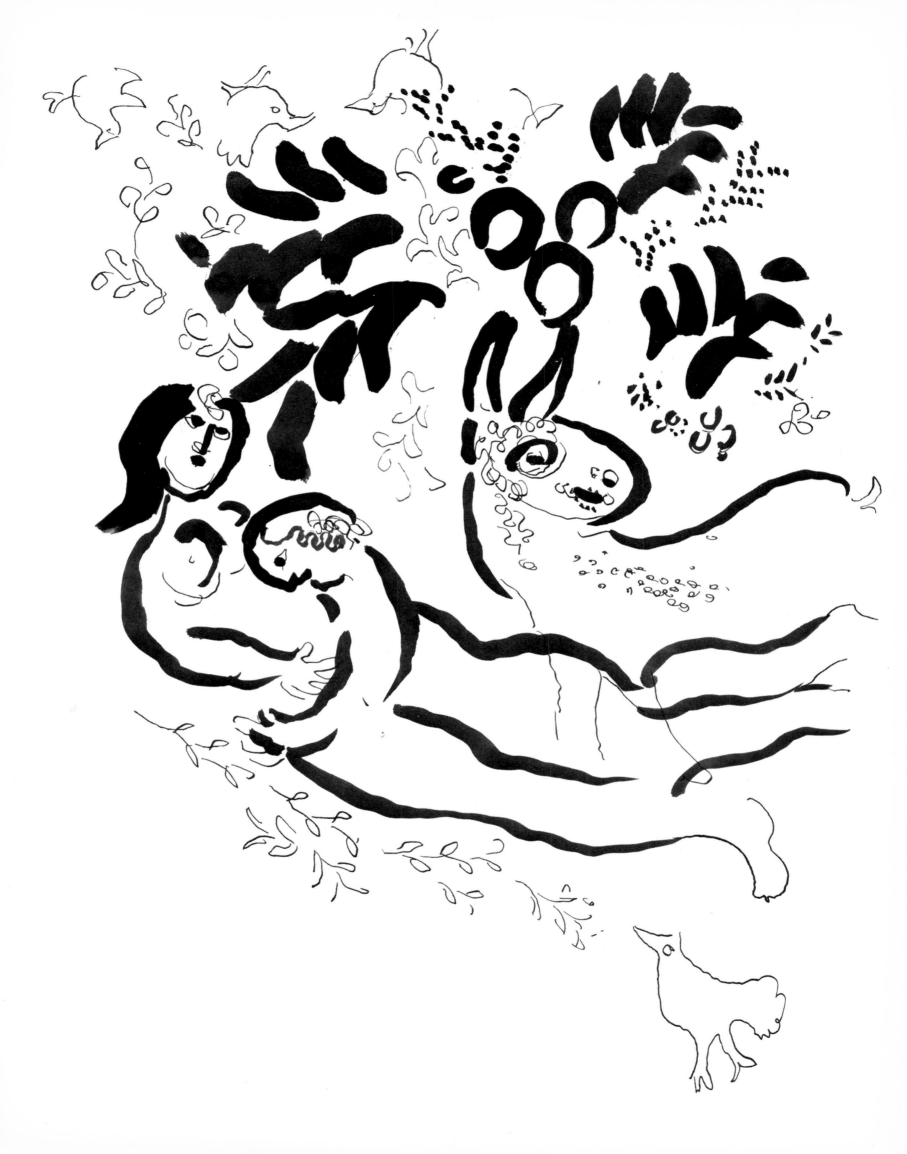

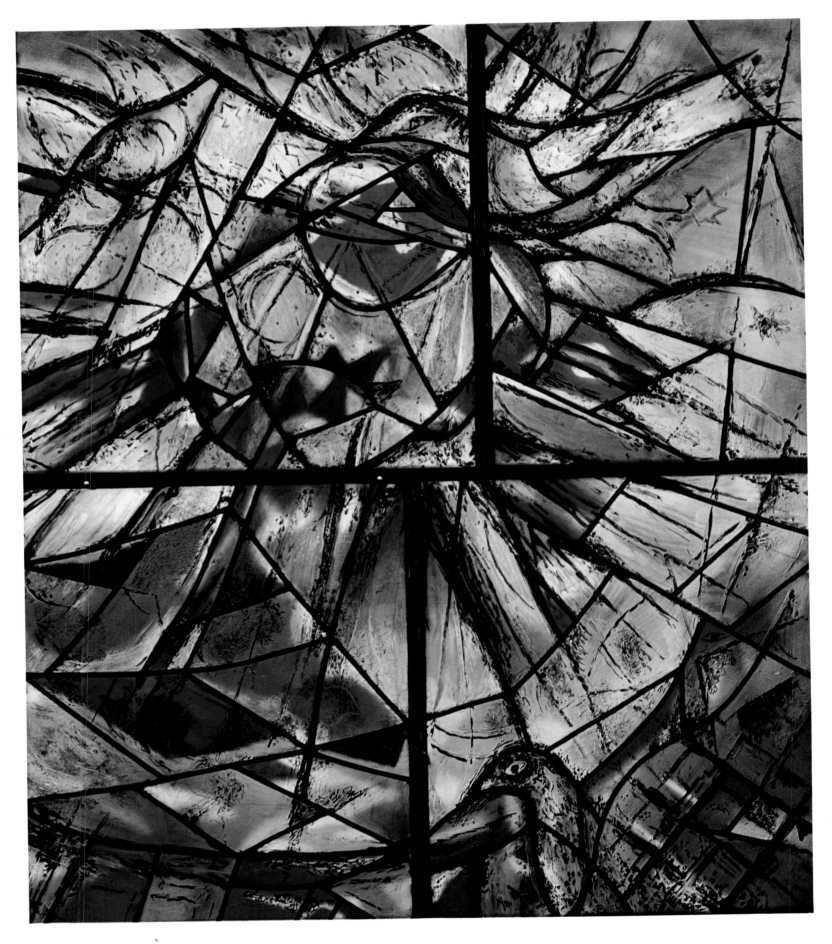

THE CREATION OF THE WORLD (WINDOW, DETAIL)

"I couldn't see the Bible, I was dreaming it," Chagall said when Ambroise Vollard suggested he should illustrate it. Later he added, "I never work out of my head. When I had to illustrate the Bible for Vollard, he said to me: 'Go and have a look at Place Pigalle.' But I wanted to see Palestine, I wanted to touch the ground." Accordingly, invited by Mr. Dizengoff, the mayor and founder of Tel Aviv, Chagall went to the Holy Land in 1931. "I was dazzled; it made a stronger impression on me than anything in my whole life," he reported. It was during this period that he made the first gouaches used for the Bible illustrations and that he initiated the *Biblical Message* project. Before the war of 1940 Chagall met Father Couturier at Jacques Maritain's home, and he saw him again in the United States. Their talks gave birth to the idea of conceiving a work destined for a "spiritual" building. On returning to France, Chagall designed the ceramic "The Crossing of the Red Sea," two bas-reliefs inspired by the Psalms, and two stained glass windows which were placed in the Notre-Dame-de-Toute-Grâce Church on the Assy plateau.

In 1950, while he was living in Vence, some friends drew Chagall's attention to a series of small, old abandoned chapels known as the Chapels of the Stations of the Cross. He inspected the largest one and, with great interest, noted its layout and measurements with a view to making a group of paintings on biblical subjects, the sizes and arrangements of the paintings corresponding to the dimensions of the chapel. In 1954 Chagall began painting the series of large canvases that constitute his *Biblical Message*.

When the Vence chapels project failed because of the limited amount of funds available for the upkeep of the paintings, Chagall nonetheless went on working until the series was completed in 1967. Meanwhile, Chagall found warm and understanding supporters in Monsieur Jean Médecin, the mayor of Nice, and Monsieur Thirion, who was then the curator of the museums of that city. When Marc Chagall and his wife, Valentina, expressed their wish to donate this series to the French State, they received the support of Monsieur André Malraux, the Minister of Cultural Affairs and National Museums. The City of Nice purchased a site on the Cimiez Hill, where the building commissioned by the State to house the *Biblical Message* of Marc Chagall was to be erected.

Monsieur André Hermant, who—with the approval of Monsieur Jean Chatelain, the Director of the National Museums of France—was put in charge of the building's architecture, met the painter and drew up the blueprints. This building was conceived to house permanently the complete *Biblical Message;* in addition, it includes a room for temporary exhibitions and another for cultural events (lectures, concerts, film showings, etc.). Chagall's idea was not to build a museum but to create, in a spirit of freedom and brotherhood, a place whose atmosphere would be favorable to all sorts of cultural events without regard to the ideological stance of the participants.

Monsieur and Madame Chagall's endowment also includes sculptures, windows, and a mosaic designed for the foundation. Further dispositions have been envisaged by the artist and his wife to enrich the foundation even further. This endowment, which Chagall has placed at the service of the love of mankind, is unique in the history of art.

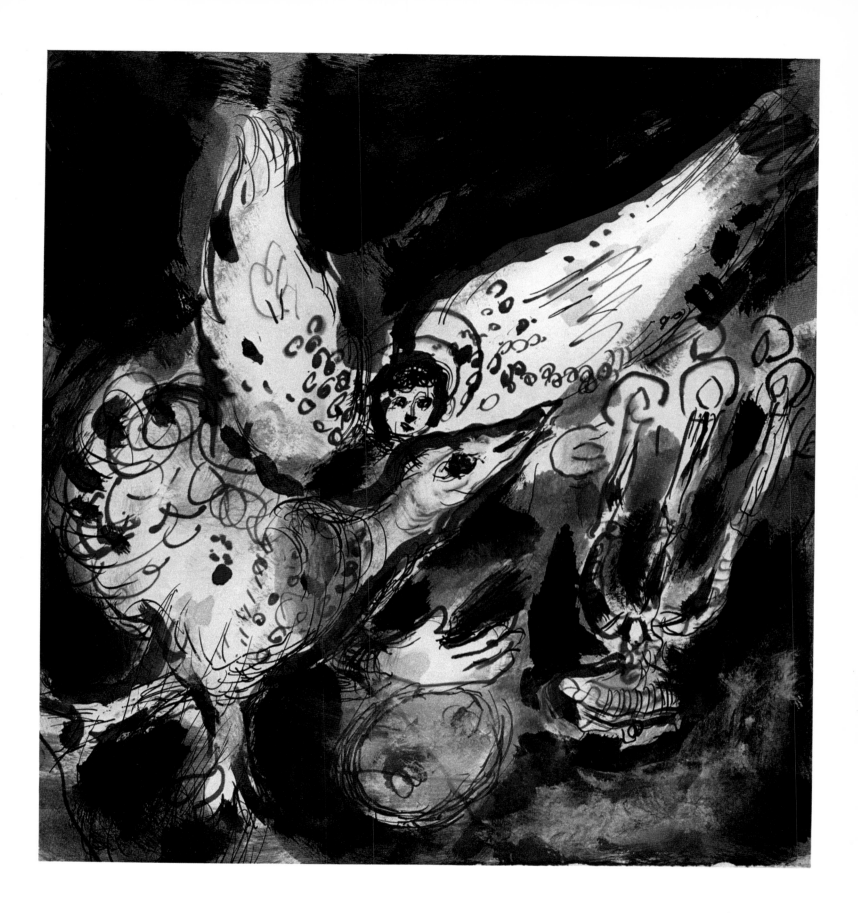

LIST OF ILLUSTRATIONS

Oil paintings

Gouaches

Tapestries, Ceramics, Stained-Glass Windows

Cover front — detail of maquette for Jacob's dream.

Chagall engraved an original lithograph, presented in the frontispiece, especially for this book; he also drew 22 compositions which are reproduced throughout.

The biblical texts illustrated by Chagall's compositions are drawn from an edition of the Holy Scriptures — printed in London by Christopher Barker in 1597 — which can be seen in the National Library in Paris.

Gaston Bachelard, Meyer Schapiro, " Dessins pour la Bible ", Éditions Verve.

Robert Marteau, " Le Message Biblique de Chagall ", Revue Esprit (Nov. 1967).

THIS BOOK, PRODUCED BY FERNAND MOURLOT
ACCORDING TO THE LAYOUT BY CHARLES SORLIER, WAS PRINTED
IN APRIL 1973
ON THE PRESSES OF DRAEGER FRÈRES
IN MONTROUGE.
THE ORIGINAL LITHOGRAPH
WAS PULLED
ON THE PRESSES OF MOURLOT
IN PARIS
BINDING BY LA RELBRO AT MALAKOFF.

D.L. 1972-4 - I. 6815 - E. 6171